MODERN QUILTS

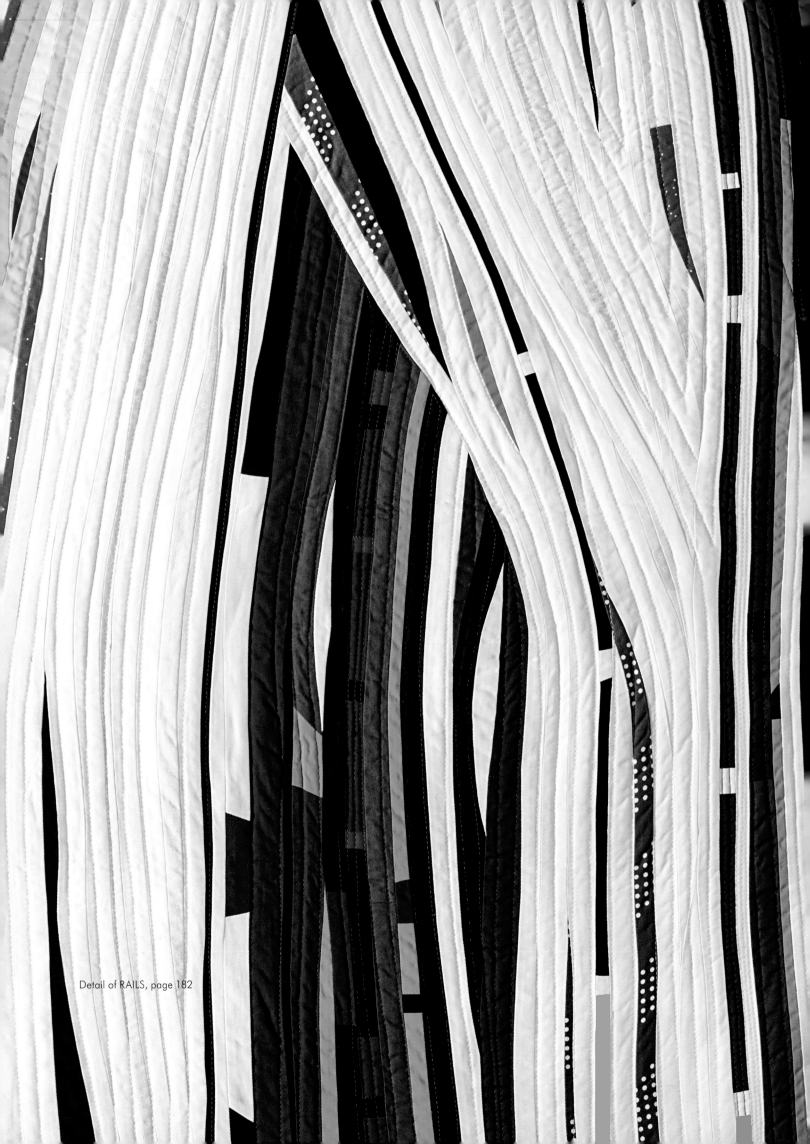

Detail of RAILS, page 182

MODERN QUILTS

Designs of the New Century

THE MODERN QUILT GUILD®

Riane Menardi, Alissa Haight Carlton, and Heather Grant

stash BOOKS.
an imprint of C&T Publishing

PUBLISHER: Amy Marson

CREATIVE DIRECTOR: Gailen Runge

EDITOR: Liz Aneloski

COVER/BOOK DESIGNER: April Mostek

PRODUCTION COORDINATOR: Zinnia Heinzmann

PRODUCTION EDITOR: Alice Mace Nakanishi

PHOTO ASSISTANT: Mai Yong Vang

PHOTOGRAPHY by Diane Pedersen of C&T Publishing, Inc., unless otherwise noted

COVER QUILT: Detail of *Go North*, page 176

Library of Congress Cataloging-in-Publication Data

Names: Menardi, Riane. | Carlton, Alissa Haight, 1976- | Grant, Heather (Quilter) | Modern Quilt Guild, issuing body.

Title: Modern quilts : designs of the new century / The Modern Quilt Guild ; Riane Menardi, Alissa Haight Carlton, and Heather Grant.

Description: Lafayette, CA : Published by Stash Books, an imprint of C&T Publishing, Inc., 2017. | Includes index.

Identifiers: LCCN 2017013881 | ISBN 9781617455988 (soft cover)

Subjects: LCSH: Quilts--History--20th century--Themes, motives. | Quilts--History--21st century--Themes, motives. | Modern Quilt Guild.

Classification: LCC NK9110 .M63 2017 | DDC 746.4609/0904--dc23

LC record available at https://lccn.loc.gov/2017013881

Printed in China

10 9 8 7 6 5 4 3 2

Dedication

To members of The Modern Quilt Guild

Acknowledgments

Thank you first to The Modern Quilt Guild (MQG) members and the modern quilt community. The quilts in this book reflect the vibrancy and vitality of the modern quilters who make up a dynamic community that has become a growing and thriving movement. Modern quilters are giving, talented, and incredibly passionate about the art of quiltmaking. Together, the community has created something that somehow adds up to more than the sum of its parts. This book reflects the diversity and passion of this community, and the inspiration it provides comes directly from modern quilters and their talents.

Thank-yous need to be given to so many additional people.

- To those early Los Angeles members who showed up to the very first MQG meeting in 2009. You showed all modern quilters that we could build our community in person, as well as online.

- To our first board—Latifah, Elizabeth H., Jacquie, and Alissa. Without your steadfast vision the guild would not be where we are today.

- To our other board members past and present—Amy, Heather, Susanne, Kathy, Andrew, Carole, Shannon, Andres, Jules, Jill, Christen, and Cheryl—who have provided leadership through all our successes and challenges.

And to all our volunteers, who over the years have dedicated so much time to building our guild from just a few people to an organization of thousands. There have been many unsung heroes who have given countless hours of their time. Thanks to our staff, past and present, the people who work hard every day, managing all the details and moving us forward—Alissa, Heather, Jen, Elizabeth D., Riane, Molly, Amanda, Natalie, and Janice. Finally, thanks to our families— Chris, Charley, Gavin, Gabe, Lucas, and Kevin—for all their love and support.

The MQG would also like to thank Liz, Roxane, Alice, Zinnia, April, Diane, Mai, and Amy from C&T for their help throughout the process of creating this book.

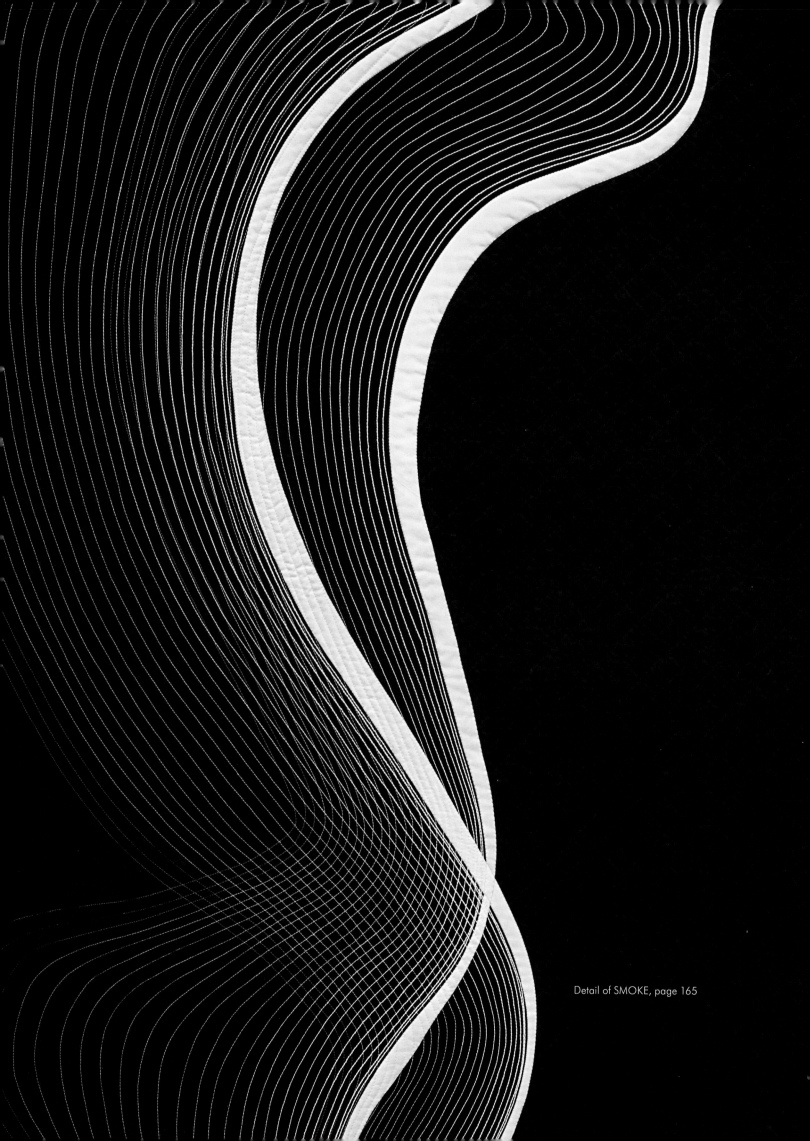

Detail of SMOKE, page 165

CONTENTS

INTRODUCTION

Modern quilts mean different things to different people. Modern quilts are utilitarian. They are art. They tell stories. They are graphic, improvisational, or minimalist. They break the rules. They make a statement.

No matter the design aesthetic, modern quilts are creative expressions made with needle and thread, fabric, and time. Modern quilters respect the rich tradition of quilts throughout history, and we recognize that we are makers in a lineage that stretches back centuries. Modern quilting is the result of years of work and countless makers and influencers who came before us. In this book, you'll see the work of modern quilters,

past and present, and learn the story of where we've been, where we are, and see a glimpse into where we're going. We are all makers; we are all storytellers; and we are all part of a community making our mark at this moment in quilt history.

We hope you enjoy this book and glean some inspiration from the more than 200 quilts within. From quilt empires like the Amish and the quilts of Gee's Bend, to the emergence of the word "modern" in quilting, we'll discuss influencers and milestones in the twentieth century and today that have paved the way for all of us.

About The Modern Quilt Guild

The Modern Quilt Guild is a community of over 12,000 quilters across six continents and 39 countries. The Modern Quilt Guild's mission is to support and encourage the growth and development of modern quilting through art, education, and community.

All the quilts in the gallery section of this book were made by MQG members, past and present.

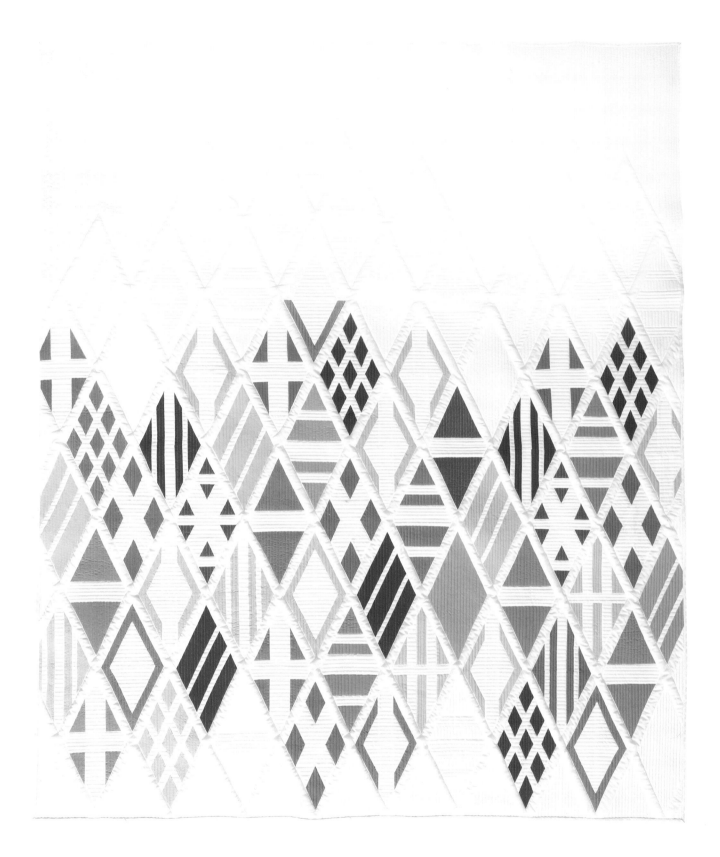

EIDOS
Designed by Agatha June, pieced by Elizabeth Dackson, quilted by Gina Pina, 2016, 68″ × 78″

This quilt is based on an extended license design by Ilya Bolotov.

Photo by Scott David Gordon Photography

EARLY INFLUENCERS OF MODERN QUILTING: BEFORE 1998

Modern quilting has existed in many forms for much of the twentieth century and quilters began stepping out of the box (and block) long before the modern quilting movement of the 2000s. When modern quilting came into its own, these outliers were the leaders who inspired modern quilters to discover their voices and make their own unique work.

Amish quilts are one of the primary influences on modern quilting. The use of large-scale piecing, solid fabrics, and bright bold colors are all traits that are frequently found in the quilts coming out of the modern quilting movement. The simple, clean design and graphic nature of their work lead to an aesthetic that speaks to today's modern quilter.

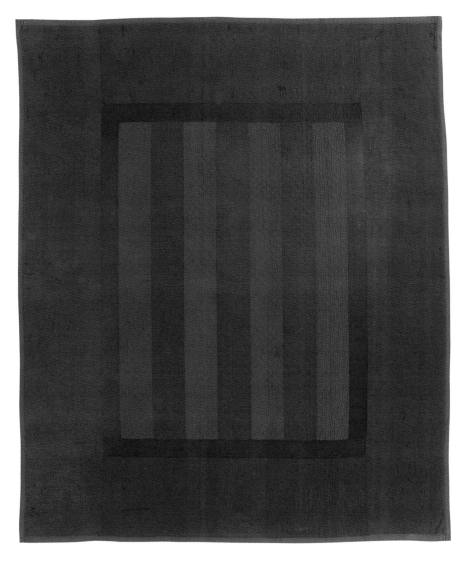

AMISH QUILT
Maker unknown, c. 1890–1910, 84″ × 71″

Photo courtesy of International Quilt Study Center & Museum, University of Nebraska-Lincoln, 2003.003.0013

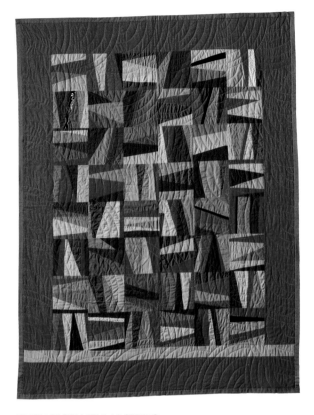

AMISH RECTANGULAR STRING
Gwen Marston, 1999, 51″ × 66″

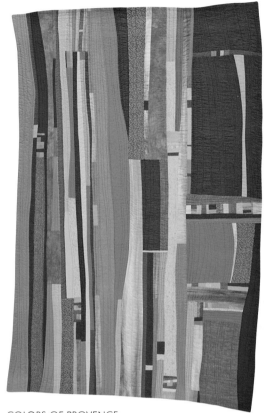

COLORS OF PROVENCE
Jean Wells Keenan, 2008, 38″ × 62″

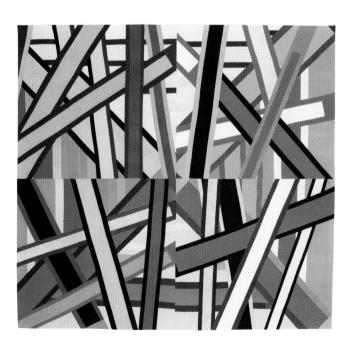

CONSTRUCTIONS #84: NO!
© Nancy Crow, 2007, 75″ × 70″

Photo by J. Kevin Fitzsimons, courtesy of Nancy Crow

Art quilting, an influential movement that began in the 1960s, laid the groundwork for modern quilters to embrace designs outside the boundaries of traditional quilts. Quilters such as Nancy Crow and Gwen Marston, whose work features improvisational piecing and solid fabrics, have consistently sewn beautiful original designs that have impacted the work of modern quilters. As a whole, art quilters made huge changes in the quilting world, and set the stage for the modern quilting movement to happen.

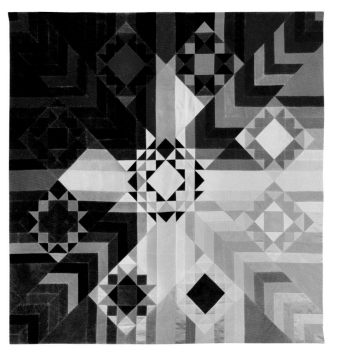

SEASONS QUILT
Nancy Whittington, 1978, 112″ × 112″

Photo by and courtesy of Nancy Whittington

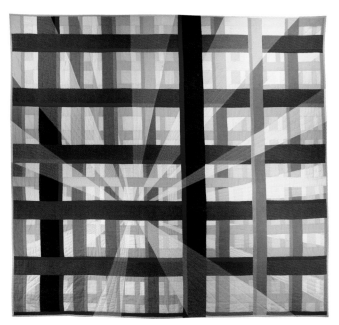

LACRIMOSA…GLORIAE
Carol Anne Grotrian, 1988, 65″ × 62″

Photo by and courtesy of Carol Anne Grotrian

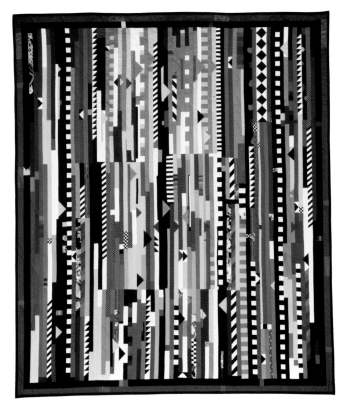

TAKOAGE
Yvonne Porcella, 1980, 82½″ × 71½″

Photo courtesy of Smithsonian American Art Museum,
Washington, DC/Art Resource, New York

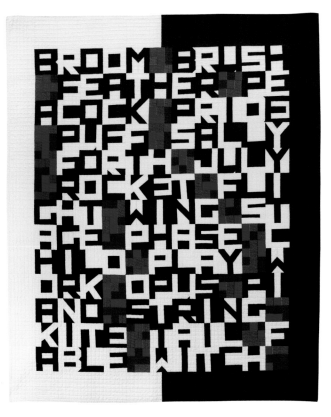

WORD PLAY
Jill Ault, 1998, 51″ × 60″

Photo by and courtesy of Jill Ault

Another influential quilter was Yoshiko Jinzenji, a Japanese quiltmaker whose voice is so original that it has had a large impact on modern quilting. Her use of creative piecing and expansive white negative space all lead to an aesthetic all her own.

The quilts of Gee's Bend, made by a small community of African American quilters in rural Alabama, have inspired modern quilters since they were first seen in 2002 at the Museum of Fine Arts in Houston, Texas (pages 15 and 16). They also approached quilting with an improvisational method and used large areas of bold, solid fabrics to create quilts that stand out and have a look all their own.

Finally, collectors of unique quilts from the past, such as Bill Volckening, Roderick Kiracofe, and the Childress Collection, have put together collections that have opened the eyes of all quilters to beautiful, quirky, and varied work created by past generations of quilters.

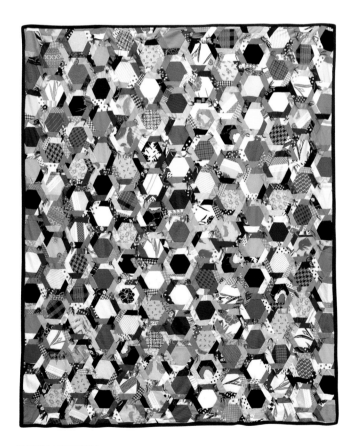

WOVEN PATTERN
Unknown maker, Georgia, c. 1975, 76″ × 92″

Photo by and courtesy of The Volckening Collection

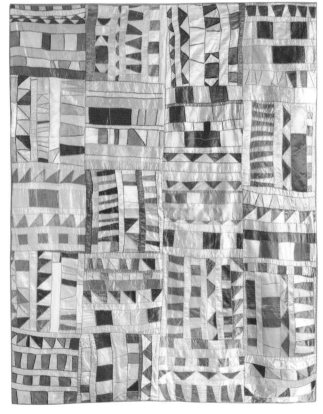

PATCHWORK QUILT
Unknown maker, found in Fort Myers, Florida, c. 1925, 60″ × 76″

Photo by and courtesy of Marjorie Childress

THE BIRTH OF MODERN QUILTING: 1998–2004

While early influencers were creating modern work prior to the late 1990s, it wasn't until just before the twenty-first century that quilts with a modern aesthetic began to appear in greater numbers and quilters began to describe themselves and their work as "modern."

A defining event occurred in 1998 when *Martha Stewart Living* featured the work of Denyse Schmidt, saying that her quilts embodied a "chic, modernist aesthetic." For many quilters in the early days of the movement, this was a key inspirational moment when the word "modern" was first used to describe a quilt. Quilters took the term and ran with it, proudly proclaiming their pieces as "modern quilts" for the first time.

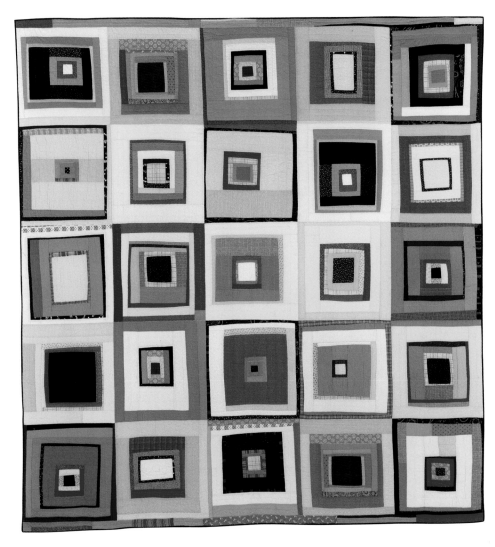

DRUNK LOVE IN A LOG CABIN
Denyse Schmidt, 1996, 86″ × 93″
Photo by Frank Poole, courtesy of Denyse Schmidt

Technological shifts in the late 1990s and early 2000s were also beginning to influence the quilt landscape. The Internet was emerging as a source of inspiration and as a means for small groups of like-minded people to meet. With the click of a button and a short message, modern quilters could find each other and connect. Soon, communities were formed and people started sharing ideas.

The momentum grew, and modern quilters continued to inspire a small but devoted community. To add fire to the flame, in 2002 the Quilts of Gee's Bend exhibit traveled across the country and exhibited in Houston; New York; Washington, DC; Cleveland; Boston; and Atlanta. The publication of Yoshiko Jinzenji's book *Quilt Artistry* further provided inspiration and presented modern quilting on a national level.

Weeks Ringle and Bill Kerr were also very influential in the modern quilting movement. As a design team and married couple, they published their first book, *Color Harmony for Quilts*, in 2002. The book featured work that encouraged quilters to explore color as a design process rather than using colors that "go together."

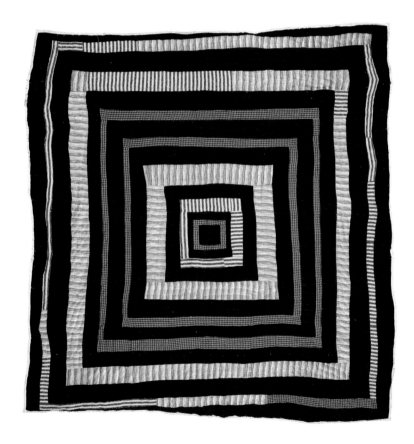

QUILT (HOUSETOP)
Nettie Jane Kennedy, c. 1955, 85″ × 77″
The Museum of Fine Arts, Houston, Museum purchase, 2002.418

PICKUP STICKS
Bill Kerr and Weeks Ringle, 2002, 48″ × 72″

Photo by Bill Kerr

Outside of the modern quilting community, the Internet was also creating a demand for quality design in the general public. Consumers now had unlimited access to images of great design in different environments—home, architecture, consumer products, art, and other industries. They wanted it, and it was now easier than ever to recognize good design, obtain it, and integrate it into daily life. Makers of many crafts incorporated modern aesthetics in their work. And with the growing number of tools and educational materials, nearly anyone could study the fundamentals of design and apply them to their work. For quilters, this was just the beginning.

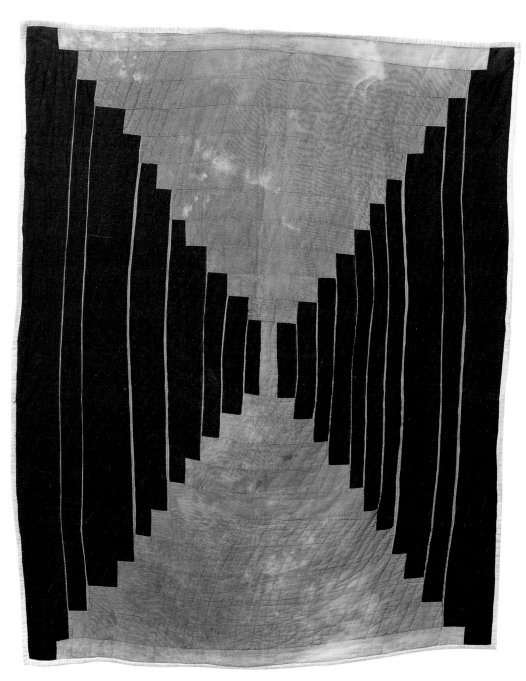

QUILT (LOG CABIN, COURTHOUSE STEPS)
Loretta Pettway, c. 1970, 84″ × 66″
The Museum of Fine Arts, Houston, Museum purchase, 2002.415

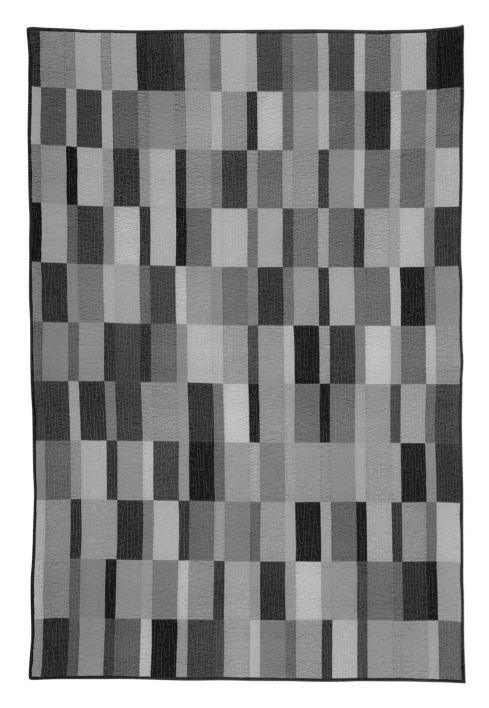

By 2005, the stage had been set. Modern quilting had emerged from its infancy and was ready to come of age. In 2005, two influential books were published—*Denyse Schmidt Quilts* by Denyse Schmidt and *The Modern Quilt Workshop* by Weeks Ringle and Bill Kerr. These were some of the first printed books to outline the design philosophy of modern quilts and share instructions for making them. The books reached larger audiences and were shared in traditional quilting communities as well as in modern circles. Bloggers posted their in-progress quilt projects and invited readers to join them; these "quilt-alongs," based around the two books, further spread awareness of modern quilts.

PLAIN SPOKEN
Bill Kerr and Weeks Ringle, 2004, 51″ × 77″

Photo by Allan Penn

It was at this time that digital cameras also became mainstream. The price of a point-and-shoot camera dropped below 200 dollars, and soon they were a staple in most households. Modern quilters became online content creators. Snapping a photo of a quilt was easy, and quilters could publish a blog post in minutes. Photo sharing platforms such as Flickr, Blogger, and early social media sites emerged, increasing the reach of modern quilters while also providing more ways for them to meet.

Offline, the fabric industry was responding to an increasing demand for more modern fabric designs. Modern prints and solids were increasingly popular, and fabric companies hired modern designers and graphic artists for new collections. These new, modern fabrics reinforced the use of vibrant and graphic color palettes in quilts and paved the way for experimentation with new design aesthetics. Amy Butler led the way with her first collection, Gypsy Caravan.

Modern quilting was about to go mainstream.

GYPSY CARAVAN FAT QUARTERS
Amy Butler, 2003, 49″ × 49″

Photo by David Butler, courtesy of Amy Butler

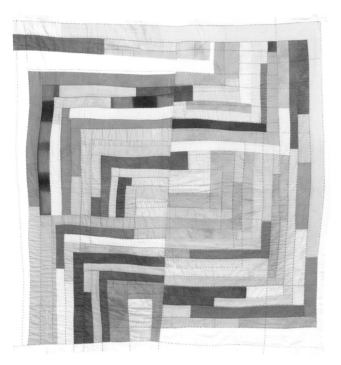

COLOR STUDY LOG CABIN
Sherri Lynn Wood, 2006, 50″ × 51″

Photo by and courtesy of Sherri Lynn Wood

In 2008, a Flickr group called Fresh Modern Quilts was established by Rossie Hutchinson and provided the first online, centralized social media venue for quilters in the movement. Between the Flickr group and many active blogs starting to emerge, the online world of modern quilting was taking off like wildfire.

Another active website that helped push the movement forward was *True Up*, a blog about fabric and quilting that brought the community to one place to learn about the latest fabrics being released for the modern quilter. Kimberly Kight, now a designer with Cotton+Steel Fabrics, single-handedly helped grow interest in modern fabrics and quilting by writing the blog.

PALETAS
Kimberly Kight, 2006, 85″ × 97″

Based on the quilt Plain Spoken *(page 17) from* The Modern Quilt Workshop *by Weeks Ringle and Bill Kerr*

Photo by Kimberly Kight

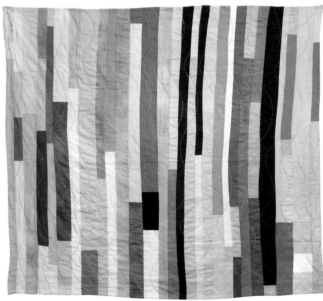

COLOR STUDY STRIP
Sherri Lynn Wood, 2008, 50″ × 45″

Photo by and courtesy of Sherri Lynn Wood

An additional way that the online modern quilting community connected was through virtual quilting bees facilitated by Flickr. Quilters living all over the world found each other online and organized to make collaborative quilts together. Usually organized around a calendar year, virtual bees often have twelve members. Each quilter is assigned a month, and in that month they request blocks made in a certain style with certain fabrics. Each quilter makes a block as requested and mails it to its owner. That quilter assembles the quilt and by the end of the year twelve collaborative quilts have been made and each member has a finished quilt to keep. It creates a sense of sewing together, even though the members sometimes live across the world from one another.

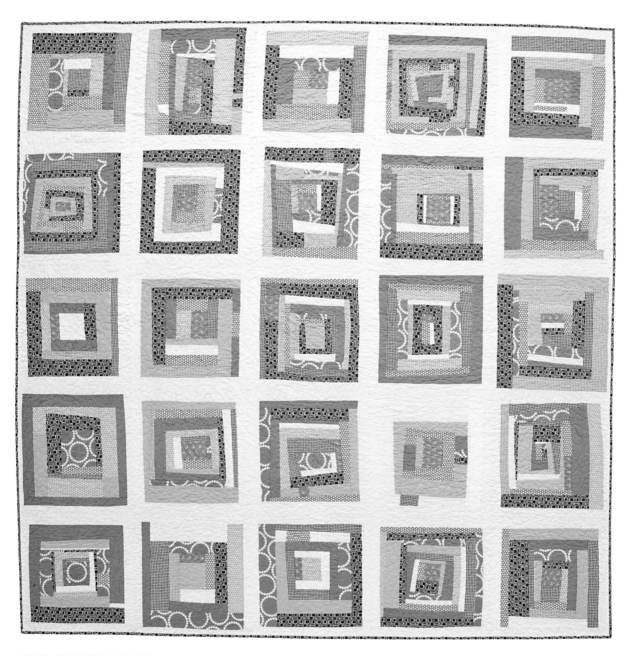

ONCE AROUND THE BLOCK
Designed, assembled, and quilted by Alissa Haight Carlton, blocks made by Lisa Billings,
Rashida Coleman-Hale, Jacquie Gering, Elizabeth Hartman, Sarah Johnson, Kristen Lejnieks,
Ashley Newcomb, Nettie Peterson, Megan Risse, Ashley Shannon, and Josie Stott, 2011, 95″ × 95″

In 2009, Alissa Haight Carlton and Latifah Saafir founded The Modern Quilt Guild, giving the online community a chance to form in-person connections with other modern quilters. Nearly ten years later, the MQG is the world's leading modern quilting organization, with a global network of over 12,000 makers and the organization behind the largest modern quilt show and conference in existence, QuiltCon. With access to newer, faster technology and more resources and inspiration than ever before, modern quilters have pushed the quilt aesthetic forward and inspired a new generation of talented sewists to take up the craft.

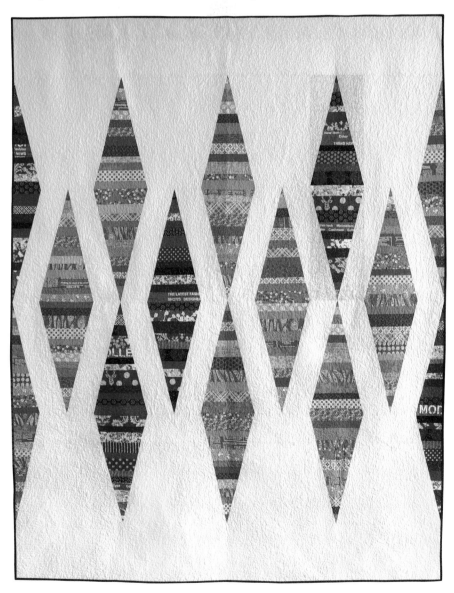

Many MQG members meet at their local guilds, where they find camaraderie through a love of modern quilting. Friendships are formed, and inspiration is found through a shared passion for fabric, sewing, and modern design. At a worldwide level, the MQG has united its members through swaps, fabric challenges, QuiltCon, and more. The MQG's mission is to support and encourage modern quilting through art, education, and community, and almost a decade after its founding, the organization is flourishing and continues working to do just that.

MARMALADE
Elizabeth Hartman, 2012, 72" × 92"

Photo by Margaret Udell

THE MOVEMENT BECOMES MAINSTREAM

Since 2009, the modern quilting movement has gained steam and ricocheted into the mainstream sewing and quilting culture. Hundreds of unique artists are adding their voices to this growing movement, pushing boundaries, and forging ahead into new and exciting territory. With the growth of social media, knowledge and inspiration flows more freely than ever before, giving way to the next chapter in modern quilting's story.

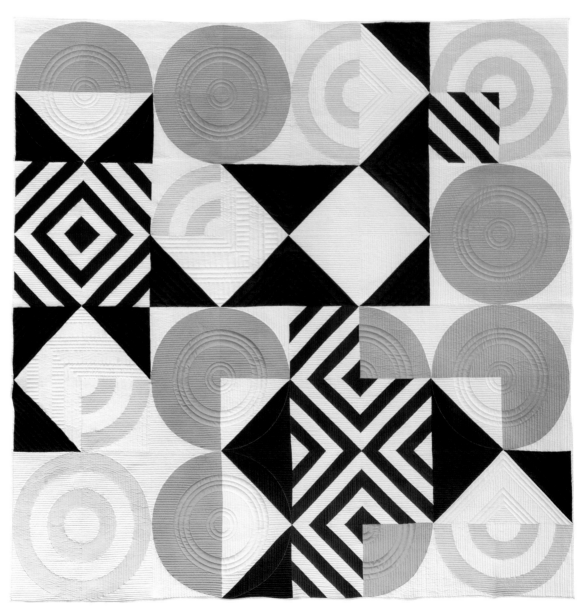

EAMES
Designed by Lorena Marañón, pieced by Shea Henderson, quilted by Gina Pina, 2014, 80″ × 80″
Photo by Scott Gordon Photography

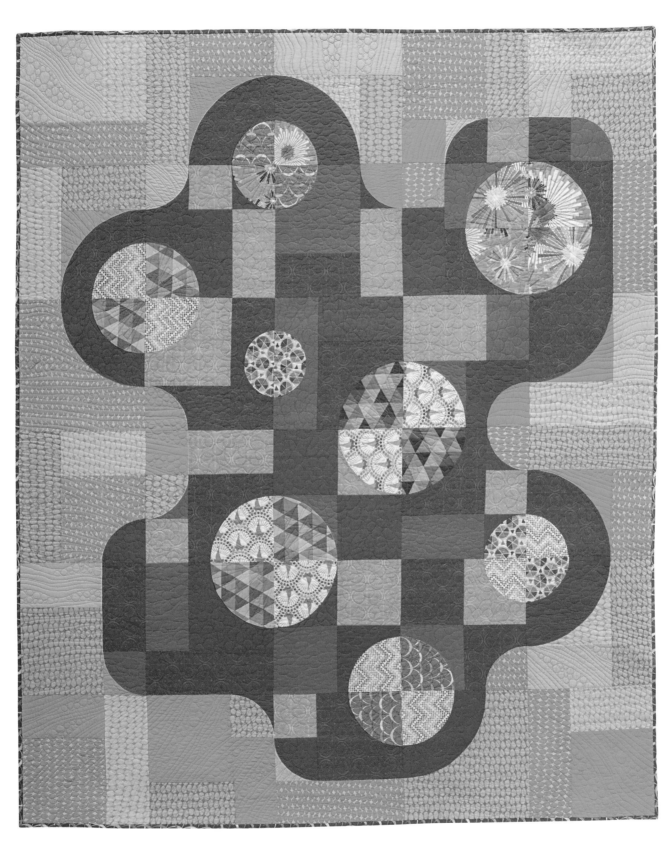

HURLE BURLE MARX
Daniel Rouse, 2012, 60″ × 72″

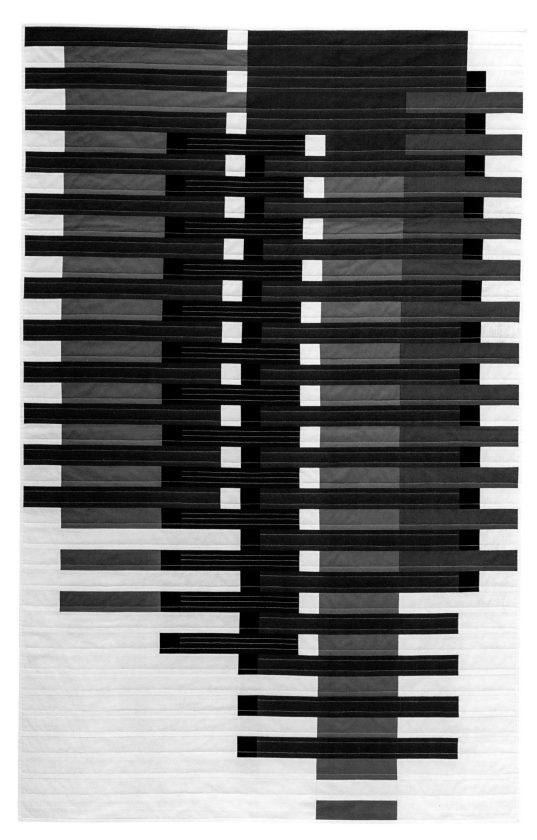

RHYTHM & BLUES
Anne Deister, 2012, 49″ × 75″

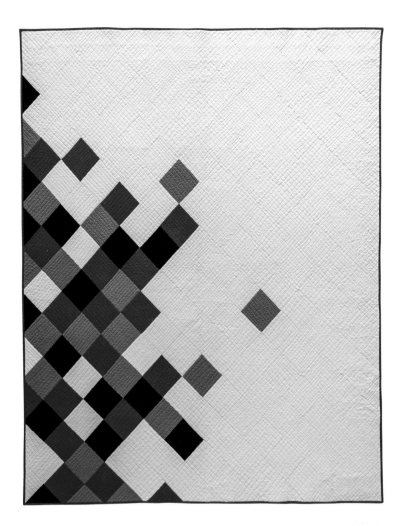

CONCERTO
Alyssa Lichner, 2012, 52″ × 66″

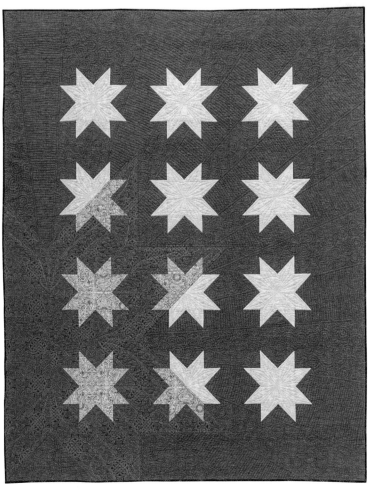

NEW STAR RISING
Ben Darby, 2014, 59″ × 73″

*This quilt is inspired by the transparency quilts
of Weeks Ringle and Bill Kerr.*

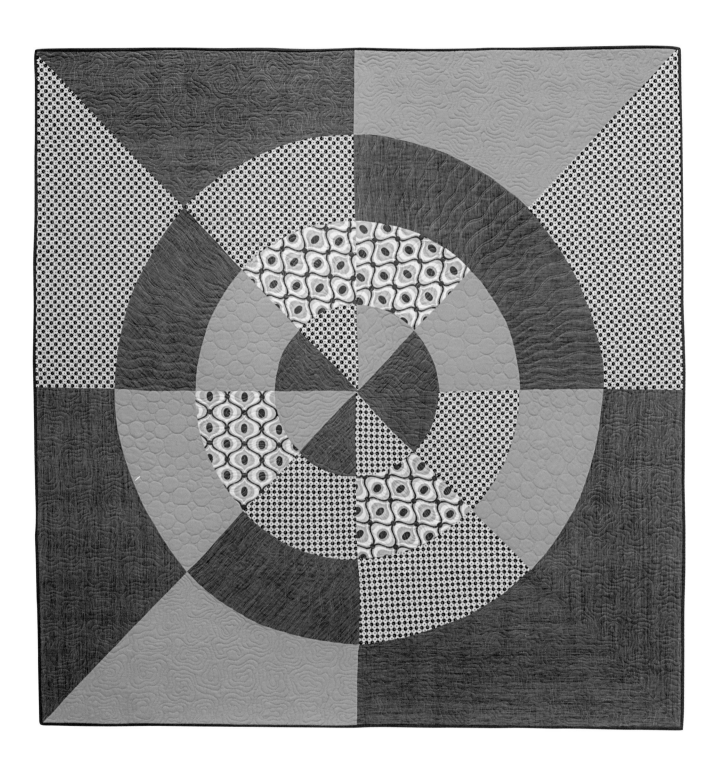

RADIOACTIVE
Kelly Wood, 2012, 60″ × 60″

This quilt is a version of the RAF Bullseye pattern by Parson Gray.

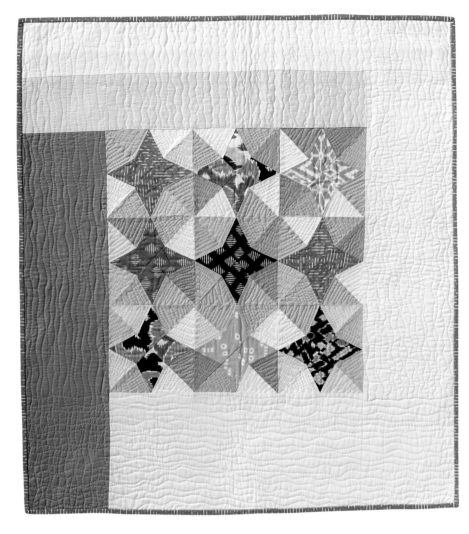

DESERT STARS
Katie Blakesley, 2012, 30″ × 32½″

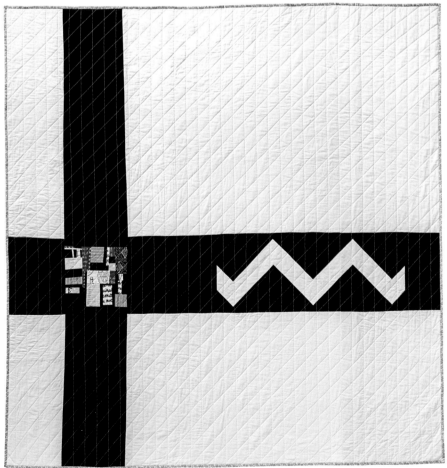

NATANI BLANKET
Katrina Hertzer, 2012, 72″ × 72″

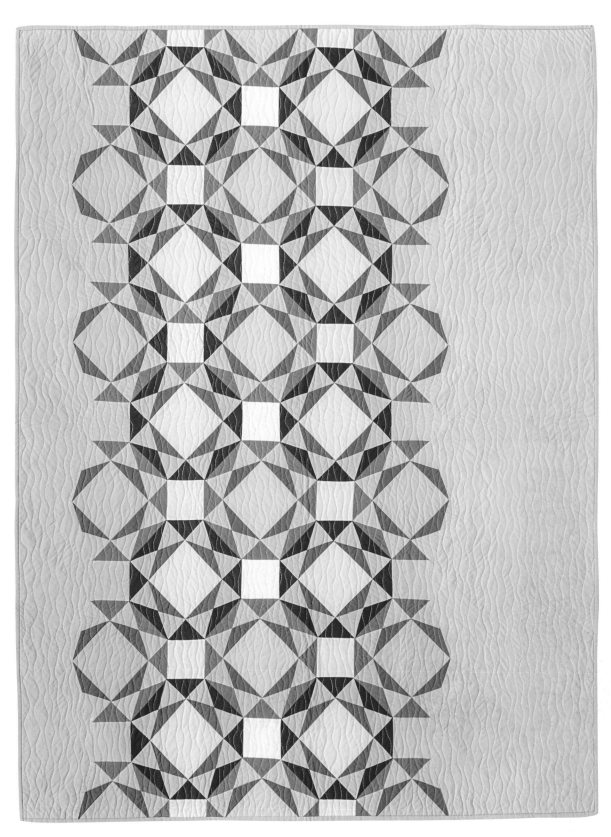

MODERN MIRAGE
Lee Heinrich, 2012, 44″ × 56″

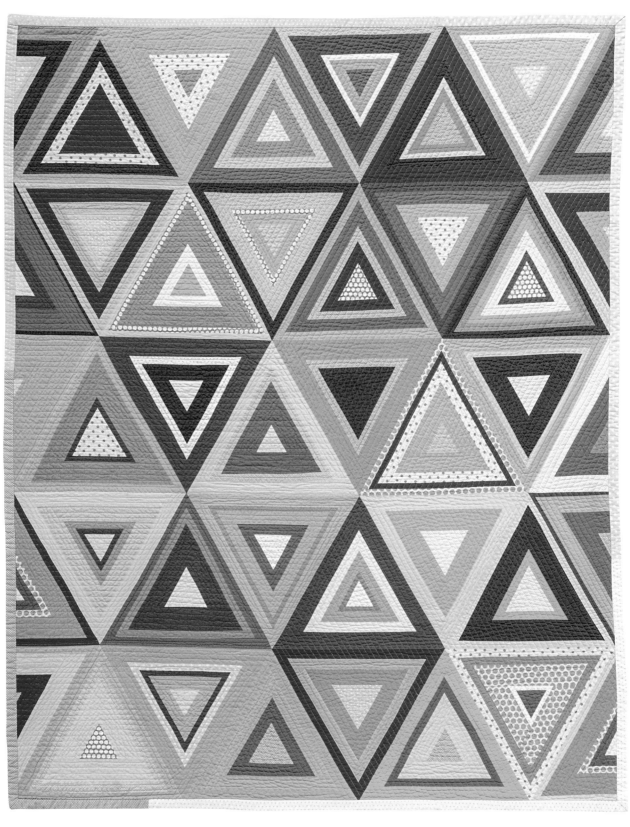

LOG PYRAMIDS
Liz Harvatine, 2012, 55½″ × 68″

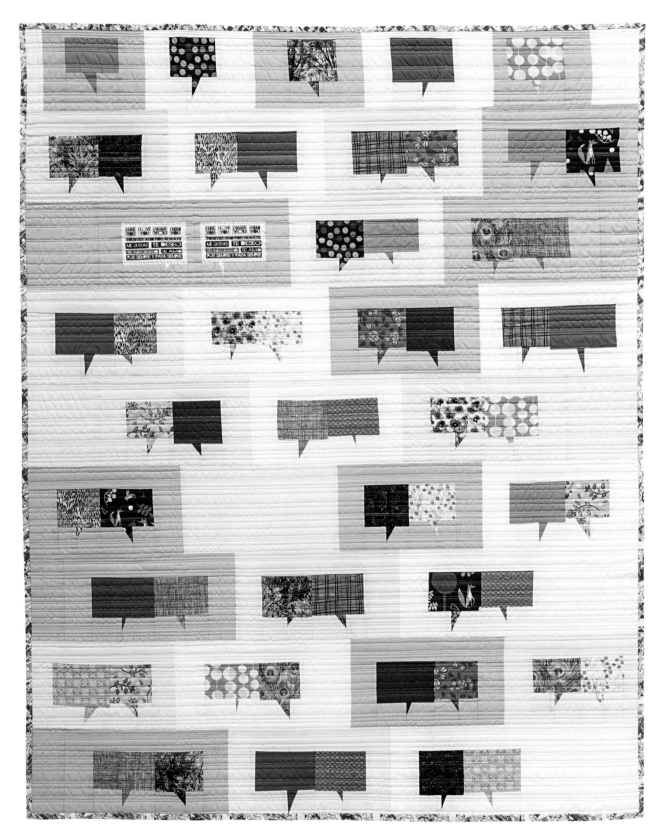

A VERY LONG CONVERSATION
Made by Rossie Hutchinson, quilted by Bernie Olszewski, 2012, 47″ × 58″

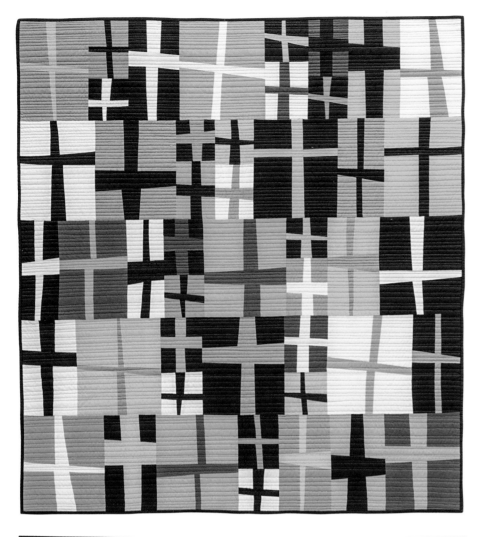

KELSEY'S CROSSES
Made by Mary Workman, Shea Henderson,
Melissa Leray, Shelly Hannon, Ruth Costa,
Sarah Seitz, Leanne Cohen,
Annette Samborski, Dena Wayne,
Beth Shibley, Leah Day, Solidia Hubbard,
quilted by Mary Workman, 2011, 48″ × 53″

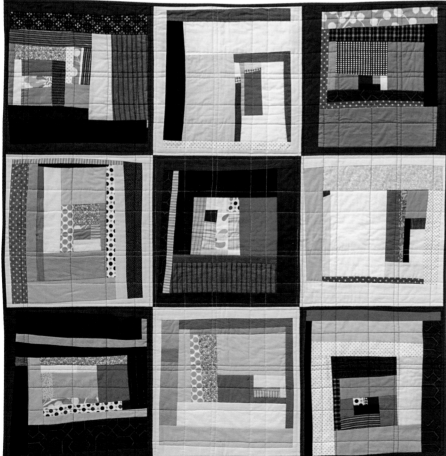

OREOS AND CREAMSICLES
Becca Jubie, 2012, 43½″ × 43½″

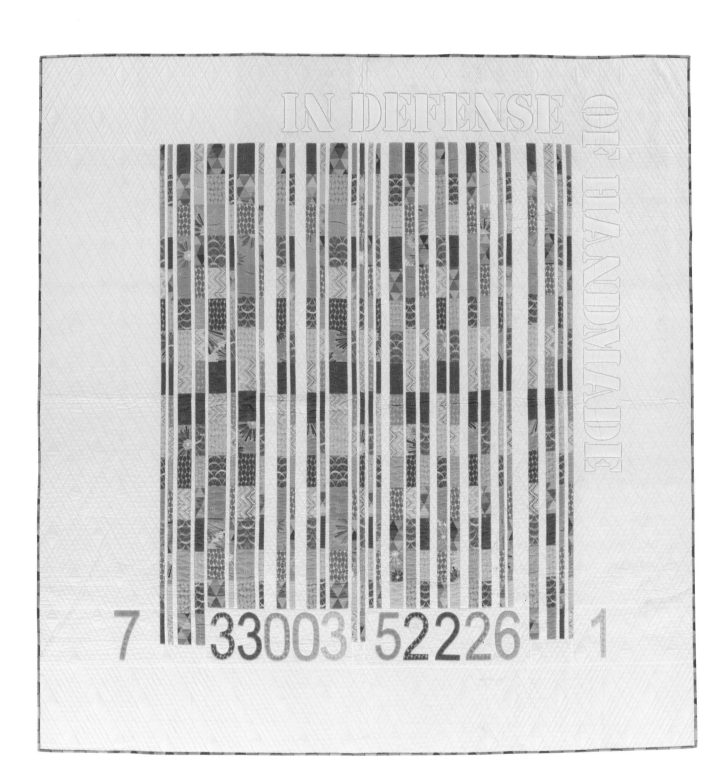

IN DEFENSE OF HANDMADE
Made by Thomas Knauer, quilted by Lisa Sipes, 2012, 85½″ × 82¾″

Photo courtesy of International Quilt Study Center & Museum, University of Nebraska-Lincoln, 2016.063.0001

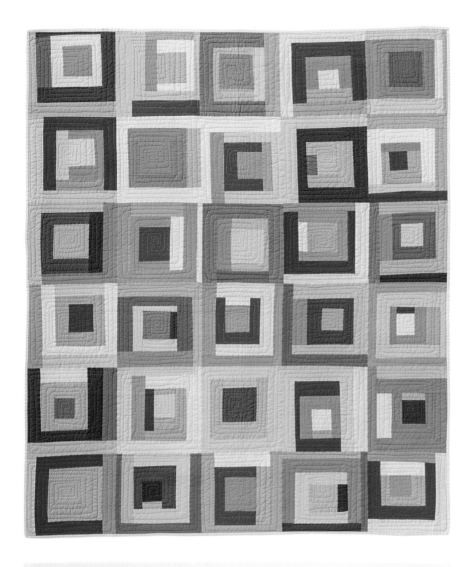

NO PRINTS ALLOWED
Shea Henderson, 2011, 52″ × 60″

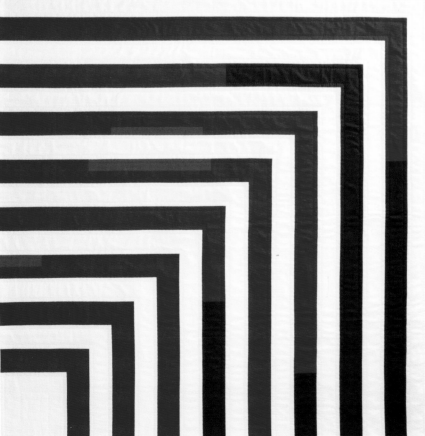

UNTITLED
Lindsay Stead, 2012, 60″ × 60″

Modern Traditionalism

Modern quilters often create quilts that pay homage to tradition. A traditional block or quilt layout can easily be updated with modern quilting elements, such as scale, negative space, modern color palettes, or alternate gridwork. Modern traditional quilts apply other modern quilt design elements to traditional blocks in a restrained, impactful way.

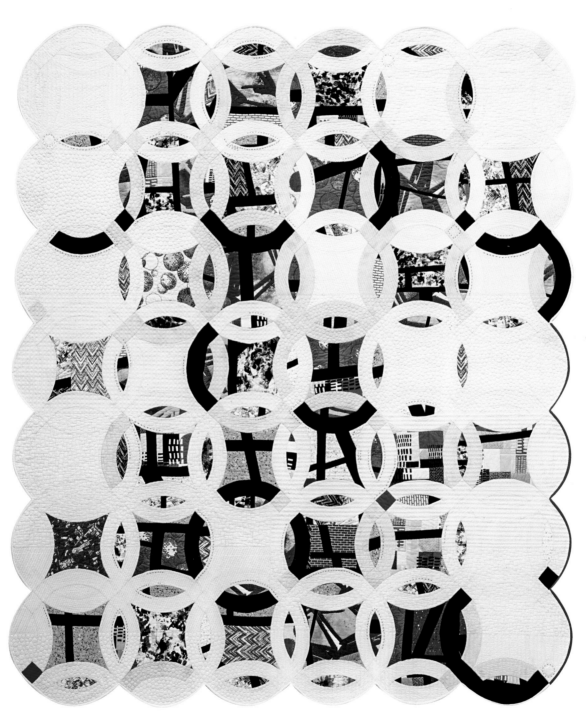

DOUBLE-EDGED LOVE
Made by Victoria Findlay Wolfe, quilted by Lisa Sipes, 2012, 66" × 77"

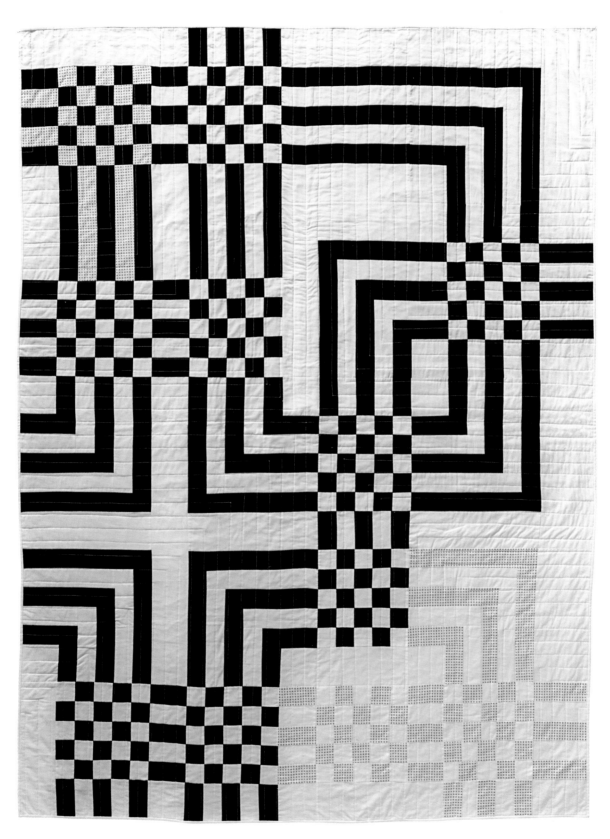

CARPENTER SQUARE VARIATION
Alexis Deise, 2016, 62″ × 82″

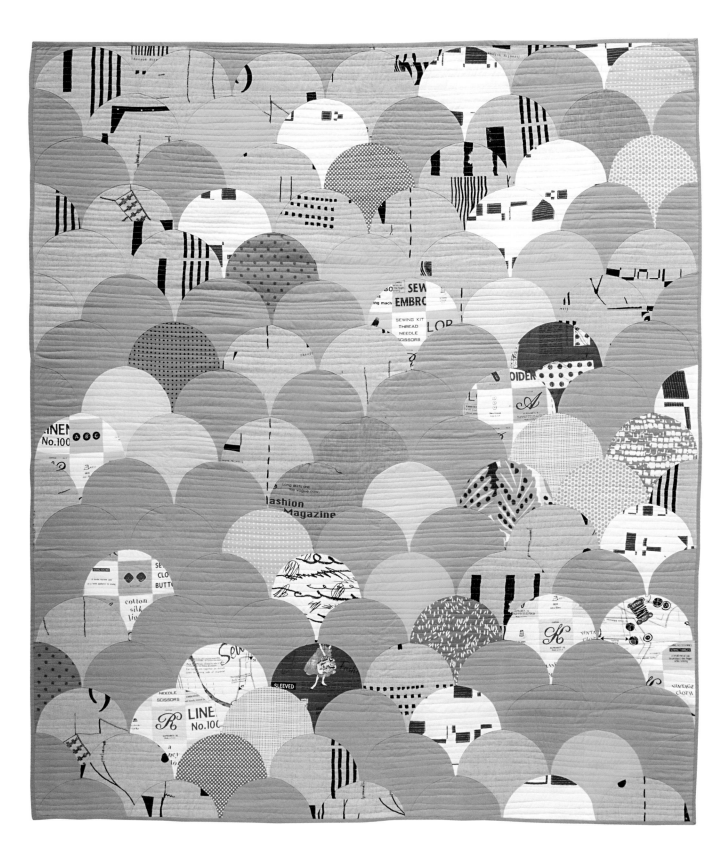

NEUTRAL AND NEON
Latifah Saafir, 2013, 50″ × 60″

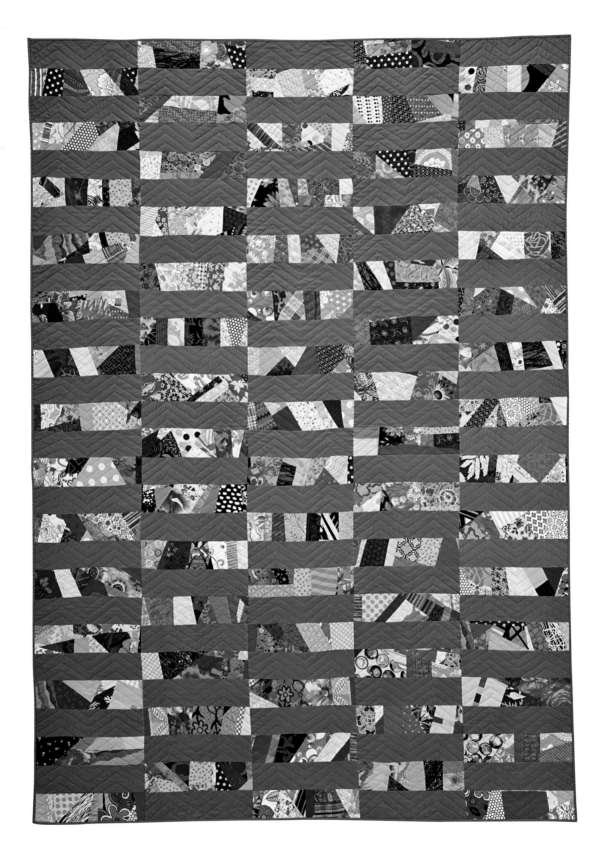

MAKING ME CRAZY
Made by Victoria Findlay Wolfe, quilted by Shelly Pagliai, 2011, 59″ × 82″

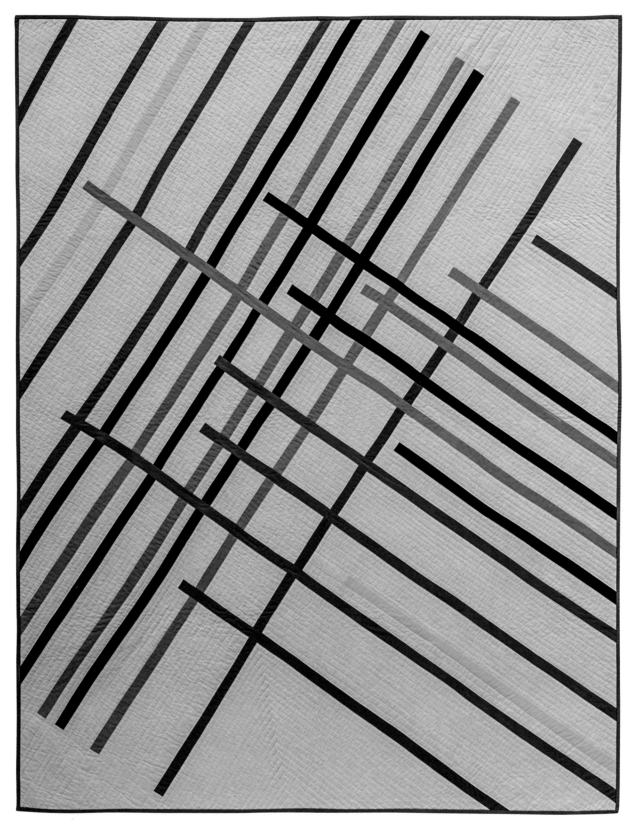

BIAS
Alissa Haight Carlton, 2012, 60″ × 75″

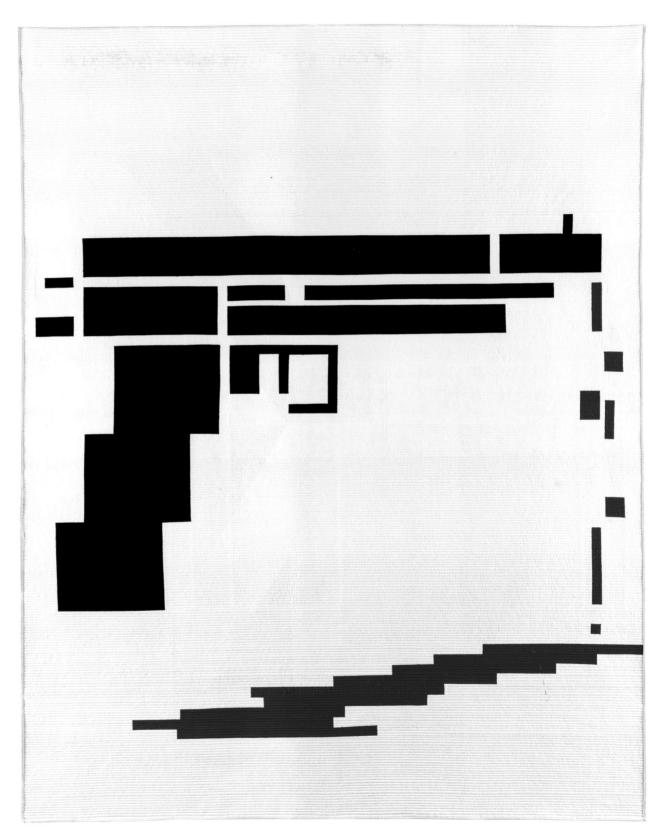

BANG! YOU'RE DEAD
Made by Jacquie Gering, quilted by Anne Christopher, 2013, 64″ × 78″

Photo by Gregory Case

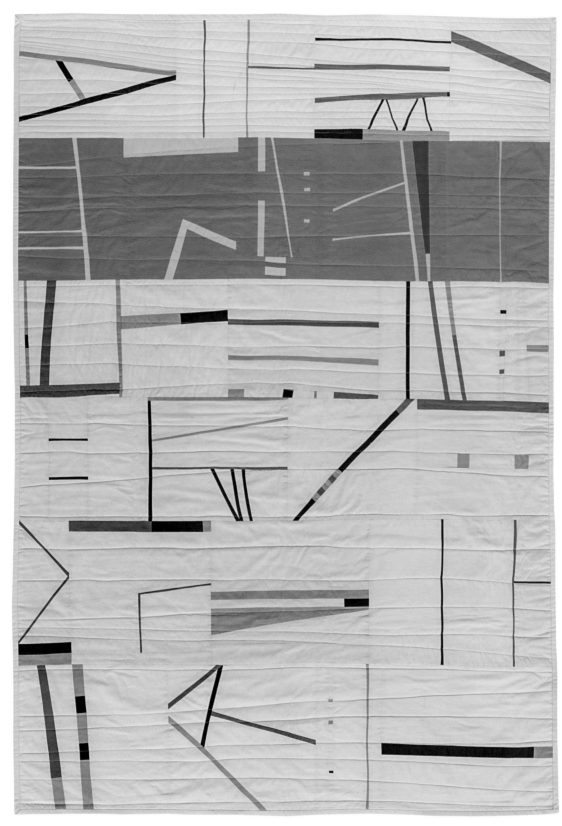

UP IN THE AIR
Latifah Saafir, 2010, 48″ × 66″

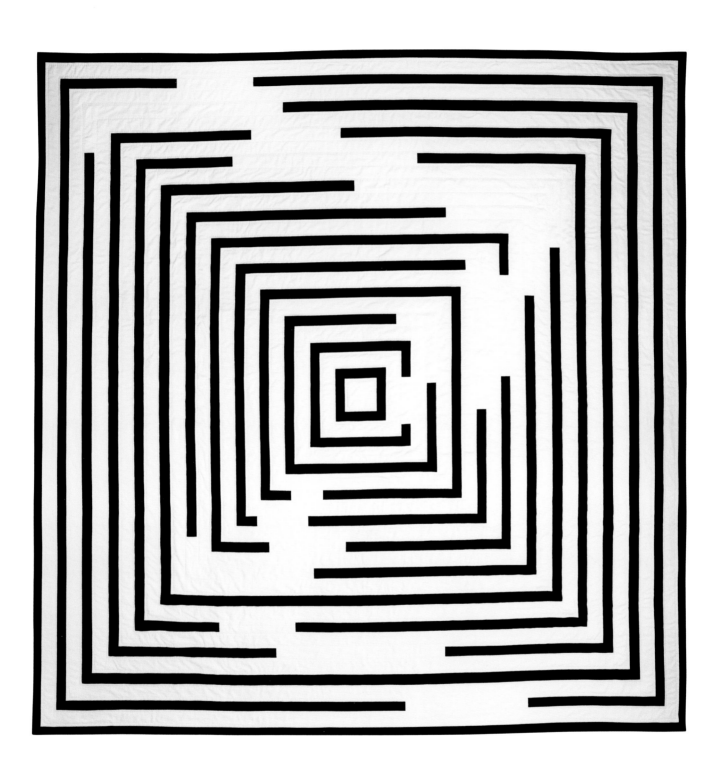

UNTITLED
Lindsay Stead, 2012, 104″ × 104″

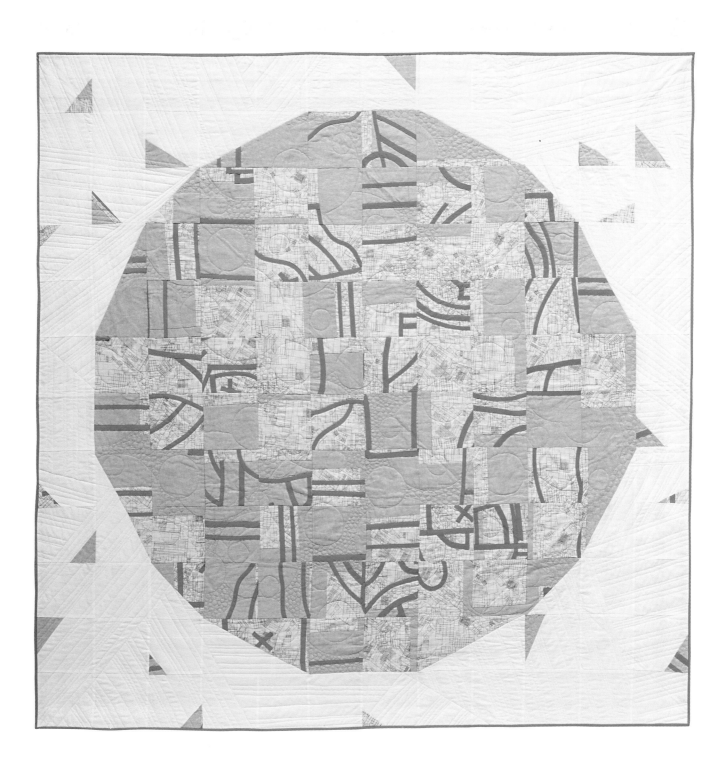

AKHATEN
Shannon Page, 2014, 65″ × 65″

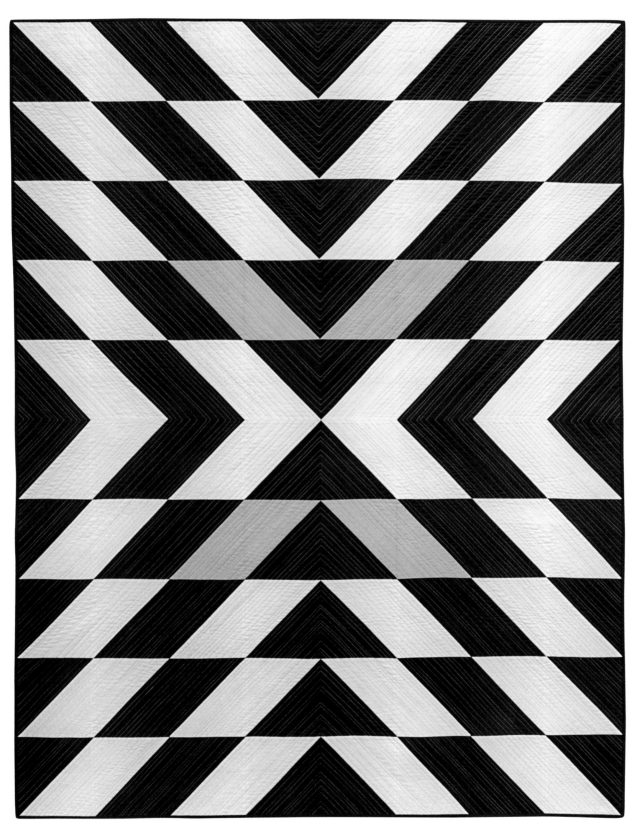

MODERN X
Christa Watson, 2014, 56″ × 70″

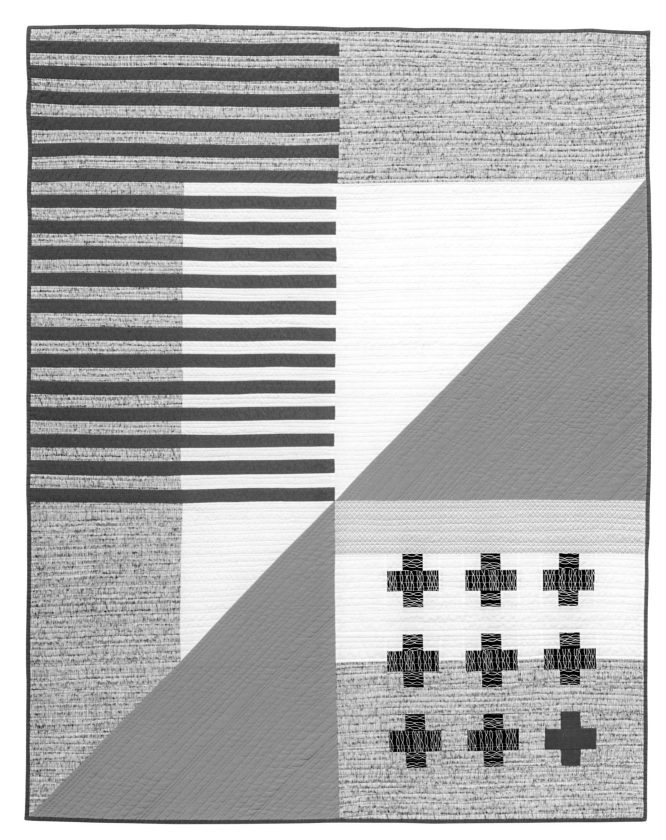

EMERGENT
Kari Vojtechovsky, 2014, 48″ × 59″

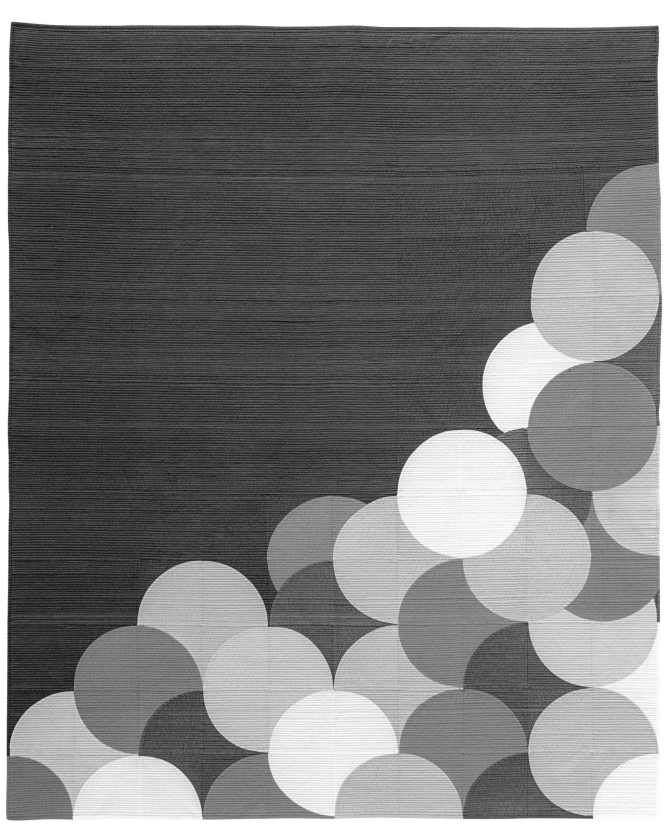

BALANCING ACT
Amanda Hohnstreiter, 2014, 58″ × 70″

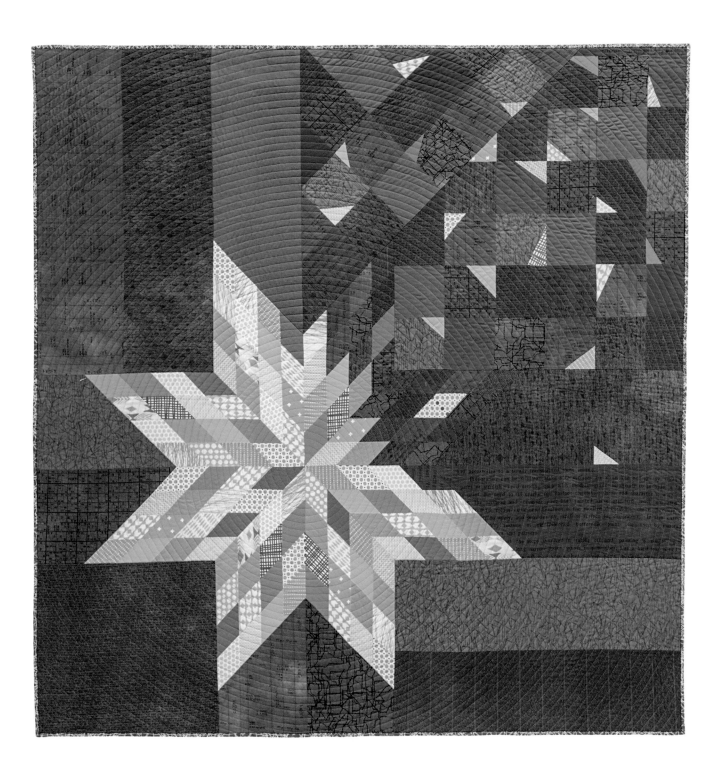

DECONSTRUCTED LONESTAR
Amy Struckmeyer, 2014, 58″ × 60″

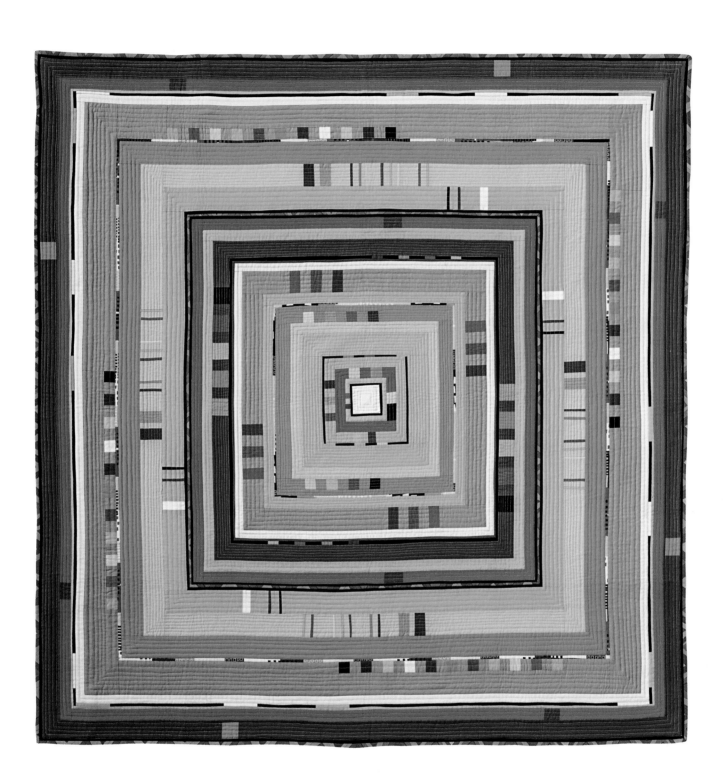

CITY CENTER
Angie Henderson, 2014, 60″ × 60″

This quilt was inspired by the pattern Modern Log Cabin created by the Art Gallery Fabric staff.

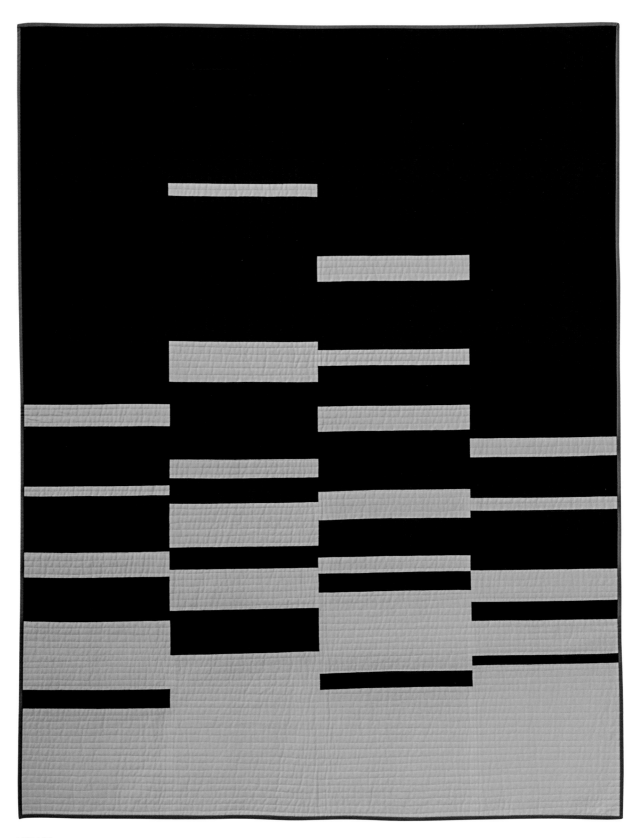

WE ARE
Anne Sullivan, 2014, 52″ × 64″

This quilt was inspired by the art of Ellsworth Kelly.

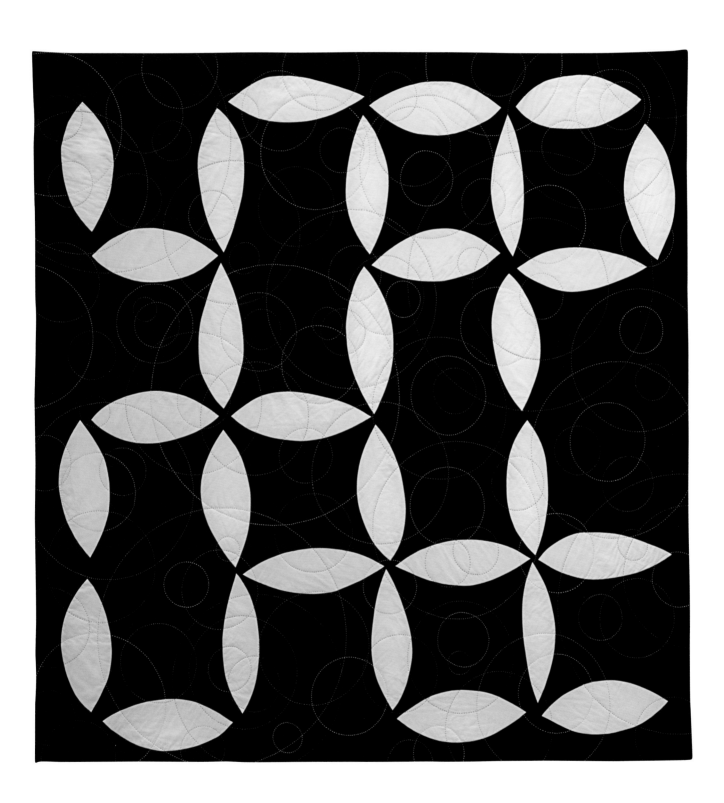

FILL THE VOID
Cinzia Allocca, 2014, 84½″ × 88½″

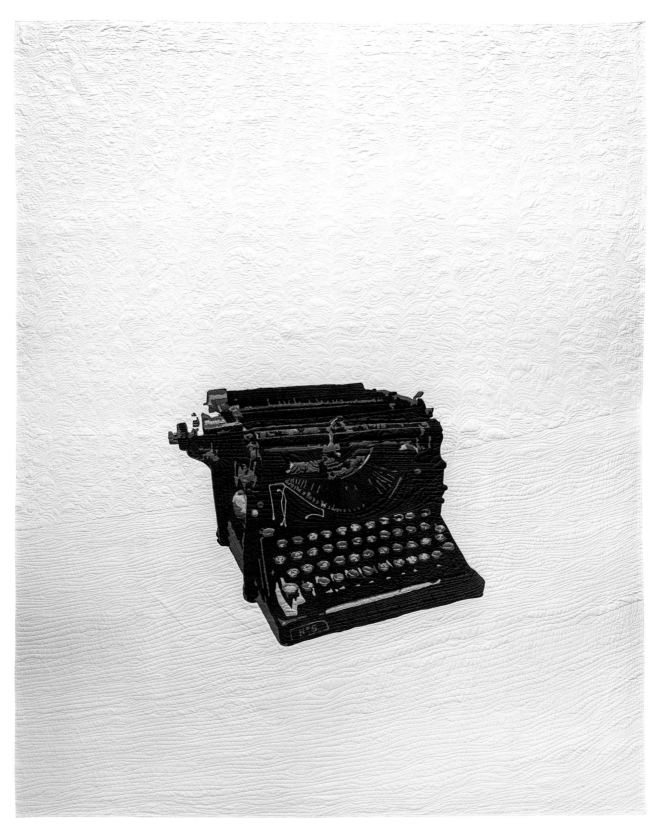

TYPEWRITER NO. 5
Jessica Toye, 2014, 91″ × 112″

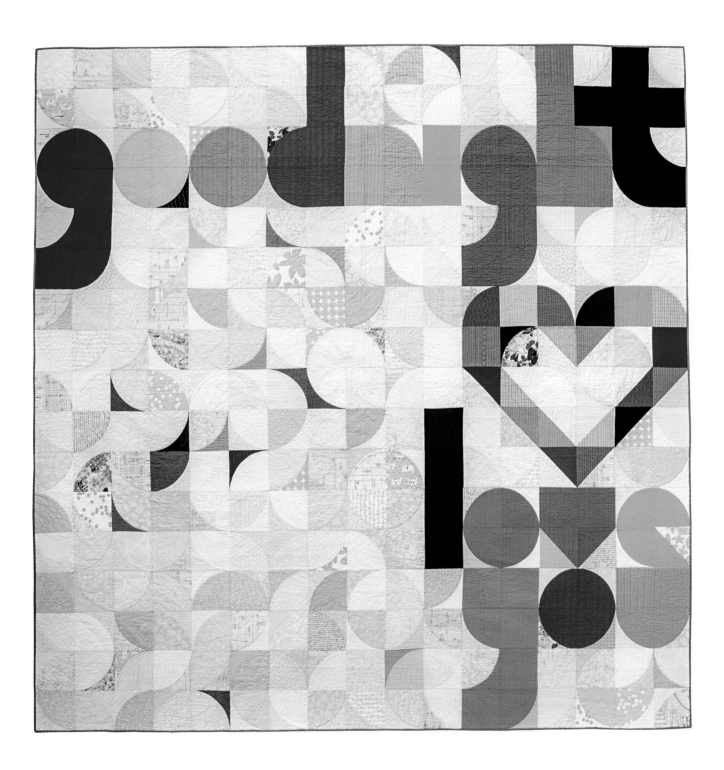

QUILT FOR OUR BED
Made by Laura Hartrich, quilted by Nikki Maroon, 2014, 108″ × 108″

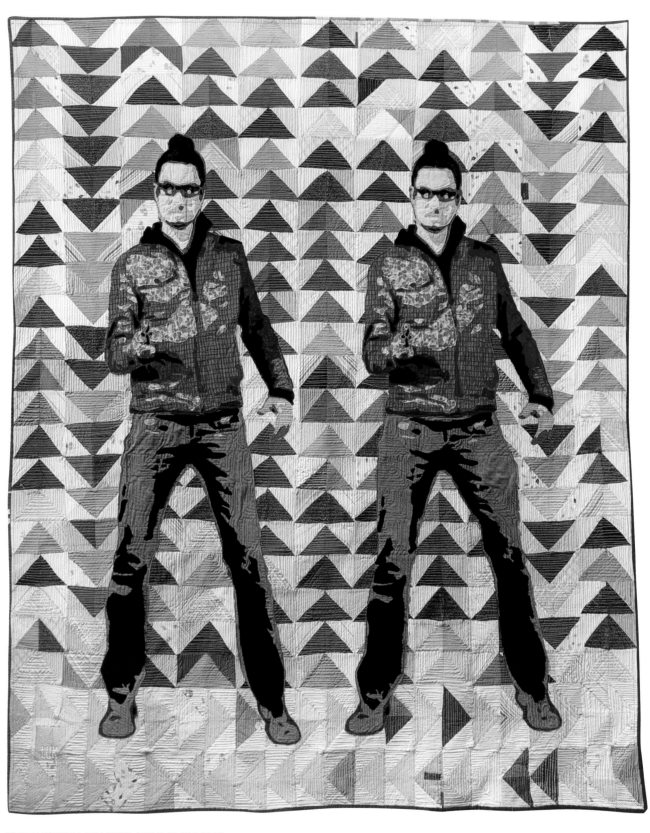

[THE AMERICAN CONTEXT #68] DOUBLE ELVIS
Luke Haynes, 2012, 60″ × 71″

Photo by and courtesy of Luke Haynes

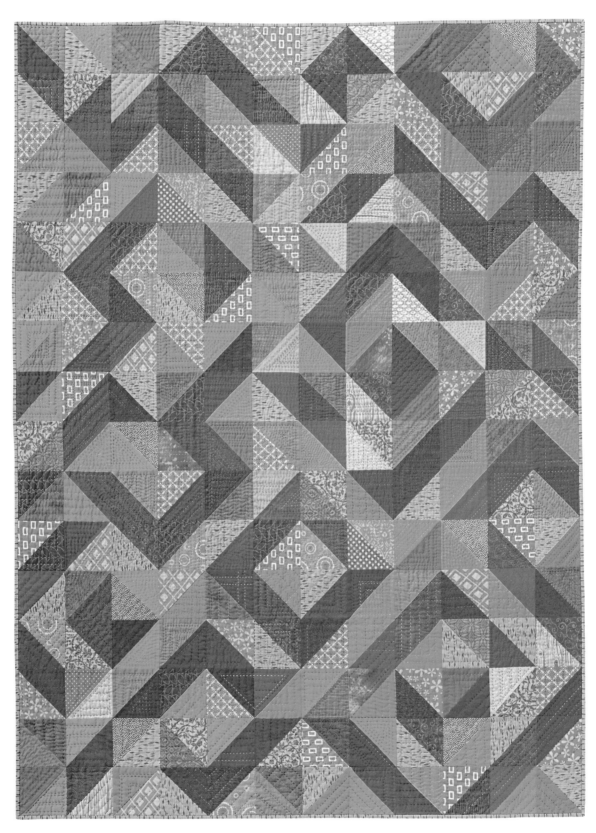

CORAL REEF
Marla Varner, 2014, 47″ × 63″

Solids / Graphic Color Palettes

Modern quilters often use graphic color palettes, rather than the jewel and nature tones found in many traditional quilts. Solid colors can complement prints, but oftentimes modern quilters will use only solids to create a quilt. Solids create clear, sharp lines between elements, creating more contrast and definition.

The combination of colors and where they are placed can also modify traditional designs into modern quilts. For example, there are many combinations of modern log cabin quilts that use a traditional block and layout, but modern color palettes and color placement update the quilt.

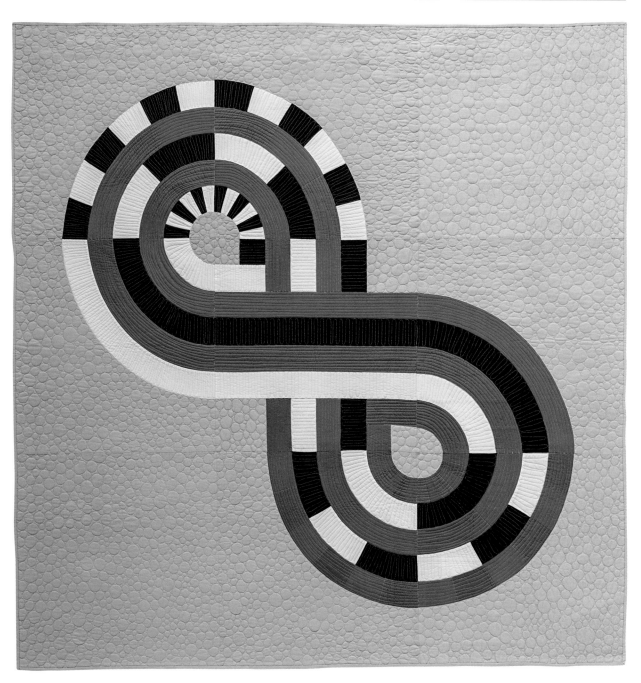

INDIE
Made by Phoebe Harrell, quilted by Emily Sessions, designed by Scott Harrell, 2014, 60″ × 60″

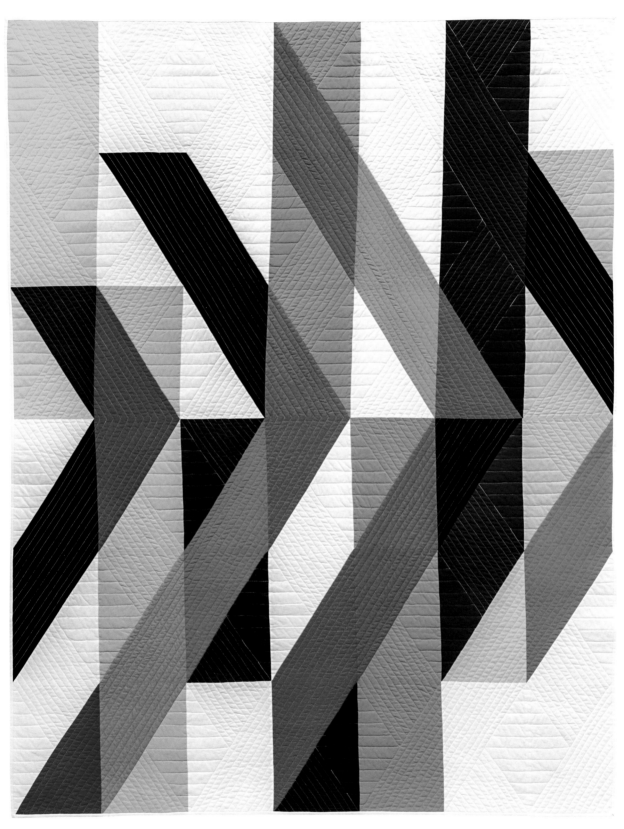

ECHOED ARROWS
Silvia M. Sutters, 2016, 55½″ × 71½″

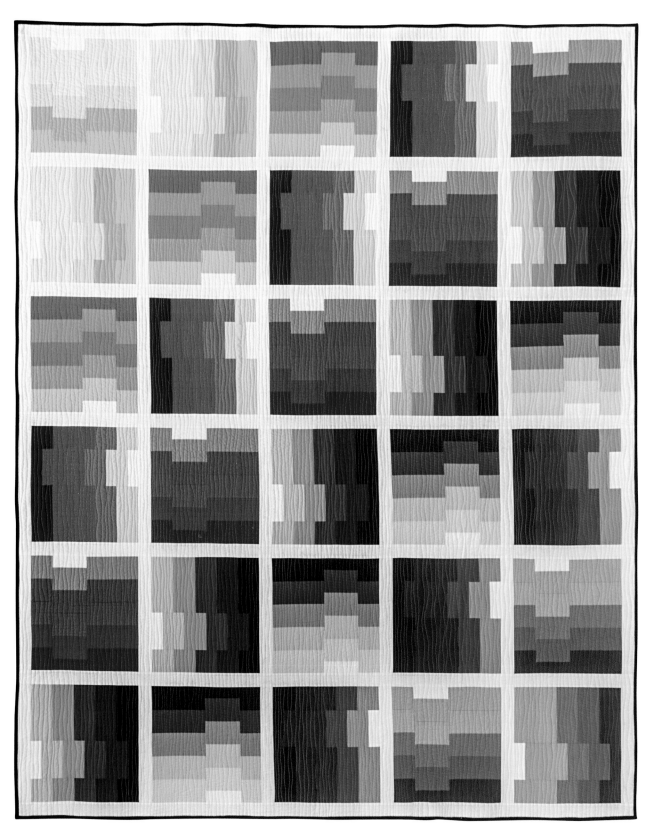

OFF KILTER
Melissa Corry, 2014, 72″ × 86″

THE WHITE RAINBOW
Shruti Dandekar, 2014, 36″ × 50″

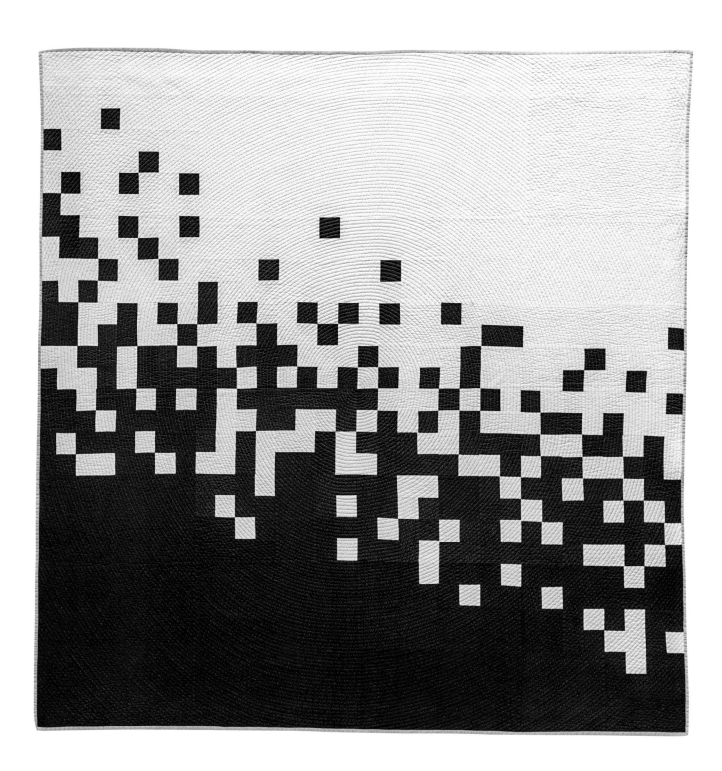

PIXEL PUSHER II
Caro Sheridan, 2014, 64″ × 64″

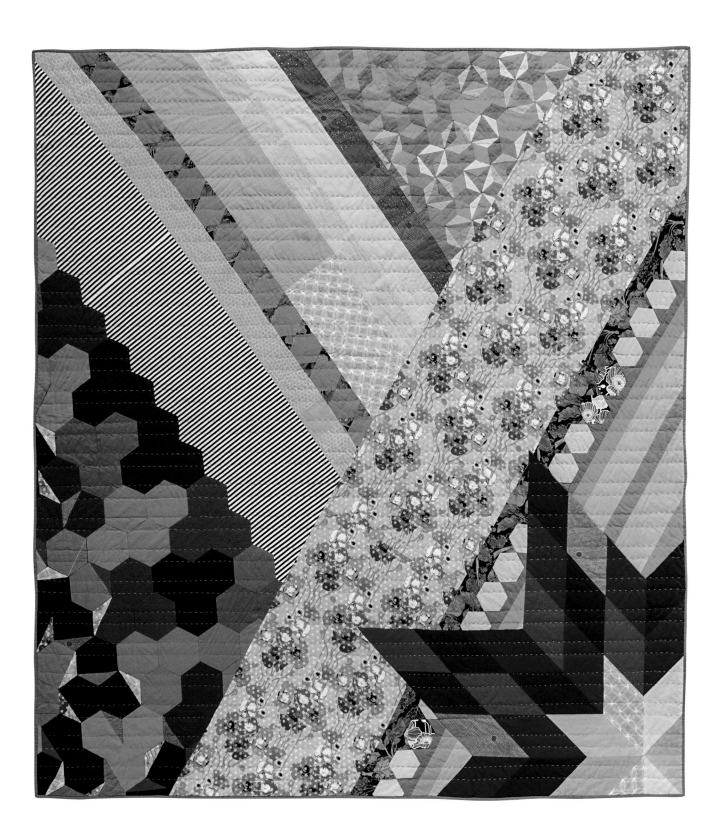

REFRESH
Anna Boenish, 2012, 80″ × 90″

Improvisation

Early improvisational quilters, such as Gwen Marston, Denyse Schmidt, and the quilters of Gee's Bend, brought a new aesthetic to quilting—one where straight lines and rulers are optional. We can think of improv as being like making dinner without a recipe, rather than reading from a cookbook.

Improv quilting was one of the first techniques modern quilters explored, but even today, it's a popular aesthetic, and many quilters piece quilts without following a pattern. Rules of construction—such as using straight lines, grids, and even blocks—are thrown out the window, and scraps of fabric are combined to create organic movement in the quilt. Some improv quilters even piece large sections and then recut them, combining them with more precise piecing to bring order to what can otherwise be a chaotic quilt.

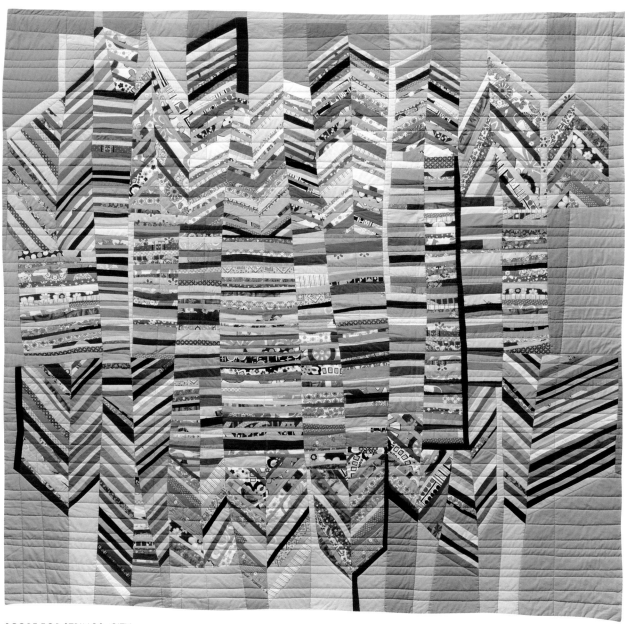

SCORE FOR STRINGS: CITY
Sherri Lynn Wood, 2014, 93″ × 90″

Photo by and courtesy of Sherri Lynn Wood

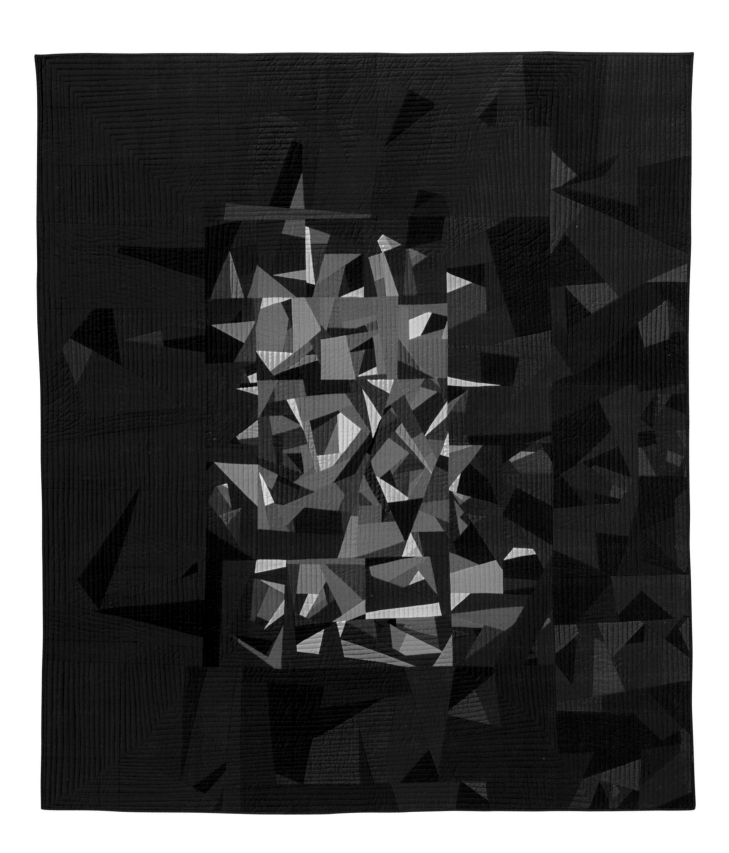

EMBERS
Stephanie Zacharer Ruyle, 2015, 56″ × 64″

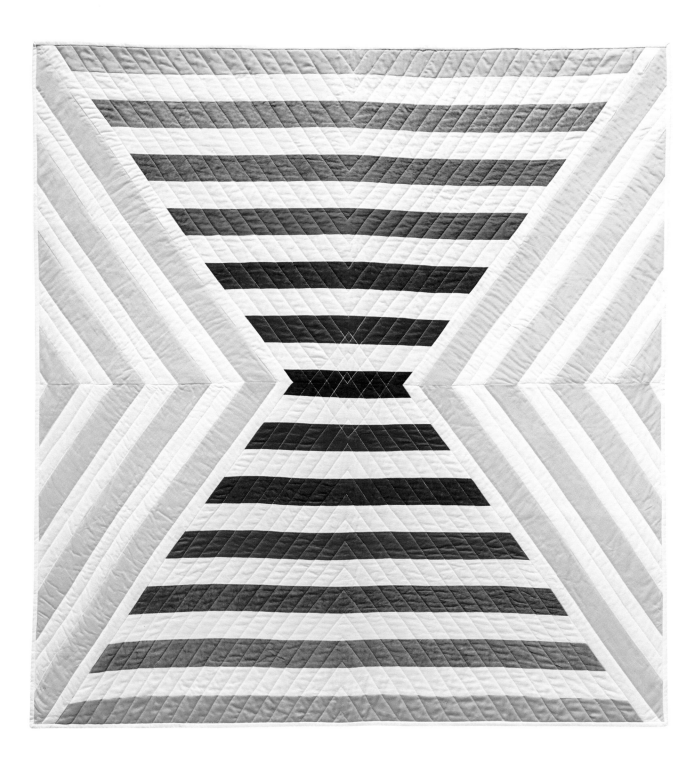

HAPPY!
Carrie Ottmers Wikander, 2014, 48″ × 48″

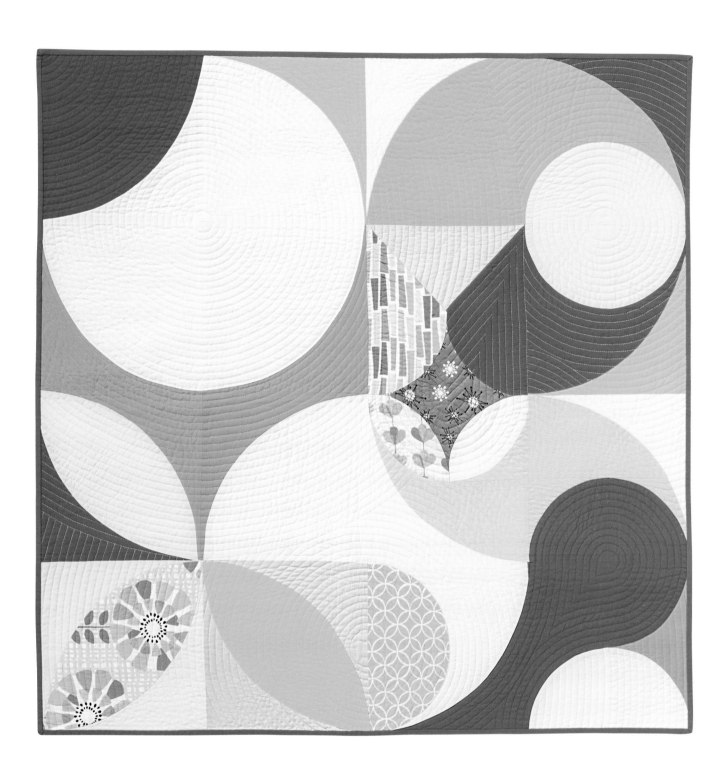

AND THE MOON AT NIGHT
Colleen Molen, 2014, 40″ × 40″

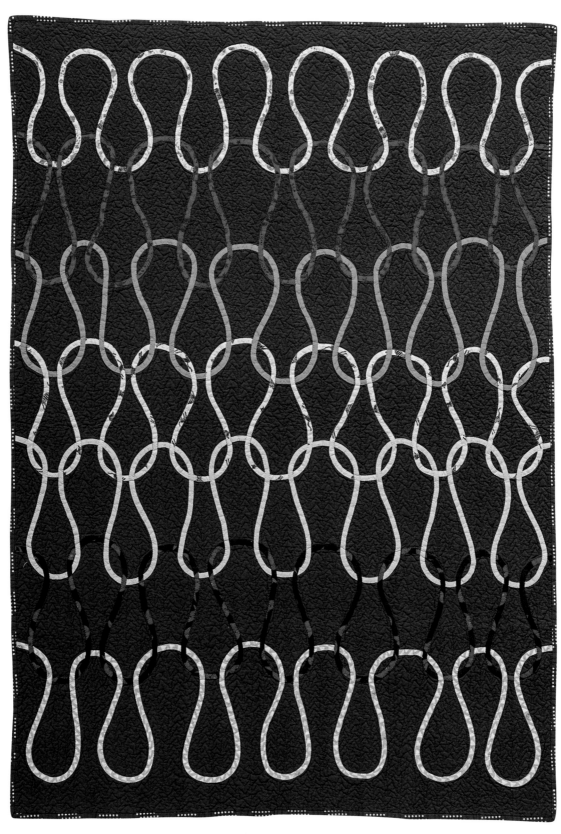

KNIT STITCH
Dorie Schwarz, 2014, 43″ × 59″

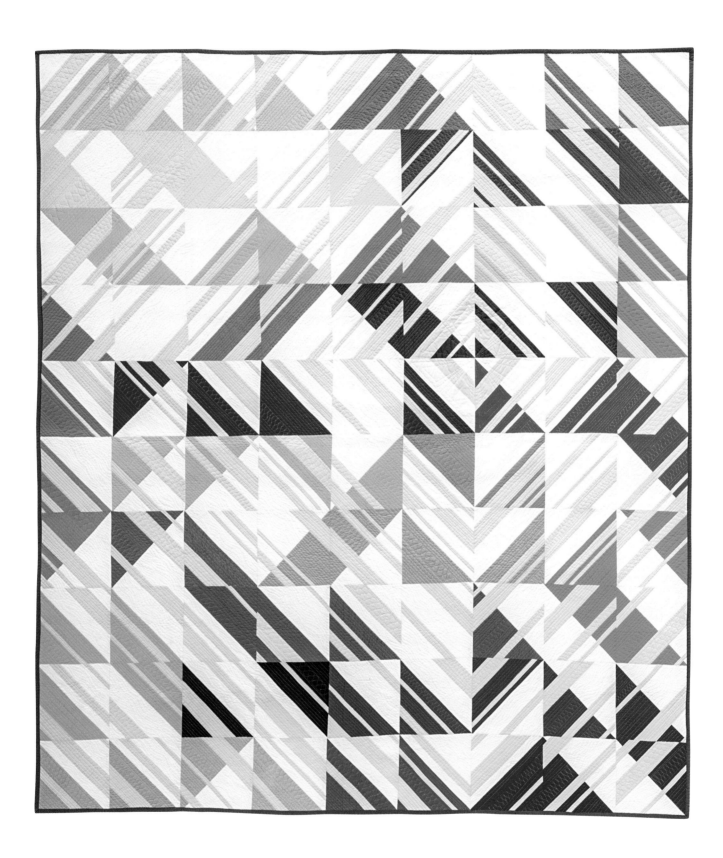

PERCOLATE
Made by Emily Cier, quilted by Angela Walters, 2014, 78″ × 87″

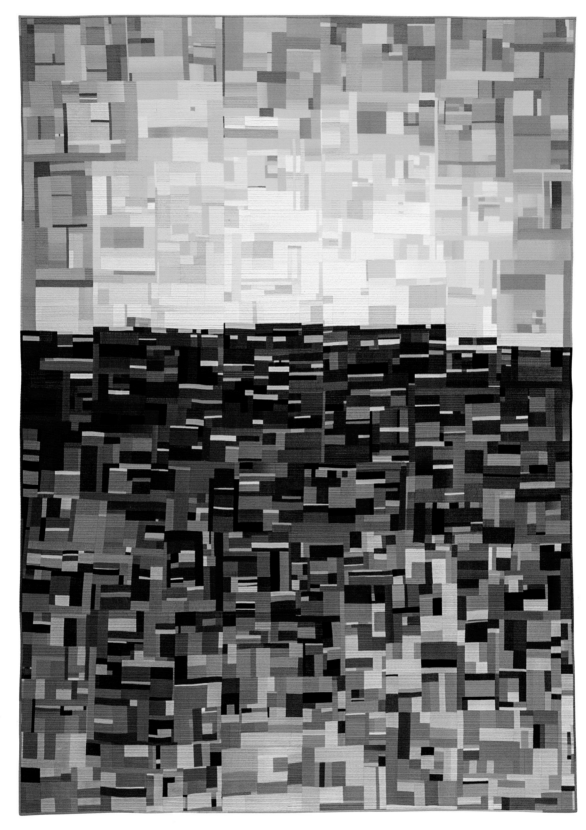

FOR TANYA
Emily E. D. Coffey and Miriam C. K. Coffey, 2014, 50″ × 63½″

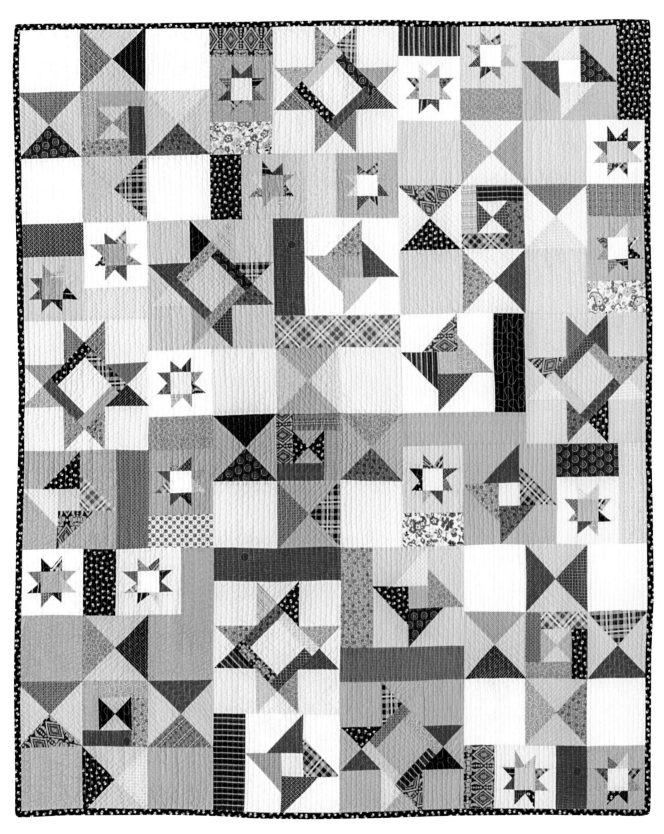

STARFALL II
Faith Jones, 2012, 60″ × 72″

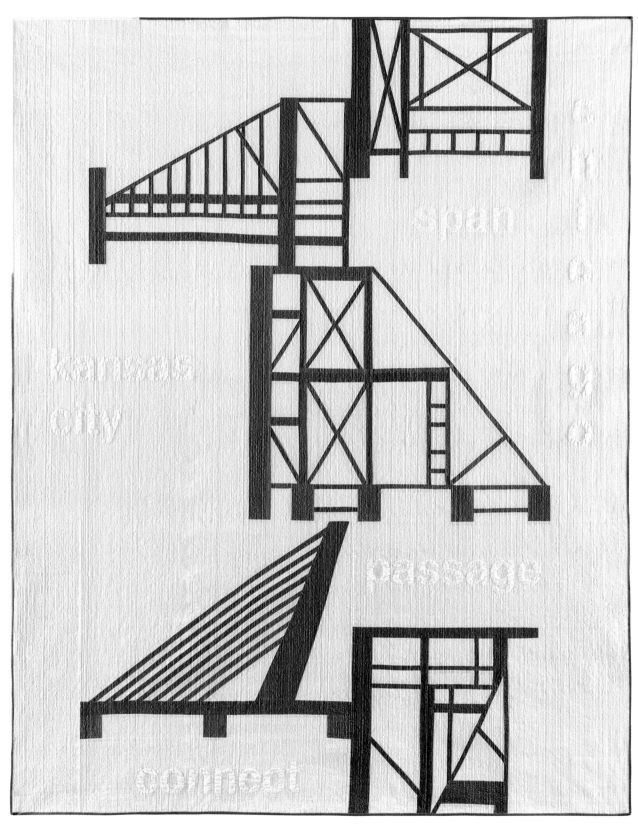

BUILDING BRIDGES
Made by Jacquie Gering, quilted by Sheryl Schleicher, 2012, 65″ × 82″

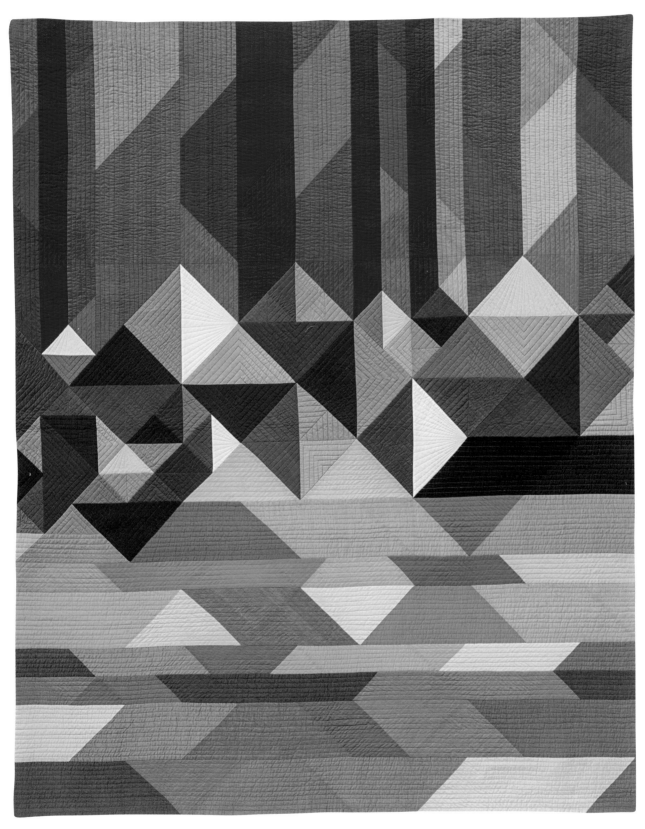

WELCOME TO COLORFUL COLORADO
Katie Larson, 2013, 66″ × 81″

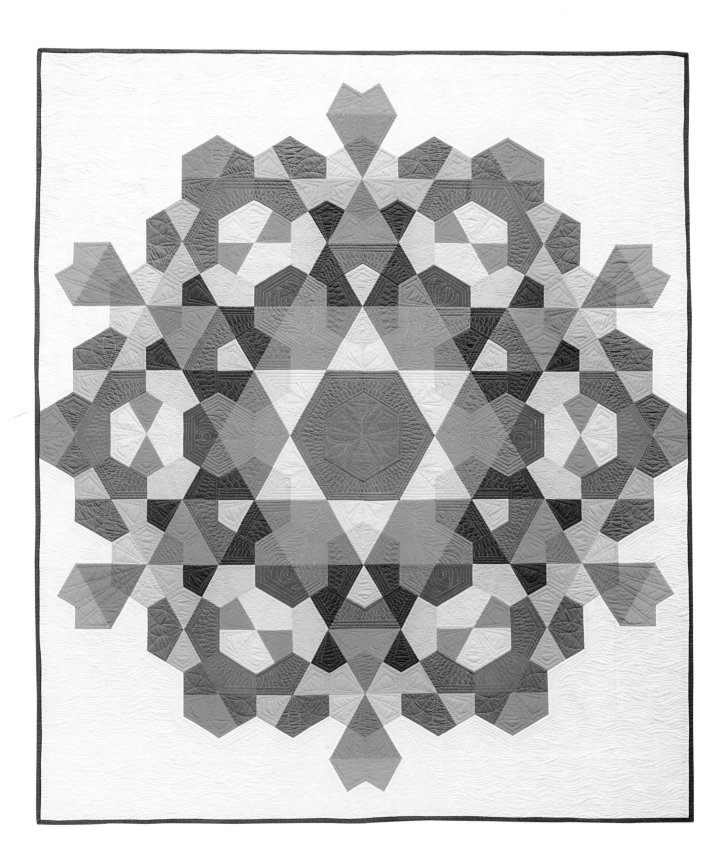

BAUBLE
Made by Emily Cier, quilted by Angela Walters, 2014, 70″ × 81″

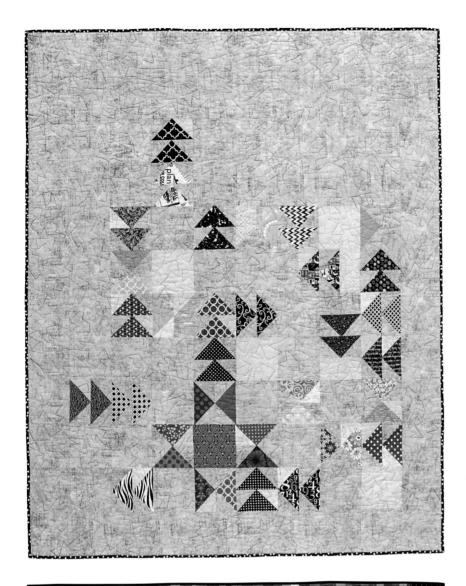

STAR'D
Kristy Daum, 2013, 50″ × 60″

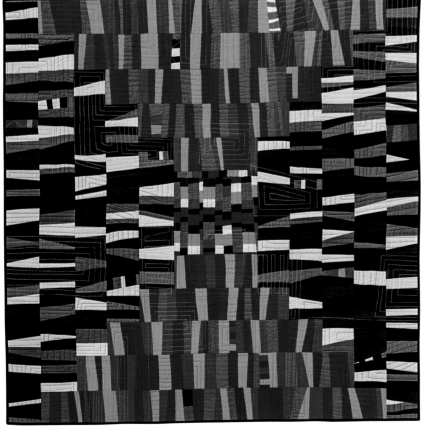

CHESS ON THE STEPS
Krista Hennebury, 2014, 50″ × 50″

This quilt was inspired by an oversized Courthouse Steps quilt seen on exhibit in "American Quilts: The Democratic Art, 1780–2007" by an unknown maker.

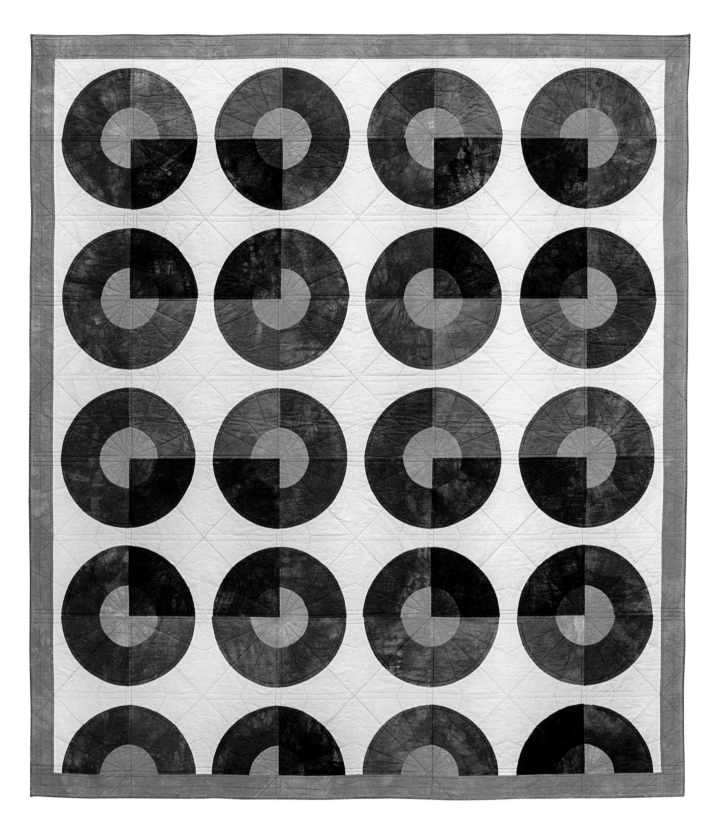

BLUE CIRCLE
Kim Eichler-Messmer, 2012, 84″ × 93″

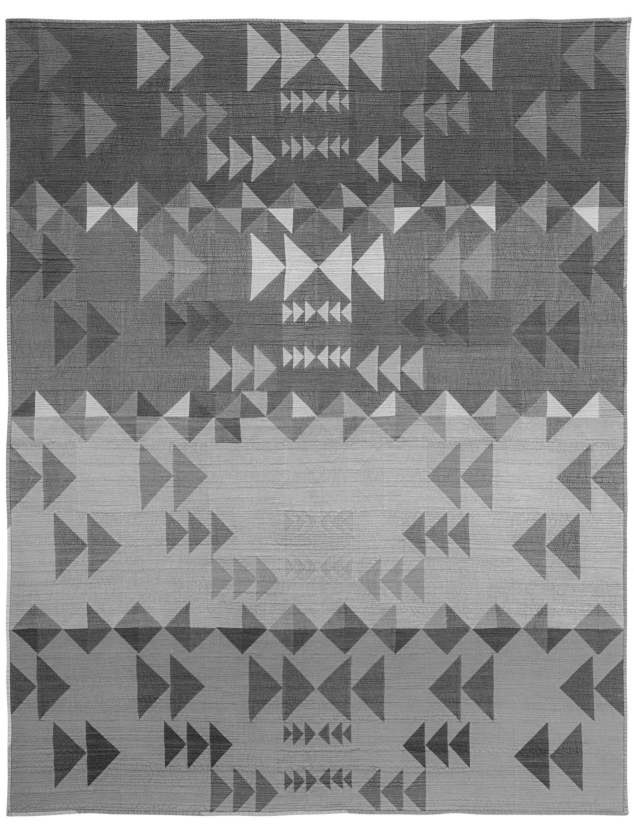

FLIGHT PATH
Mary A. Menzer, 2014, 50″ × 63″

Minimalism

Minimalism in quilting is similar to minimalism in art—the less there is, the more minimal it is. Minimalism is distilling down the most basic parts of quilt construction to their fundamental aspects. Often in quilting, the more negative space a quilt has, the more minimal it becomes.

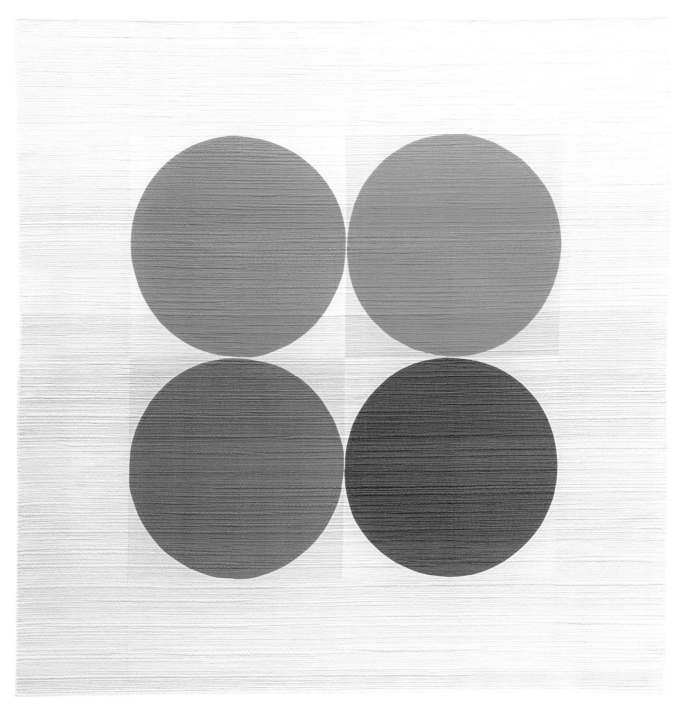

BREATHE
Leanne Chahley, 2014, 63½″ × 63½″

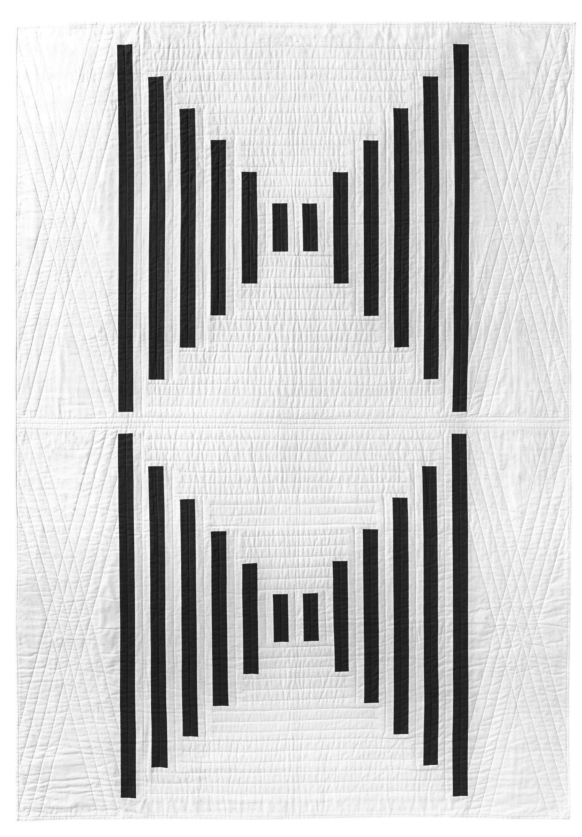

STEREO
Season Evans, 2014, 52″ × 74″

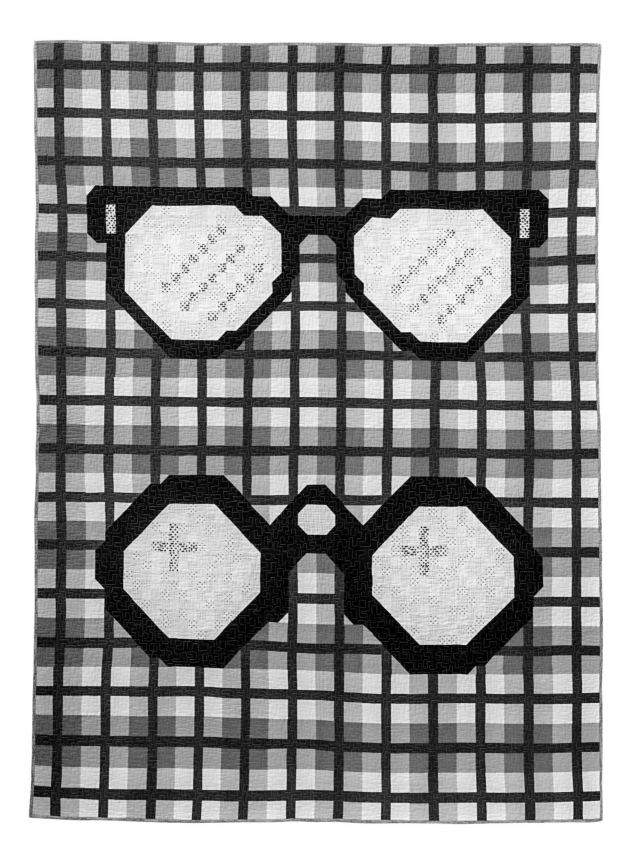

SAM AND SUZY
Made by Megan Callahan, quilted by Elizabeth Hartman, 2014, 60″ × 80″

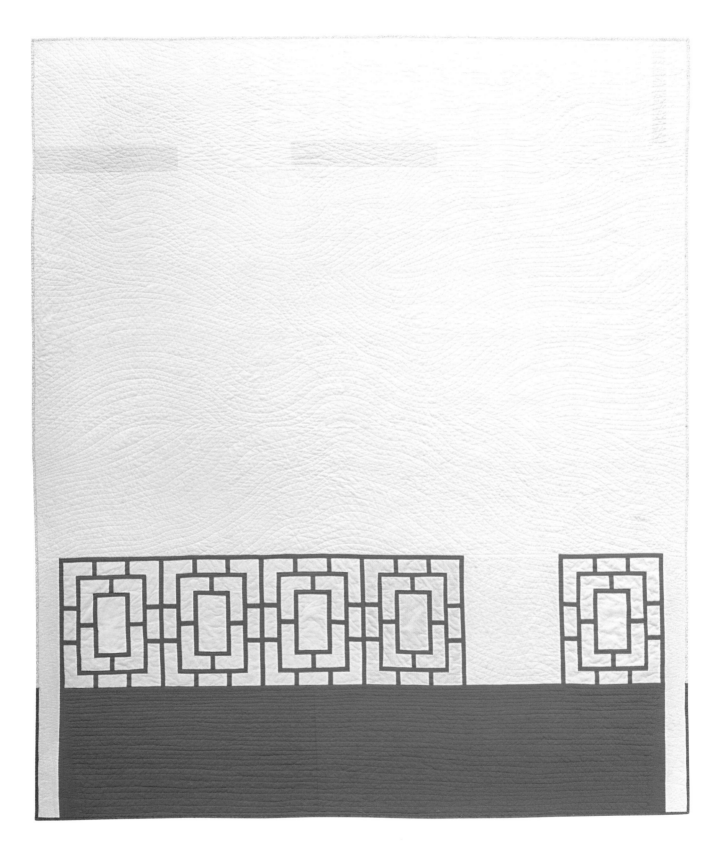

PEEK
Melanie Tuazon, 2014, 78″ × 90″

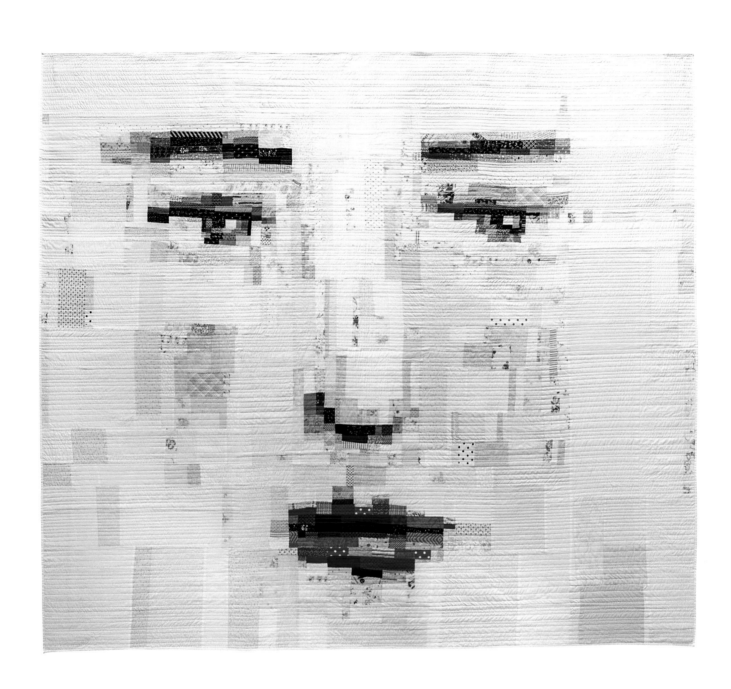

FACE #1
Melissa Averinos, 2014, 90″ × 80″

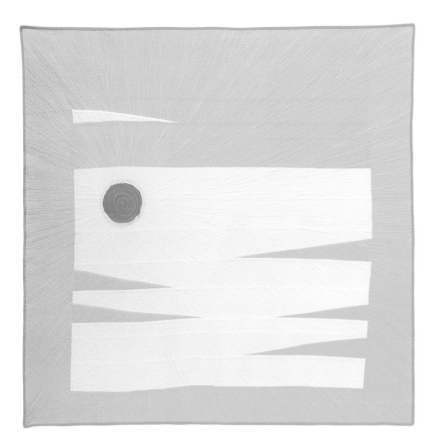

SOL
Nathalie Bearden, 2014, 53″ × 54″

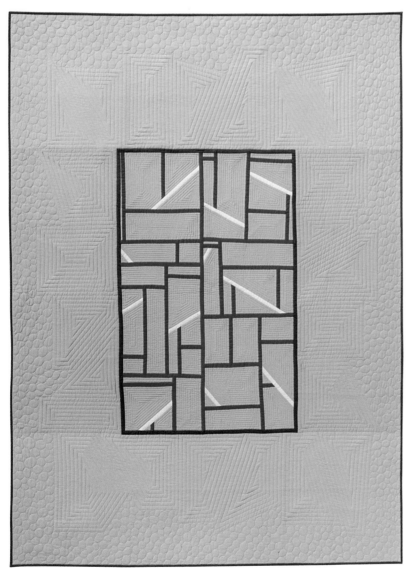

INTERSECTION
Neva Asinari, 2014, 52″ × 71″

I AM A WOMAN WHOSE CHILD IS DEAD

SELF-PORTRAIT, YEAR TWO (BENEATH THE SURFACE)
Penny Gold, 2014, 68″ × 94″

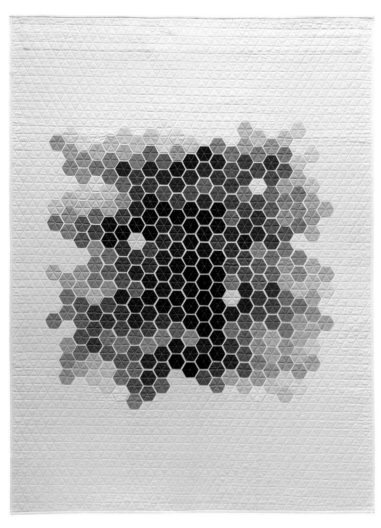

GEOMETRIC RAINBOW
Nicole Daksiewicz, 2014, 44″ × 58″

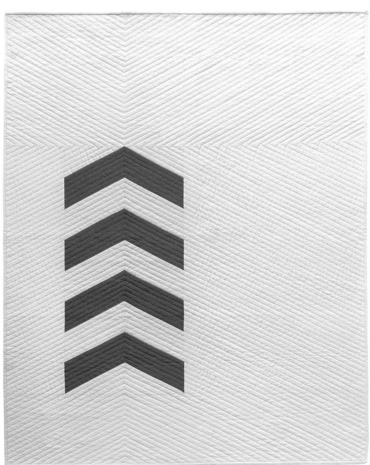

ASCEND
Nicole Neblett, 2015, 36″ × 43″

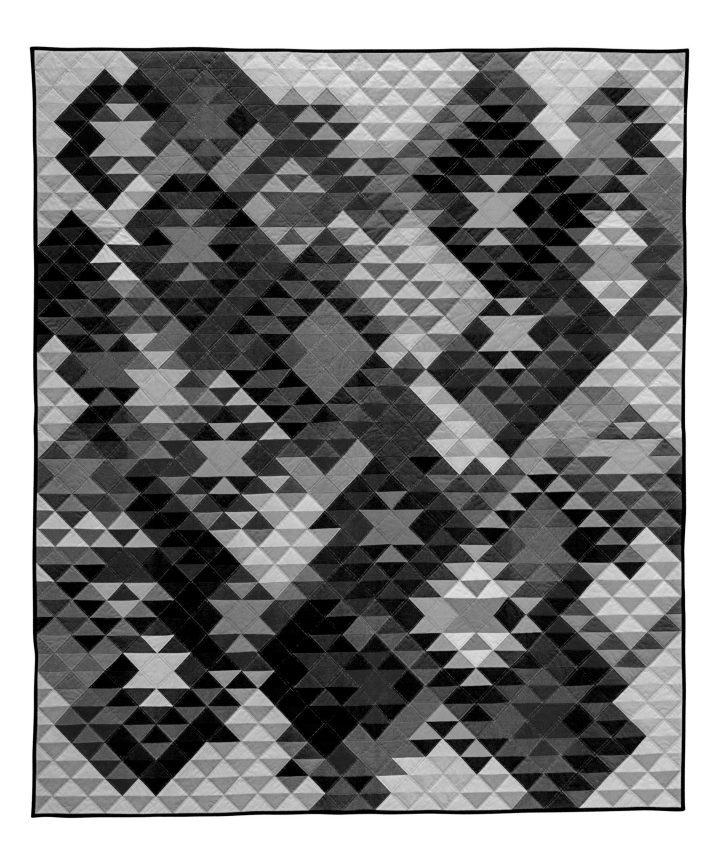

HALF SQUARE TRIANGLES
Tara Faughnan, 2014, 55″ × 63″

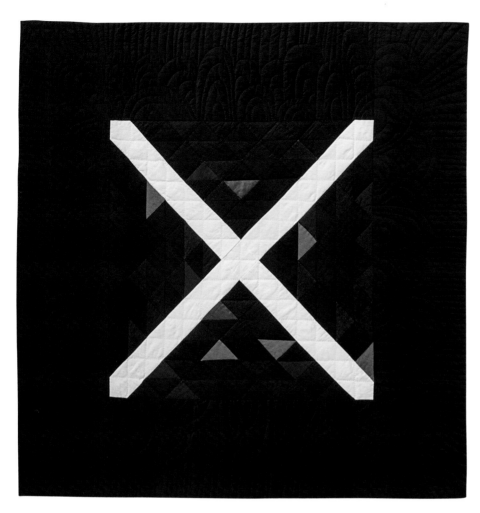

X QUILT
Stacey Sharman, 2014, 65″ × 65″

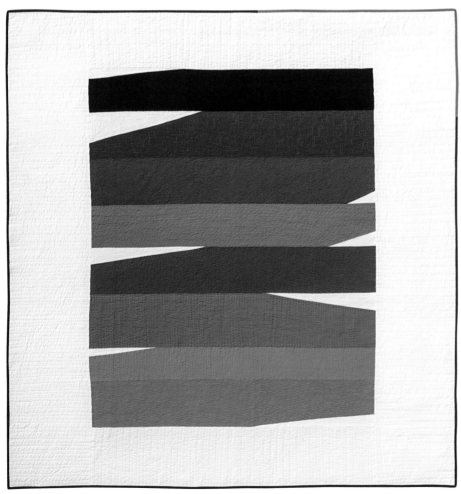

AMAZONIA
Nathalie Bearden, 2014, 63″ × 67″

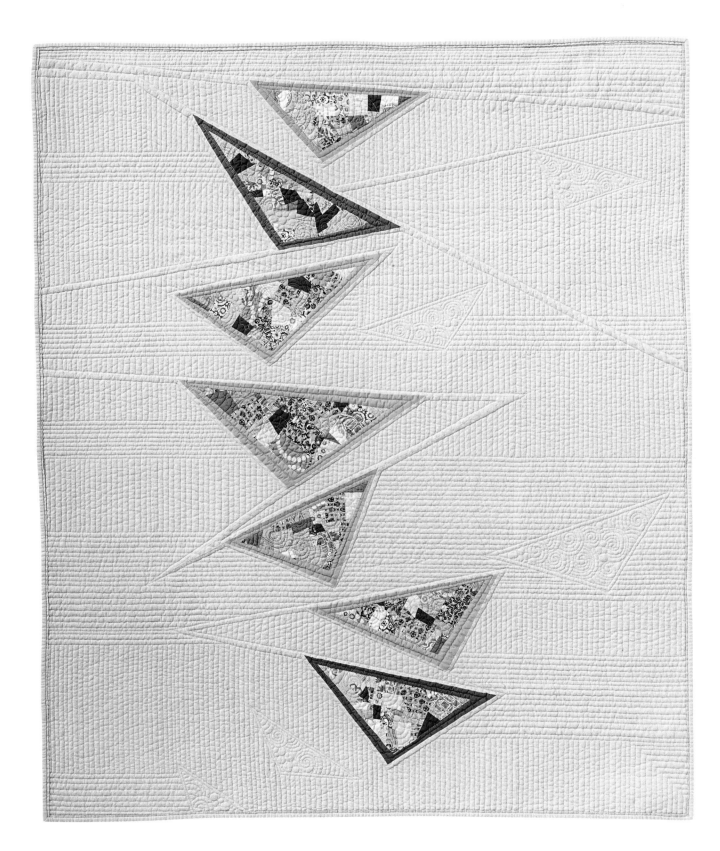

DIVING GEESE
Made by Katie Pedersen, quilted by Krista Withers, 2013, 44″ × 51″

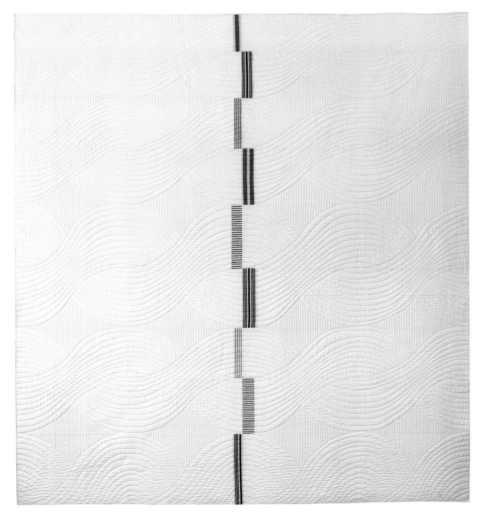

CENTERLINE
Made by Denyse Schmidt,
quilted by Angela Walters,
2013, 84″ × 88″

Photo by and courtesy of Denyse Schmidt

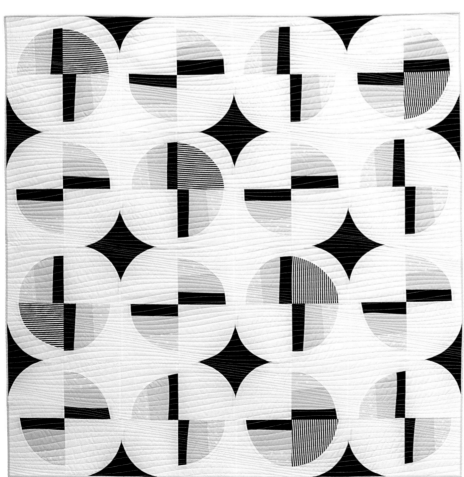

MODERN FANS
Made by Suzy Williams,
quilted by Quantum Quilts,
2015, 56″ × 56″

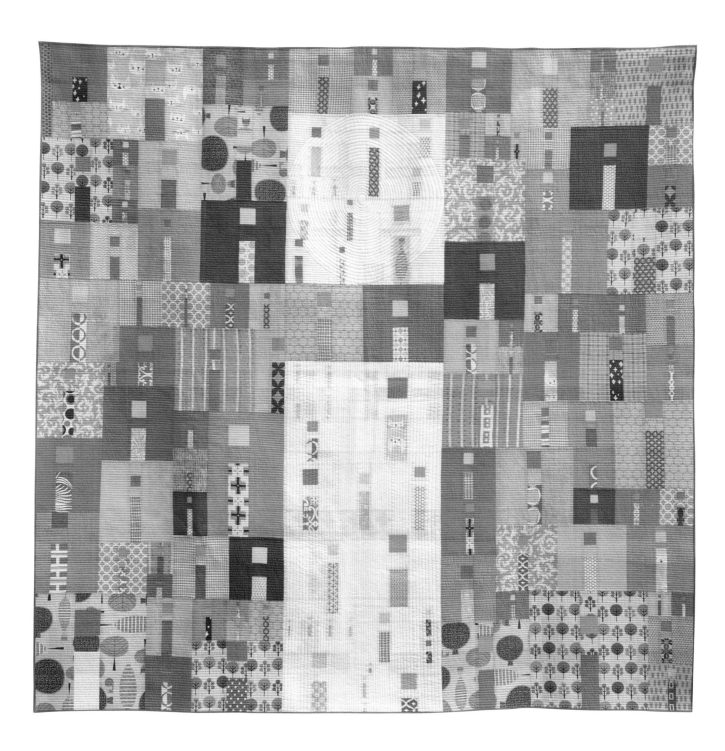

I QUILT
Kathy York, 2014, 64½″ × 62½″

Photo by Kathy York

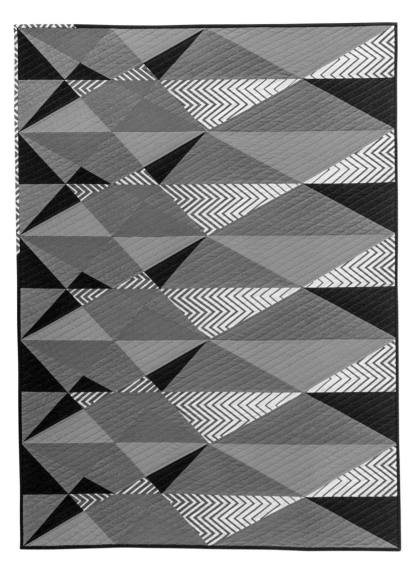

ZAG
Kari L. Anderson, 2014, 43″ × 58″

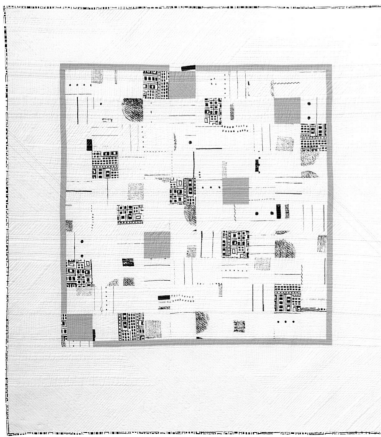

WHITE SPACES
Bev Bird, 2013, 50″ × 54″

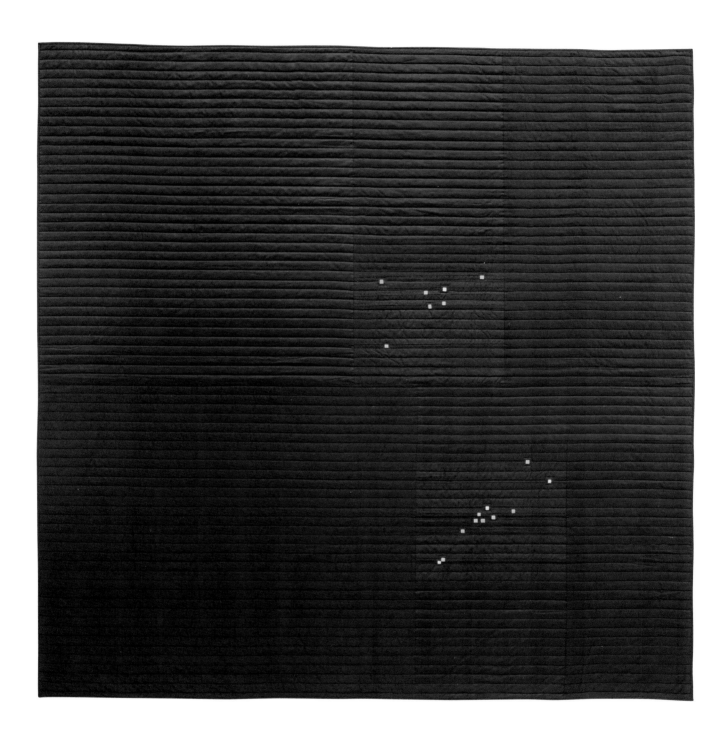

CANCER & TAURUS (CONSTELLATION QUILT)
Made by Amber Platzer Corcoran, quilted by Susan Santistevan, 2015, 84″ × 84″

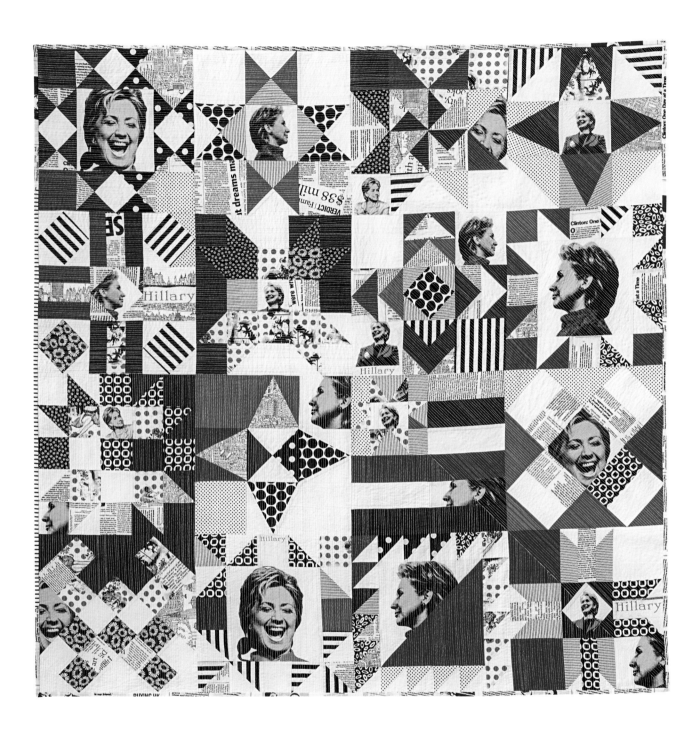

HILLARY QUILTON
Diana Vandeyar, 2015, 48½″ × 48½″

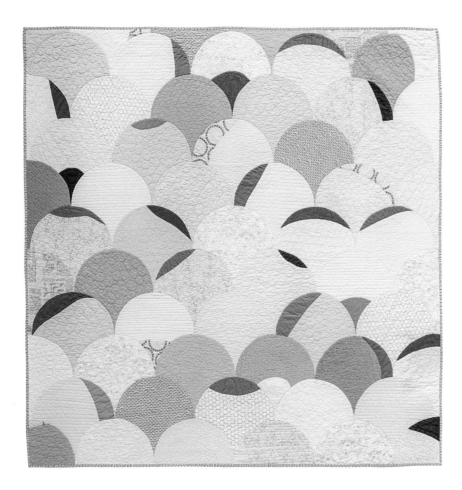

DUNES
Jenna Brand, 2015, 68″ × 68″

QBI (THE QUIET BEAUTY OF IMPERFECTION)
Jenny K. Lyon, 2016, 45″ × 54″

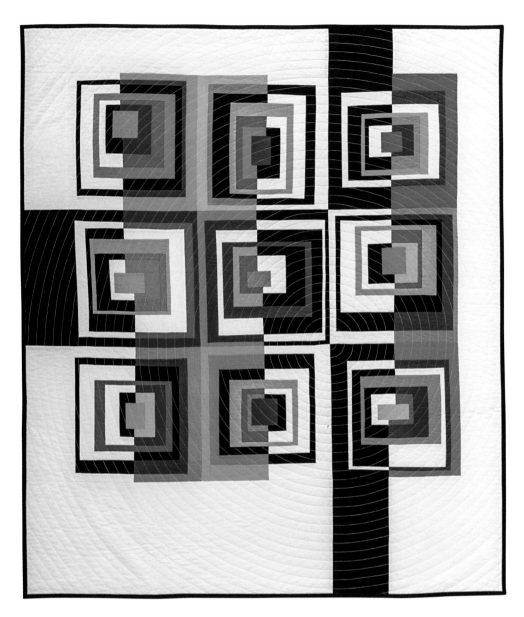

THE COLOR OF SQUARES
Juli Irene Smith, 2015, 56" × 64"

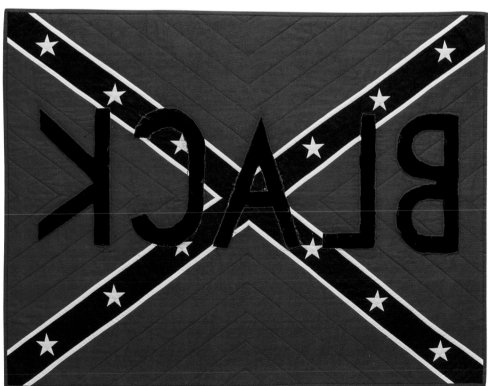

BLACK LIVES MATTER
Karen Maple, 2015, 42" × 32"

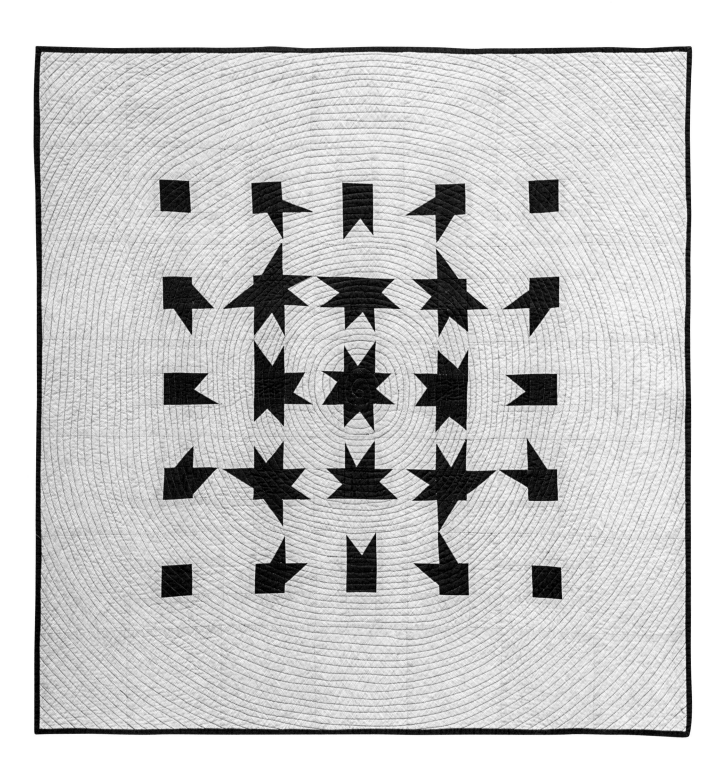

WONKY METAMORPHOSIS
Katherine Dithmer, 2015, 41″ × 41″

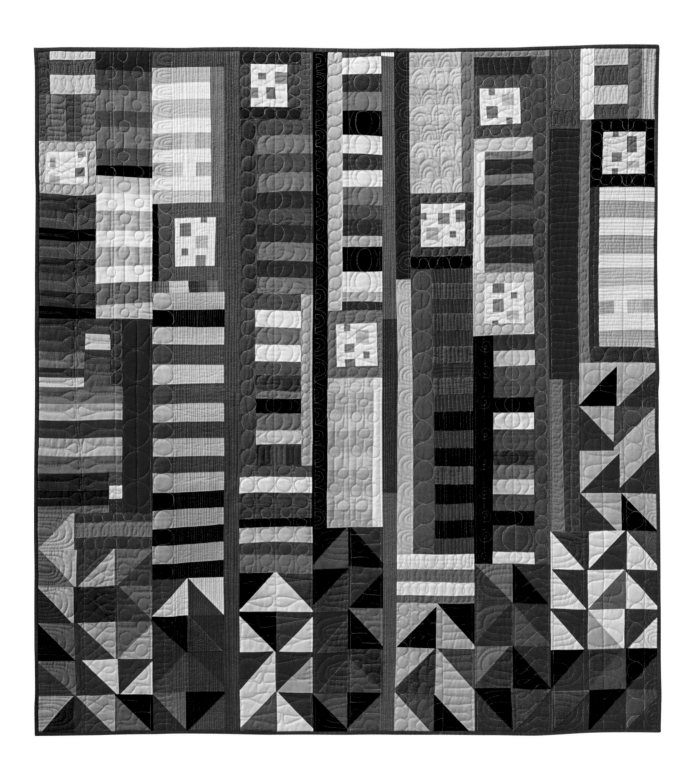

THE SPECTRUM OF THE ORDINARY
Kristin Shields, 2015, 45″ × 47″

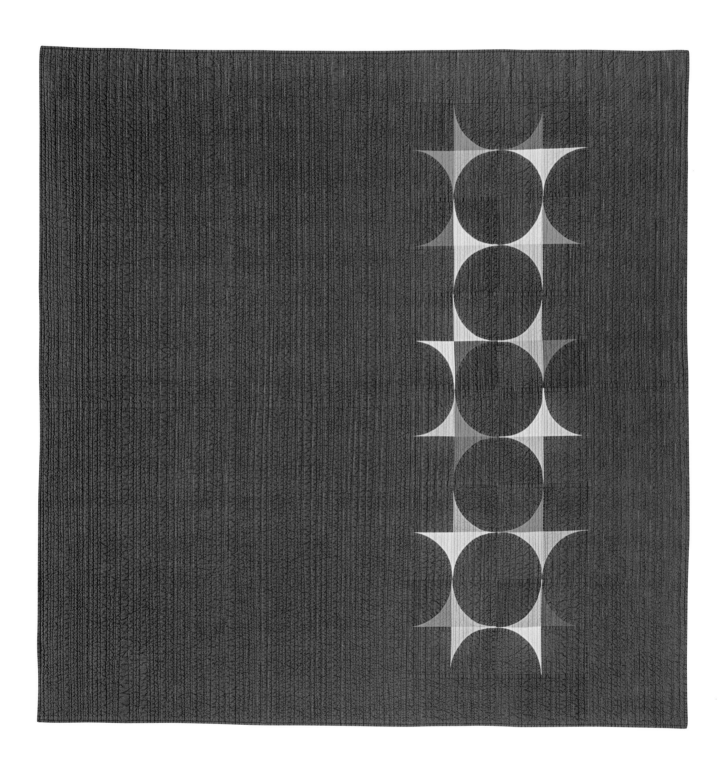

ECHOES
Leanne Chahley, 2014, 66″ × 66″

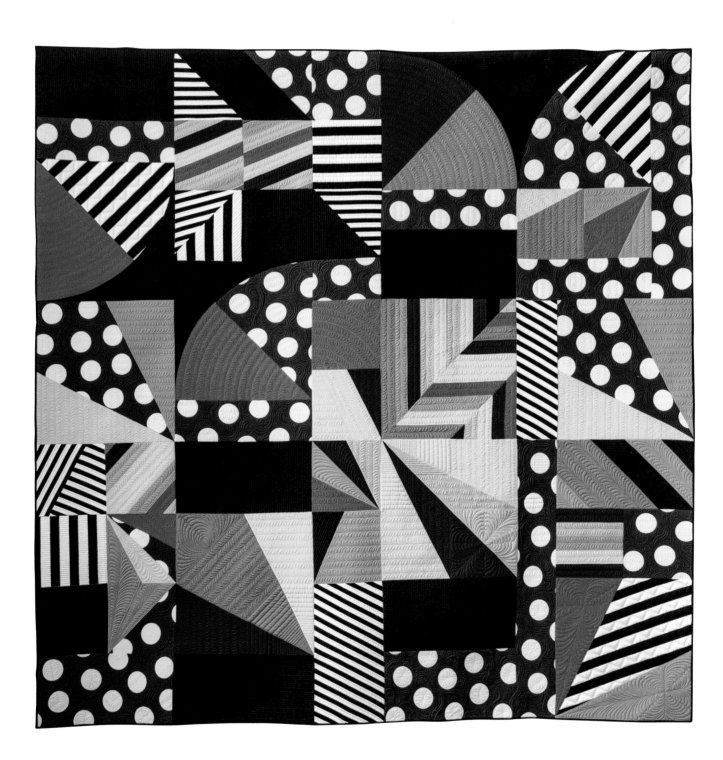

KILL IT WITH FIRE
Made by Libs Elliott, quilted by Rachael Dorr, 2015, 69″ × 69″

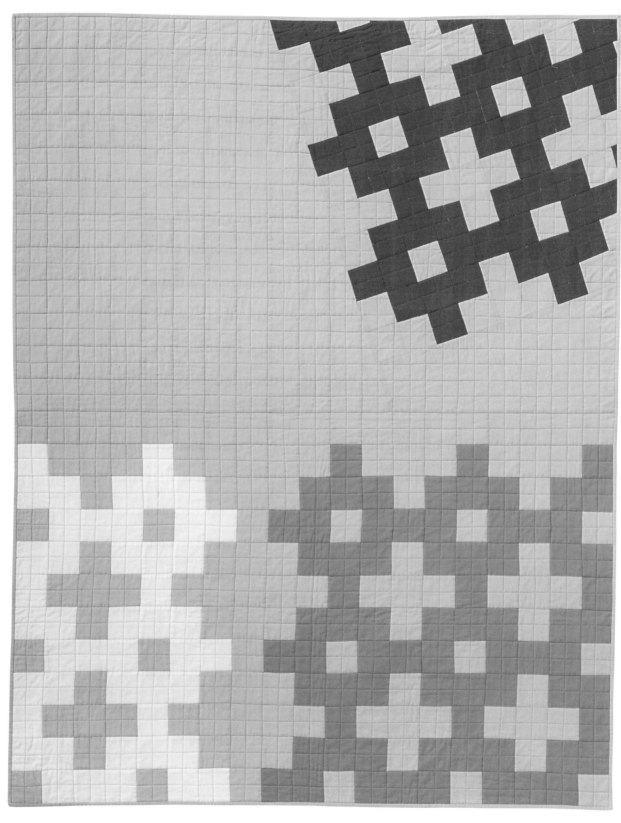

OFF THE GRID
Michelle Engel Bencsko, 2014, 48″ × 60″

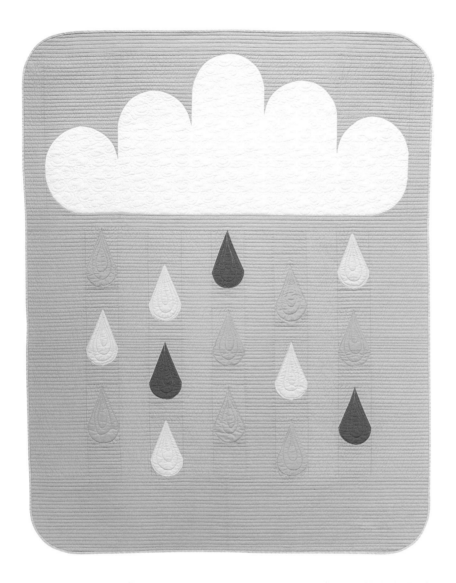

RAINY DAY
Made by Lindsey Neill,
quilted by Sarah Wilson,
2015, 56″ × 72″

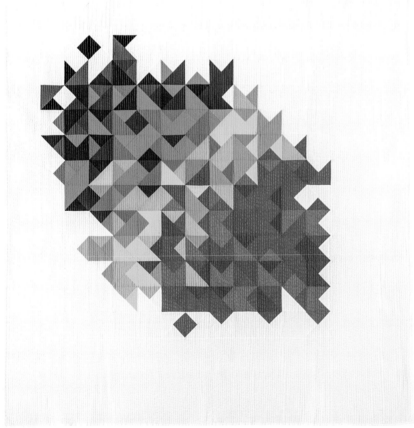

FRACTION
Lou Orth, 2015, 60″ × 60″

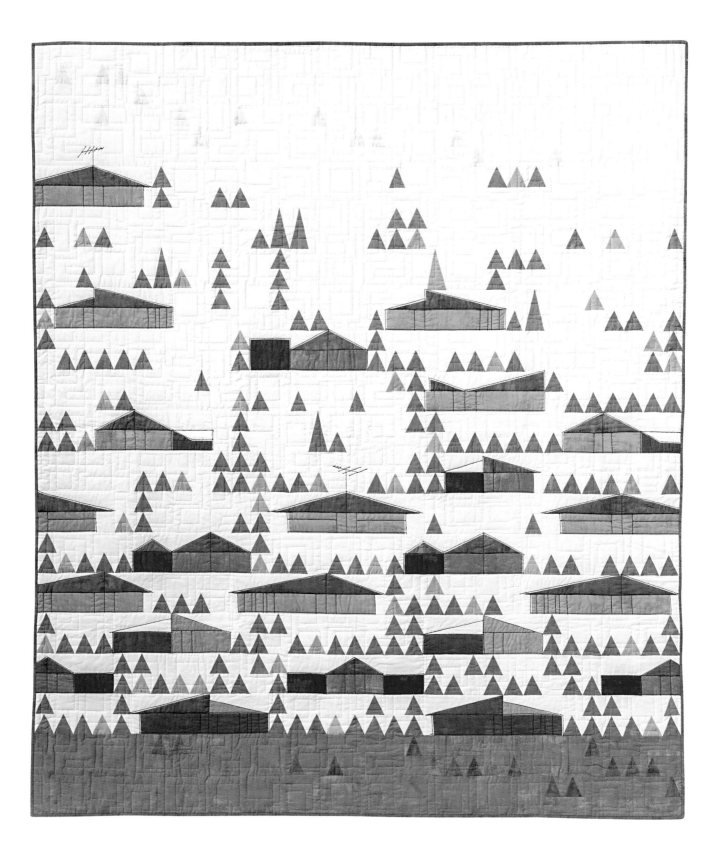

EICHLER HOMES
Made by Mickey Beebe, quilted by Tami Levin, 2015, 66″ × 76″

This quilt was inspired by a poster—Mad About Modern by Ryan DeMarco.

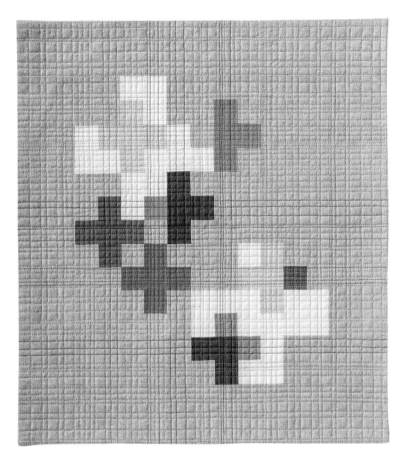

POSITIVELY TRANSPARENT
Paige Alexander, 2015, 16″ × 18″

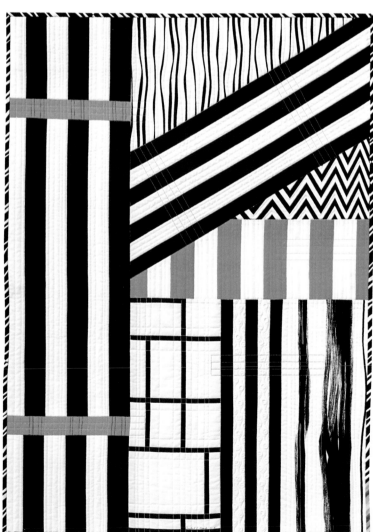

CHEATIN' SONG: STRIPES
Rosalind Daniels, 2015, 28″ × 39″

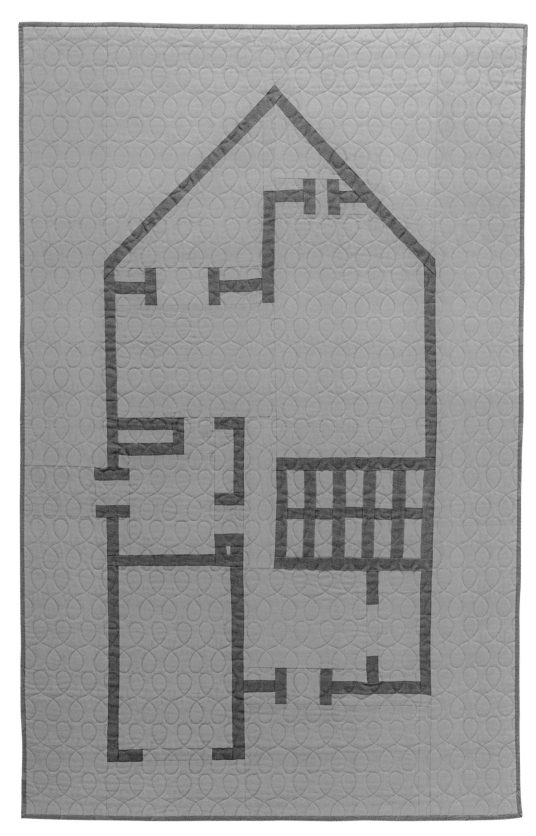

HOUSE PLAN
Made by Pam Rocco, quilted by Linda Barbin, 2013, 42½″ × 64″

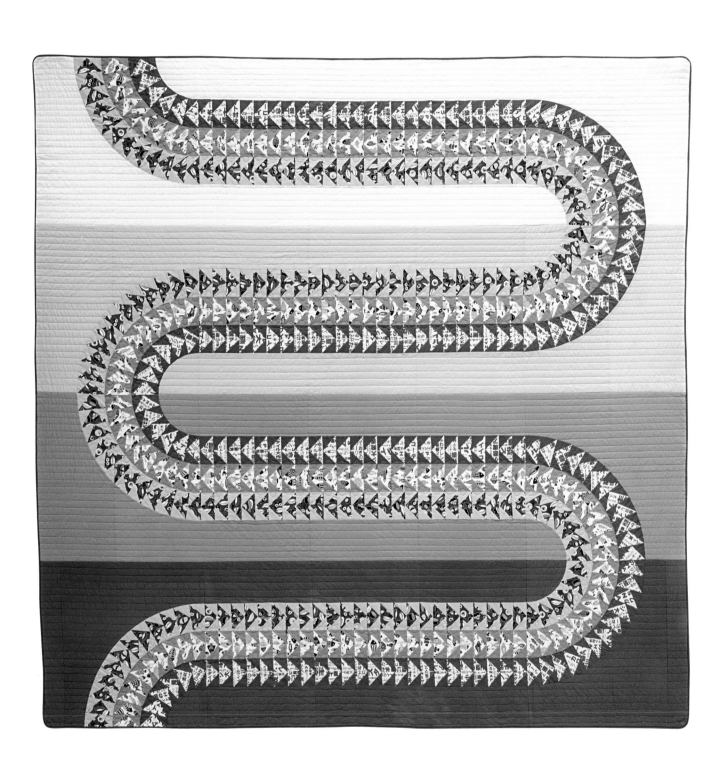

RELEASE THE GEESE II
Made by Sarah Bond, quilted by Carol Heisler, 2015, 96″ × 96″

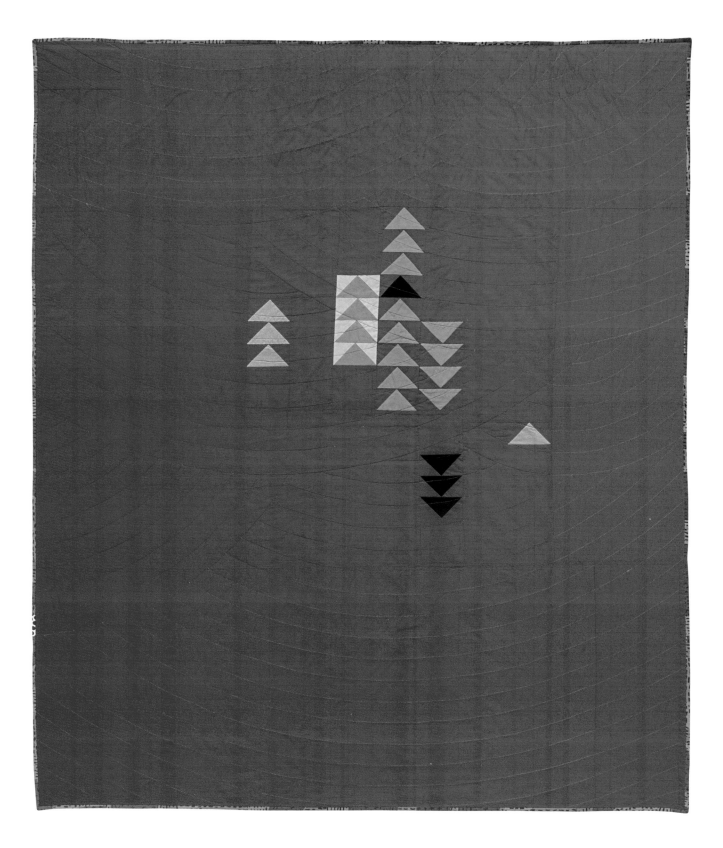

RED HOT
Shawna Doering, 2015, 55″ × 66″

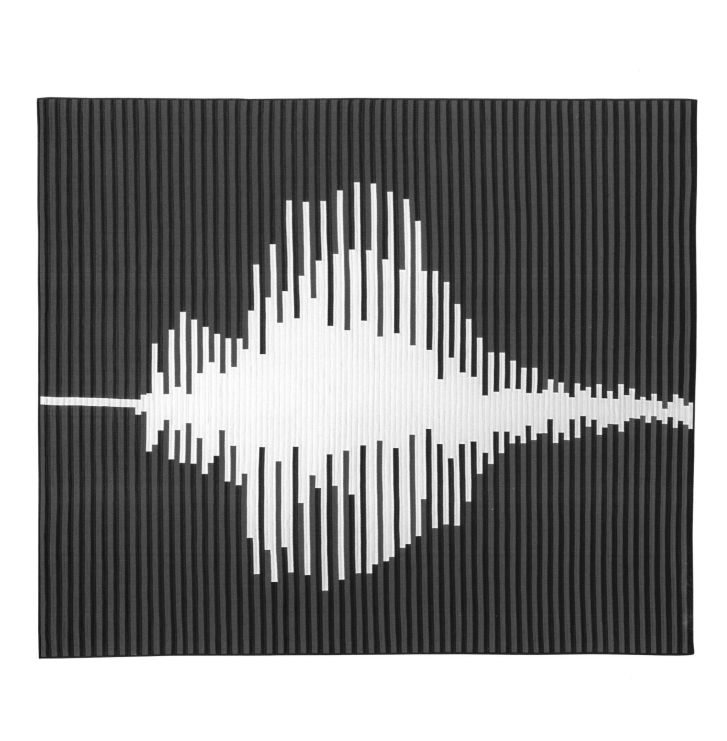

BIG LOVE
Sheri Cifaldi-Morrill, 2015, 95" × 78"

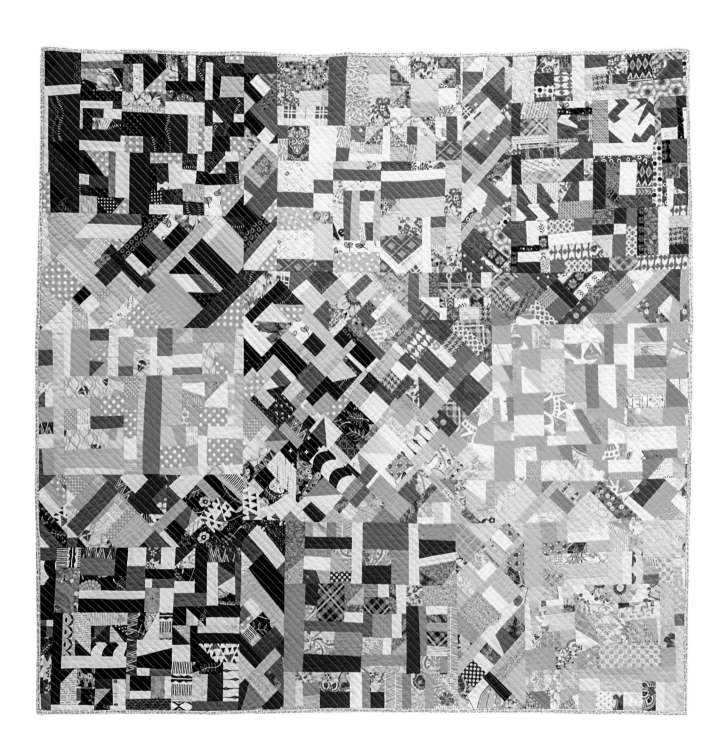

ACCUMULATIVE EFFECT
Stacey Lee O'Malley, 2015, 55″ × 55″

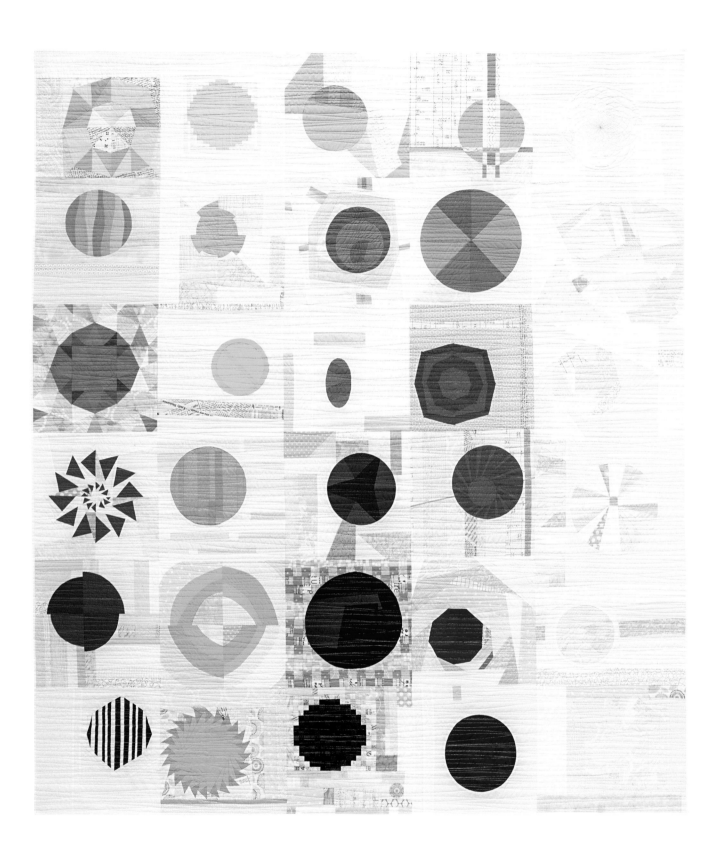

TWISTED SISTERS
Made by Stephanie Zacharer Ruyle, Christine Perrigo, Wendy Bermingham, Amy Wade, Chelsea Camalick, Sheri Nichols, Michelle Davis, Wendy Roth, Teri Ladtkow, Susan Santisteven, Charlayne Dunn, Shelby Skumanich, Andrea Berryhill, Teresa Barbagallo, Lauren Lang, Dena Mehling, Anne Deister, Katie Rapp, Carla Keahey, Marsha Loewenberg, Judy Sanclaria, and Heather Ferguson; quilted by Wendy Bermingham and Christine Perrigo, 2015, 78″ × 88″

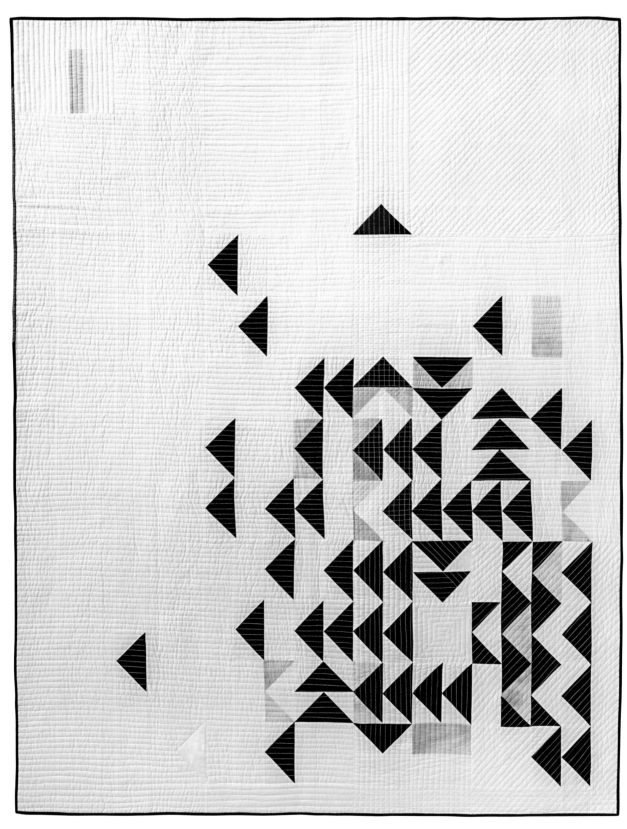

MIGRATION QUILT
Yara Greuter, 2015, 62″ × 80″

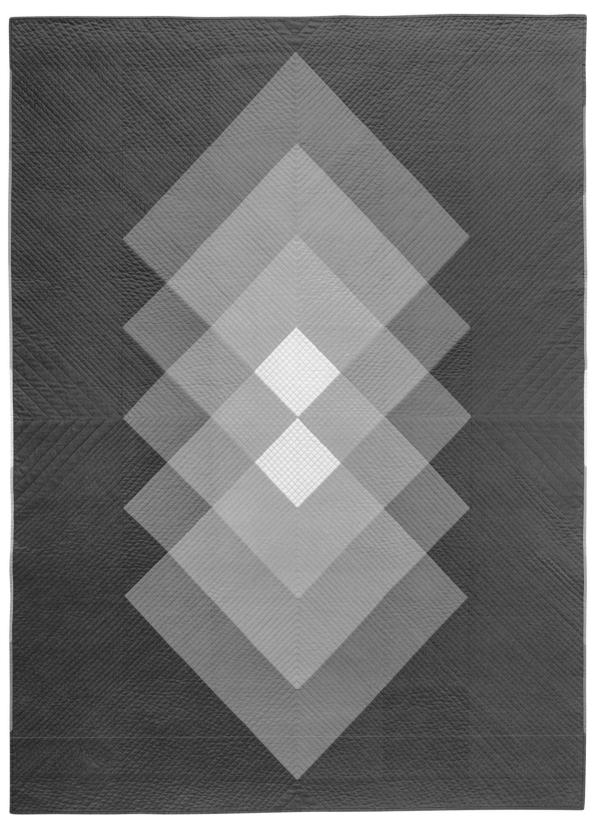

SUNBURST
Yvonne T. Fuchs, 2015, 59″ × 77″

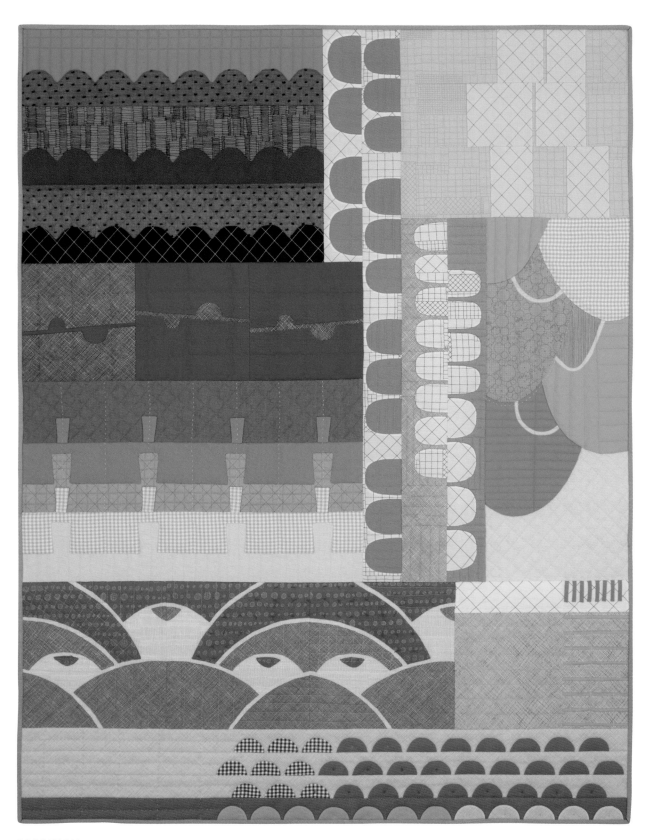

COLLECTION
Carolyn Friedlander, 2015, 40½″ × 51½″

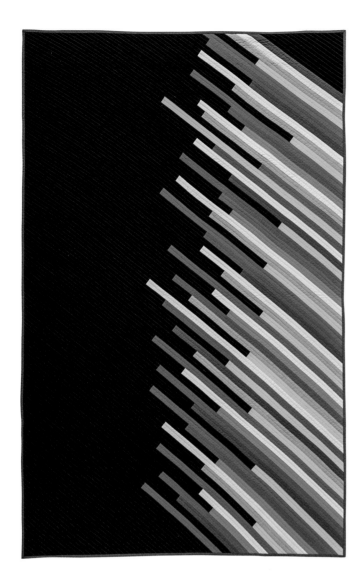

BIAS 4
Alissa Haight Carlton, 2016, 60″ × 75″

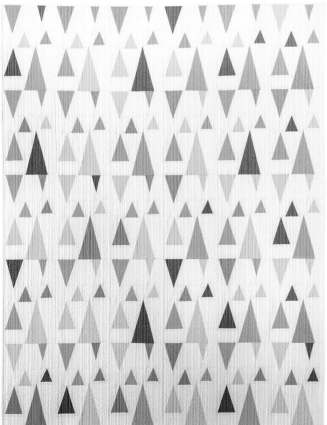

POINTED STATEMENT
Amy Friend, 2015, 48″ × 60″

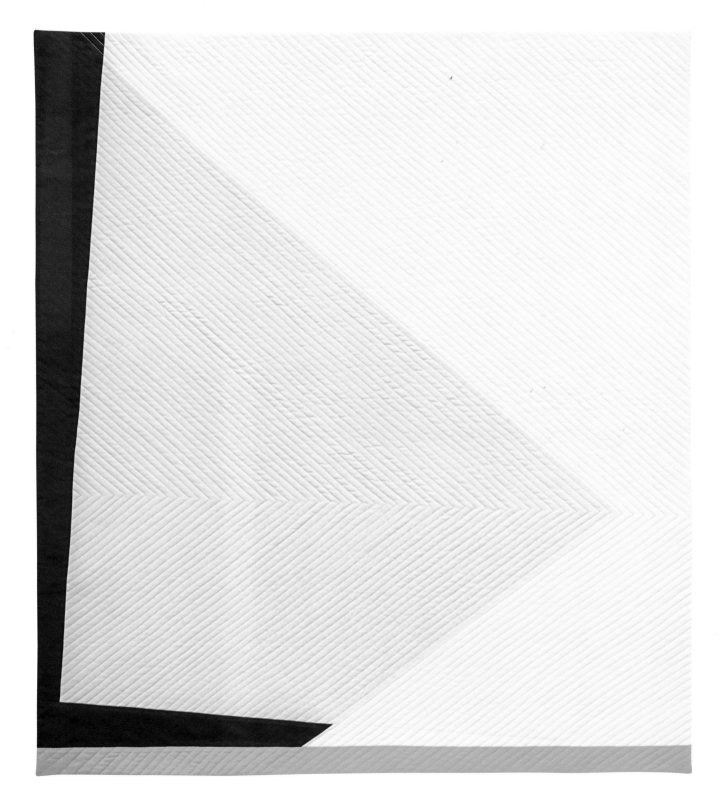

SHIFT
Carson Converse, 2013, 37½″ × 41″

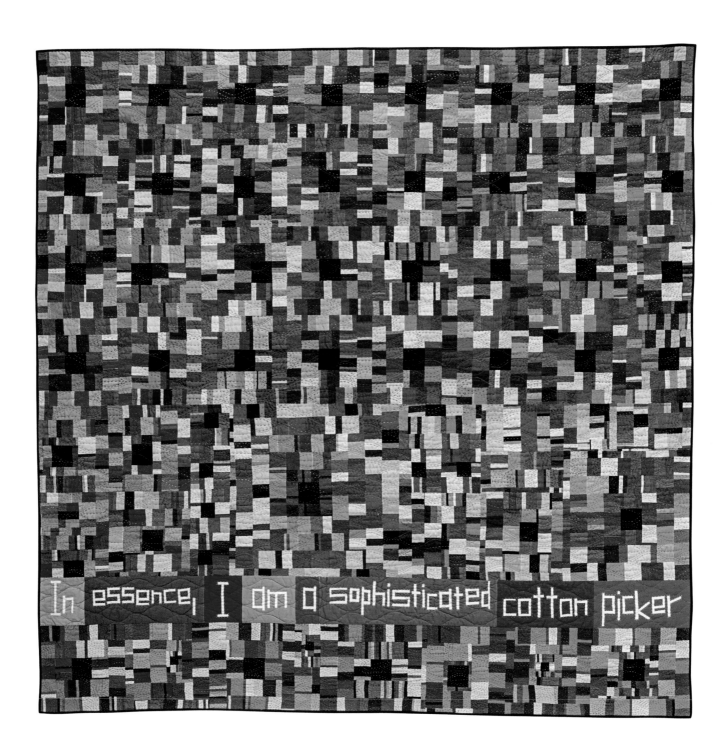

COTTON SOPHISTICATE
Made by Chawne Kimber, quilted by Chawne Kimber and Pamela J. Cole, 2015, 72″ × 72″

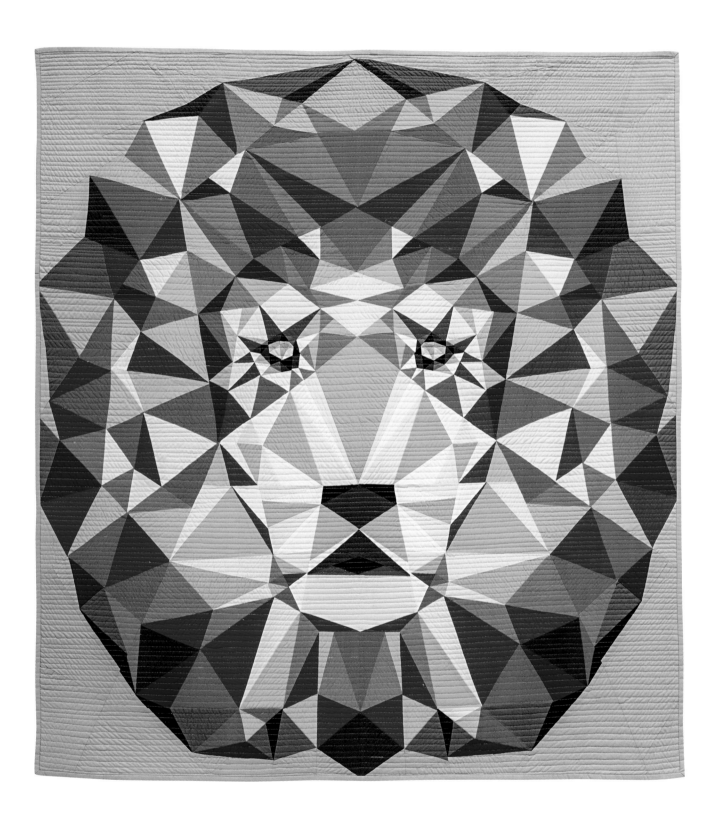

JUNGLE ABSTRACTIONS: THE LION
Violet Craft, 2015, 60″ × 60″

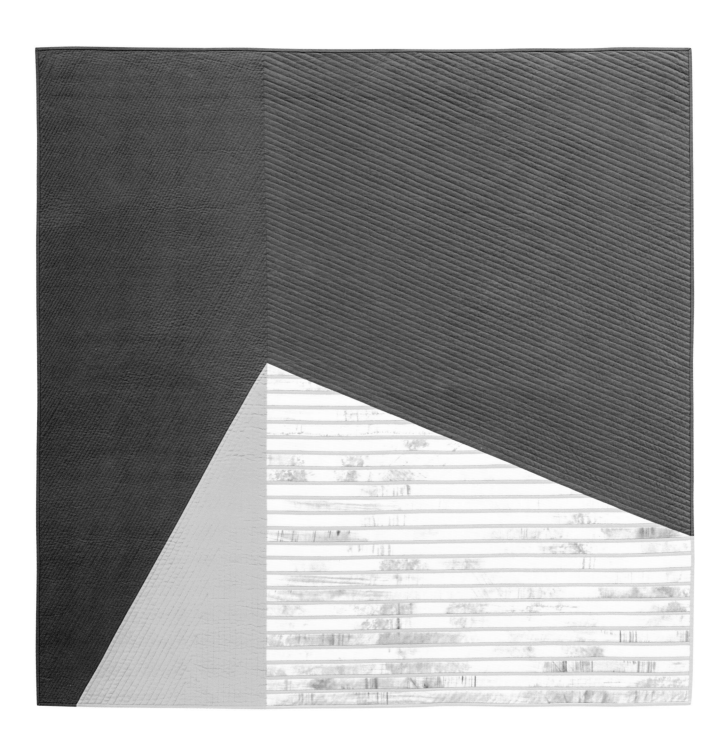

THE OTHER SIDE
Carson Converse, 2015, 59″ × 57″

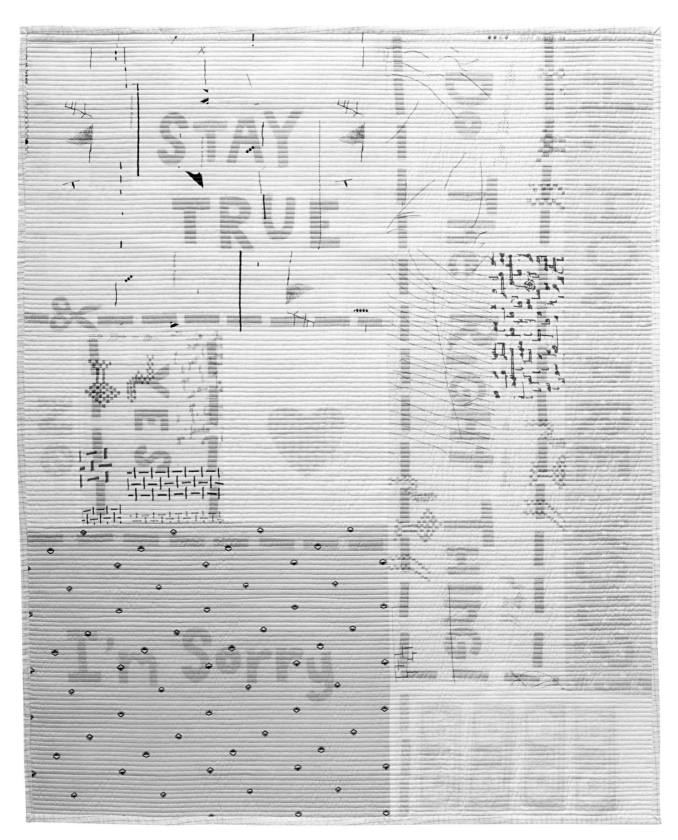

CUT & KEEP
Gina Pina, 2015, 37″ × 44″

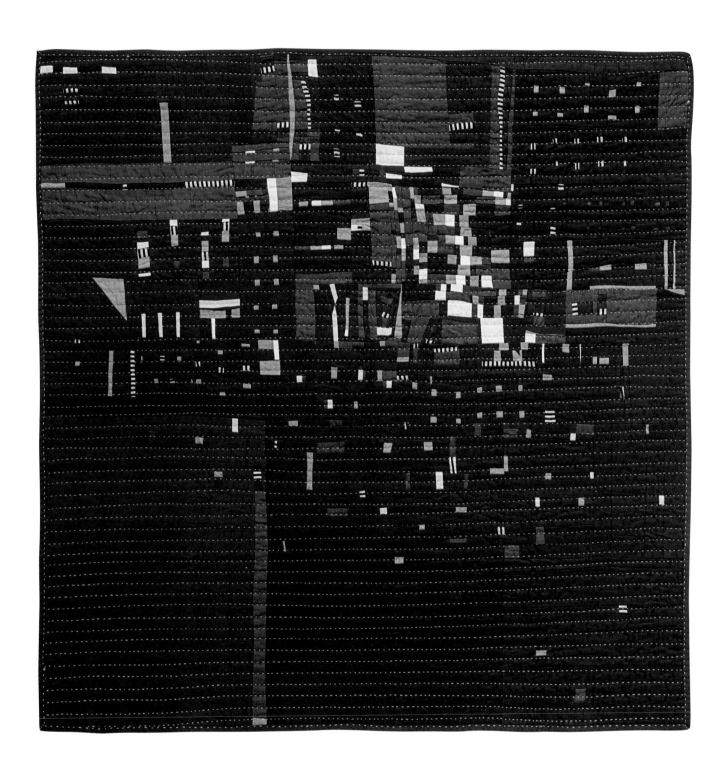

NIGHT FLIGHT NO. 1
Heidi Parkes, 2015, 58″ × 58″

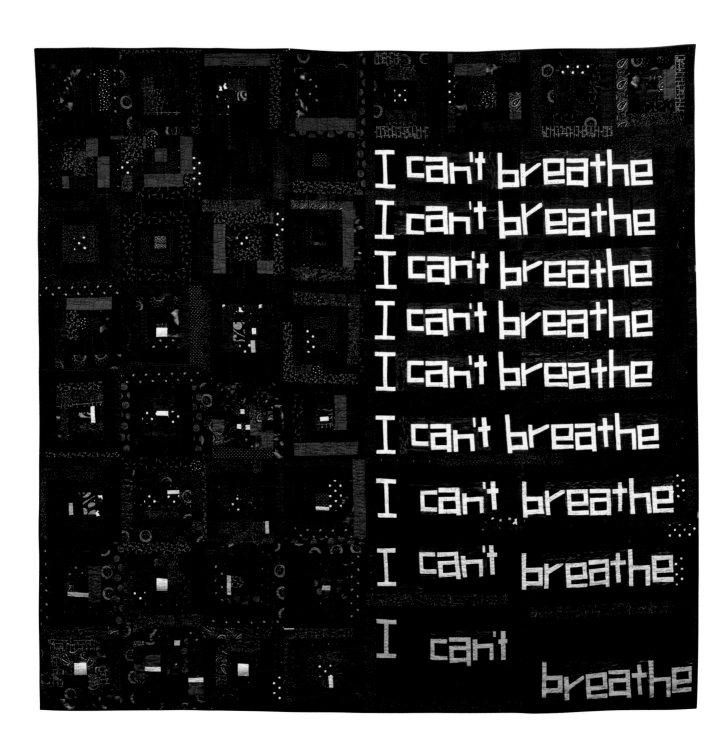

THE ONE FOR ERIC
Made by Chawne Kimber, quilted by Chawne Kimber and Pamela J. Cole, 2015, 79″ × 77″

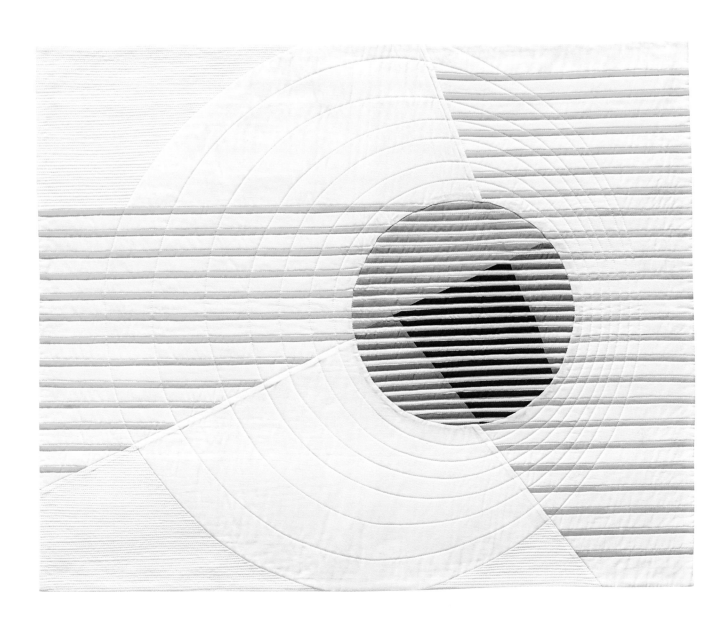

LINES LOST AND FOUND
Jennifer Jones Rossotti, 2015, 34" × 27"

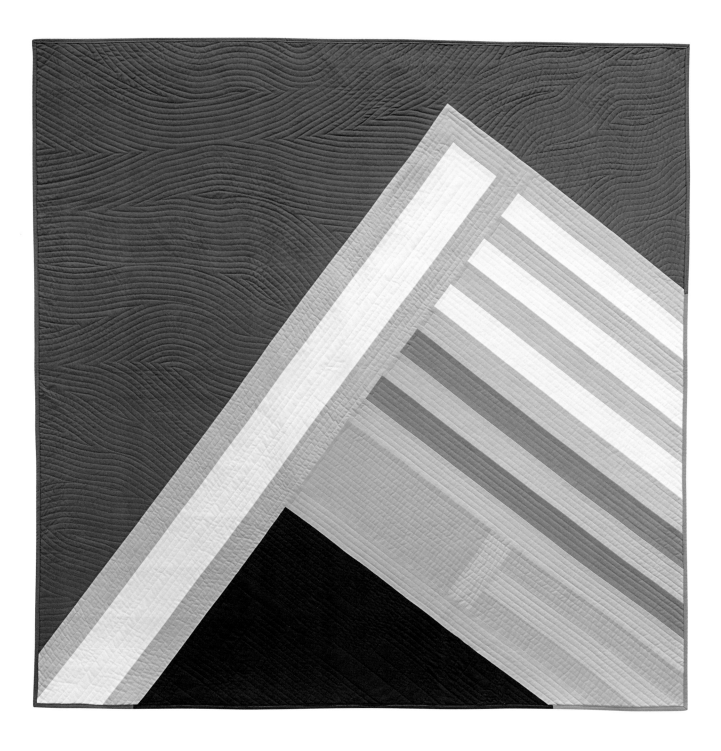

ALTITUDINAL ECOSYSTEM
Michelle Wilkie, 2015, 60″ × 60″

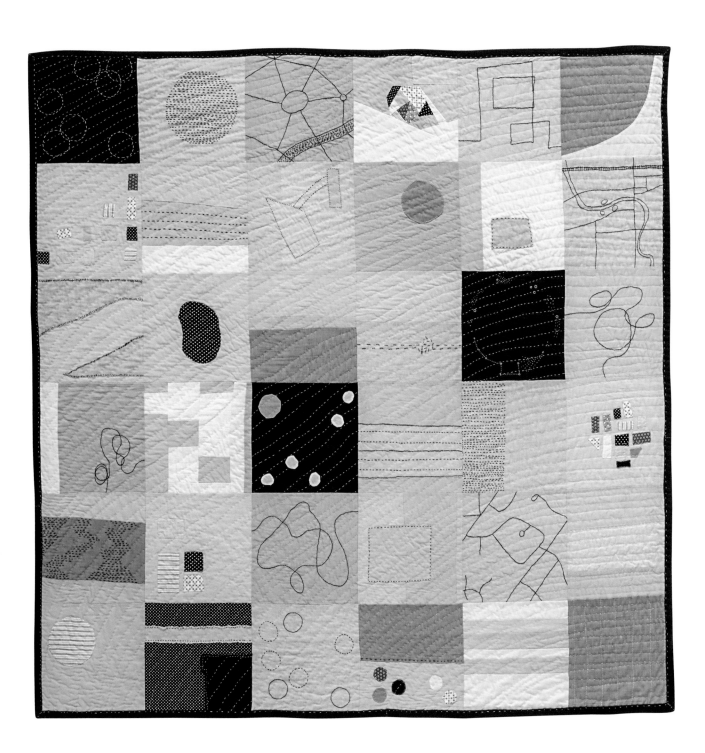

PLACES UNFOLD
Heidi Parkes, 2014, 59″ × 59″

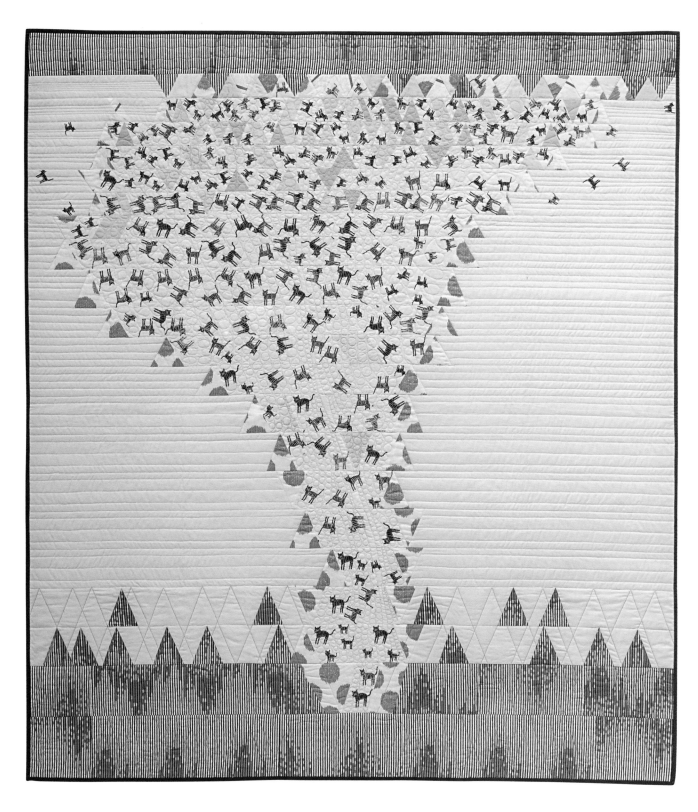

CATNADO
Karen B. Duling, 2015, 56" × 61"

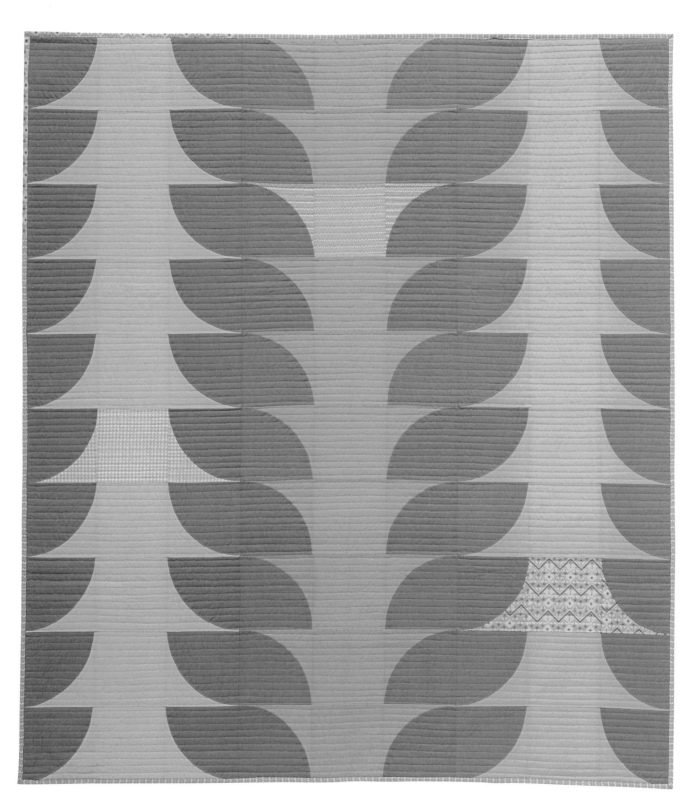

FLOUNCE
Melanie Tuazon, 2015, 52″ × 57″

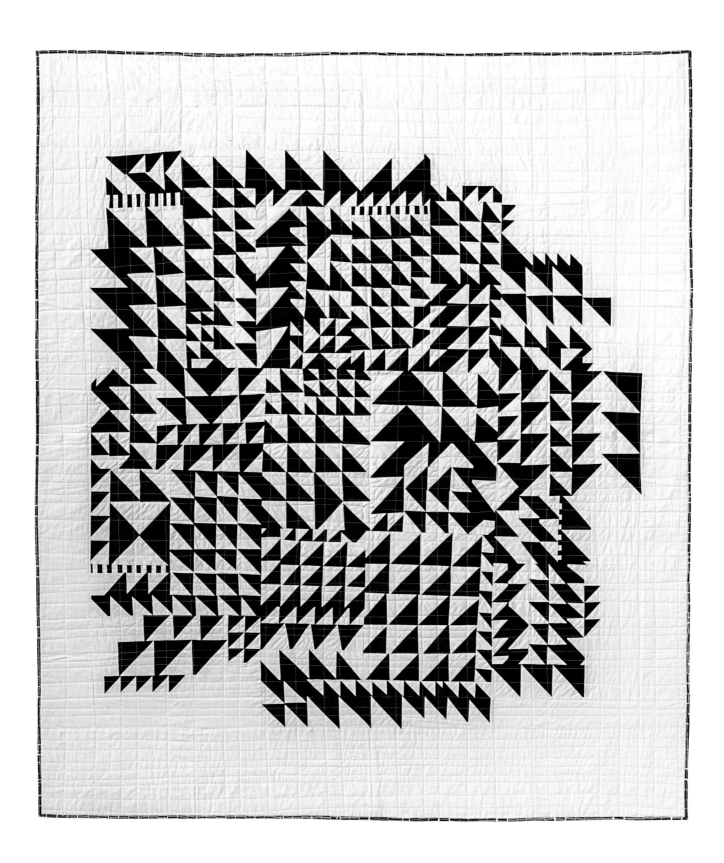

F*CK THE QUILT POLICE
Nancy Purvis, 2015, 69″ × 81″

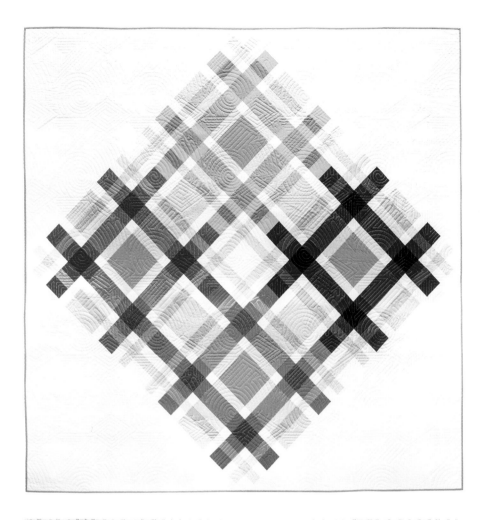

PLAID ON POINT
Made by Jennifer Jones Rossotti,
quilted by Darby Myer,
2015, 108″ × 108″

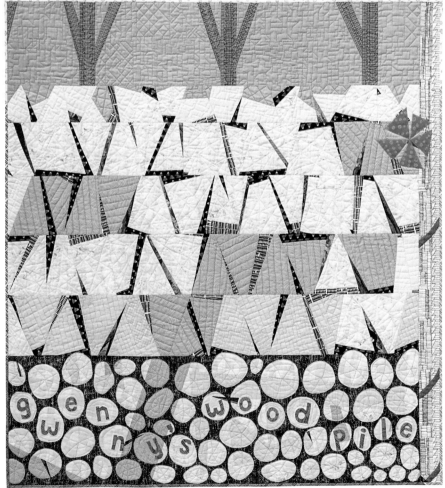

GWENNY'S WOODPILE
Karen B. Duling, 2015, 41″ × 44″

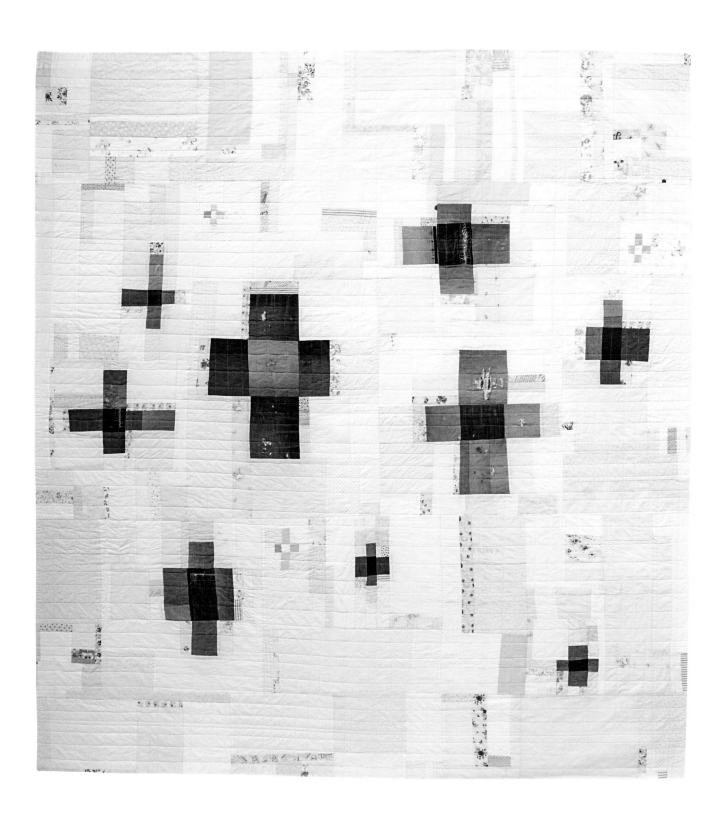

MY BROTHER'S JEANS
Melissa Averinos, 2015, 84″ × 91″

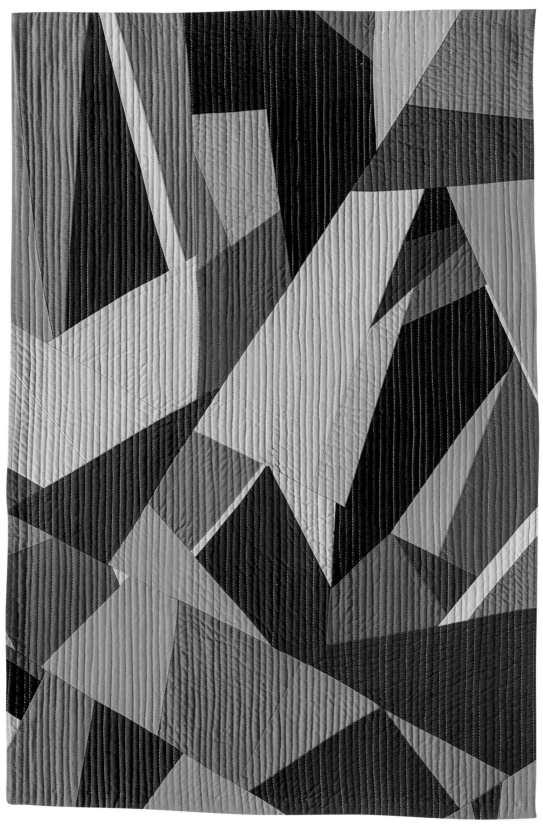

PHYLLO
Scott D. Griffin, 2015, 22½″ × 32½″

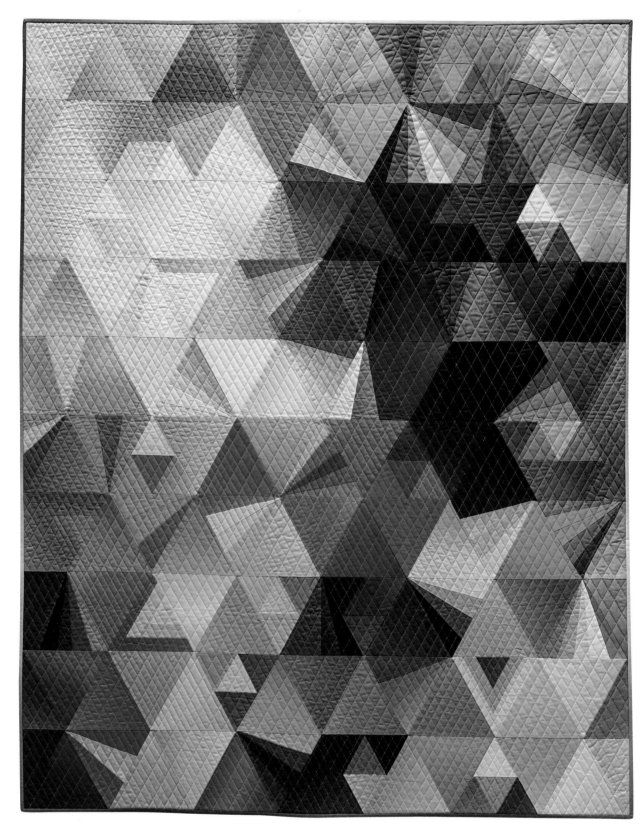

TESSELLATION 4
Made by Nydia Kehnle, quilted by Gina Pina, 2015, 48″ × 60″

This quilt is a version of the published pattern Tessellation, which is an original design created by Nydia Kehnle and Alison Glass.

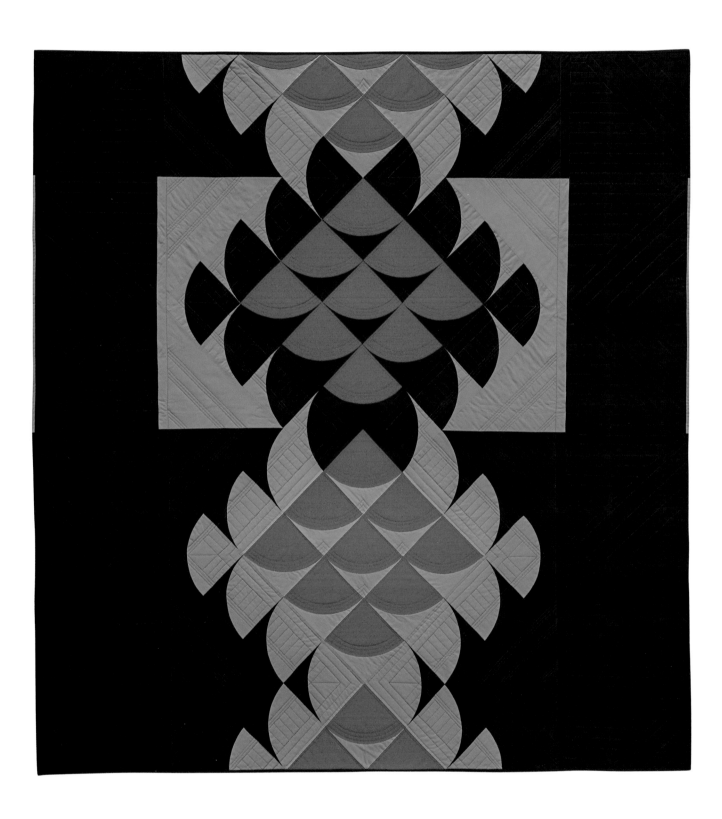

PHOENIX
Anne Sullivan, 2015, 68″ × 72″

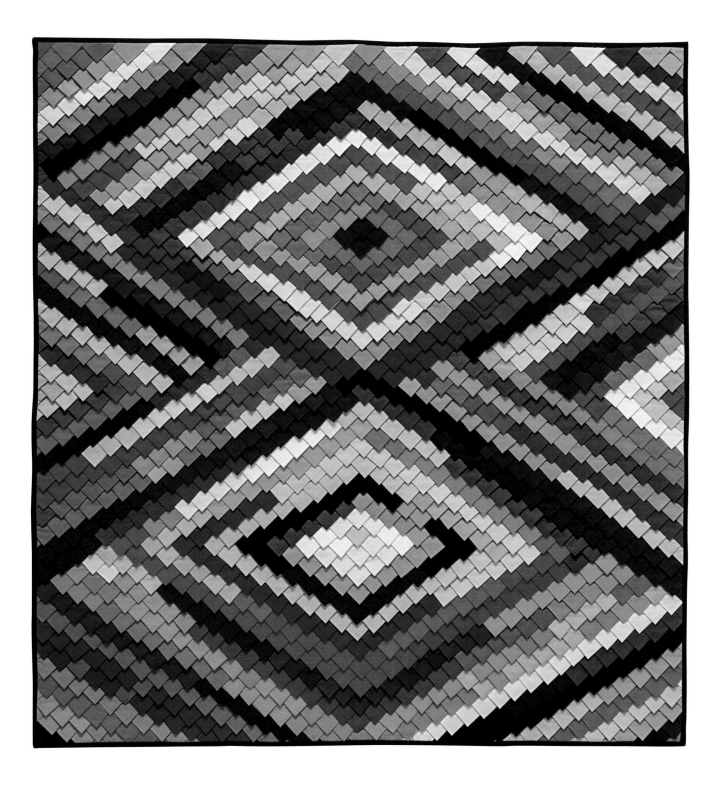

PINE BURR
Tara Faughnan, 2015, 52″ × 54″

HORSESHOES & HAND GRENADES
Rebecca Burnett, 2015, 63″ × 85″

HST
Christa Watson, 2015, 84″ × 84″

UNDER THE RADAR
Corinne Sovey, 2015, 47¾″ × 65″

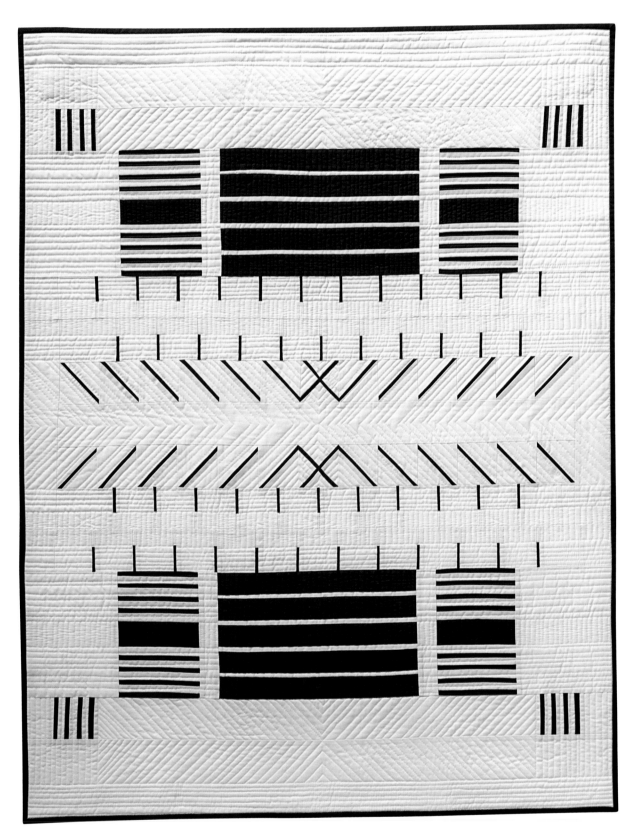

REFLECTION
Made by Nancy Purvis, quilted by Mary Gregory, 2015, 37″ × 47″

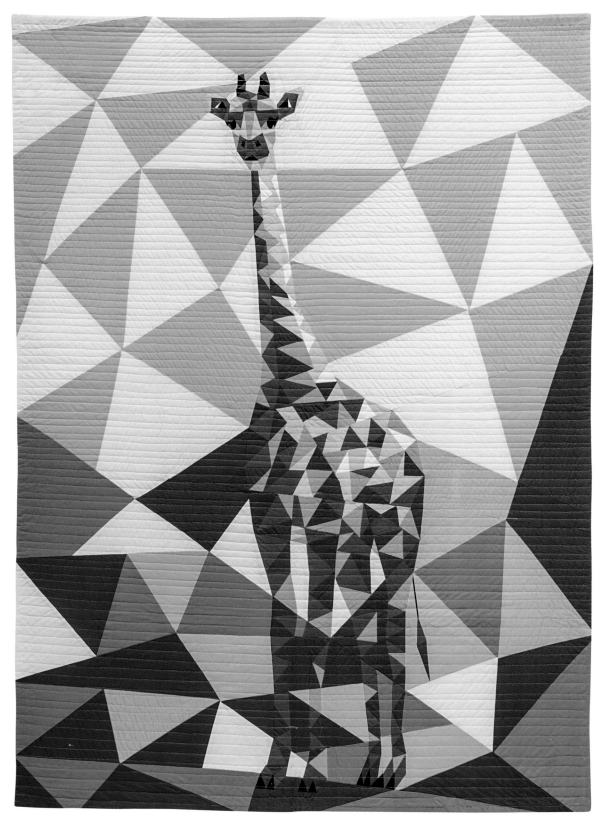

GIRAFFE ABSTRACTIONS
Violet Craft, 2015, 44″ × 60″

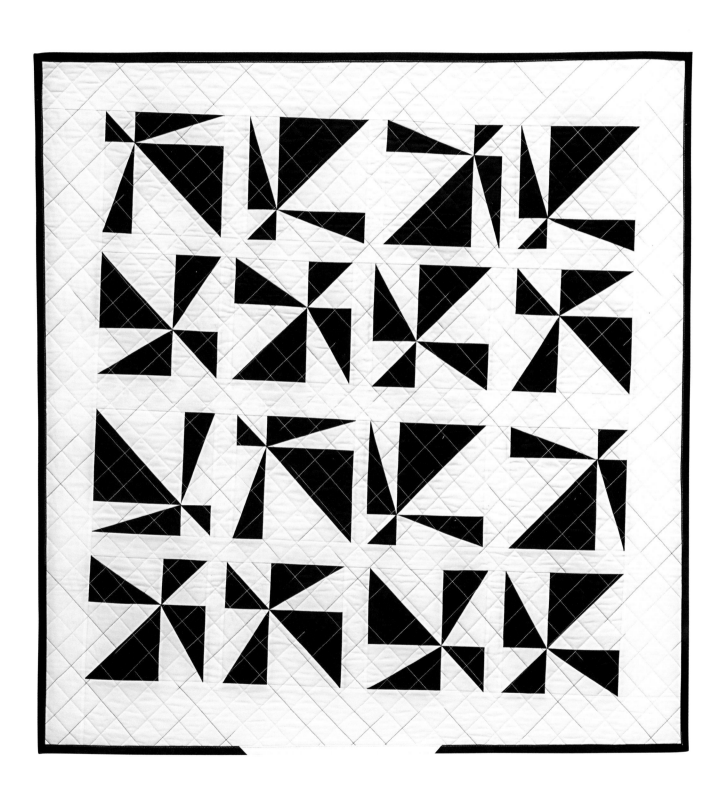

TILTING AT WINDMILLS
Susan Strong, 2015, 44″ × 45″

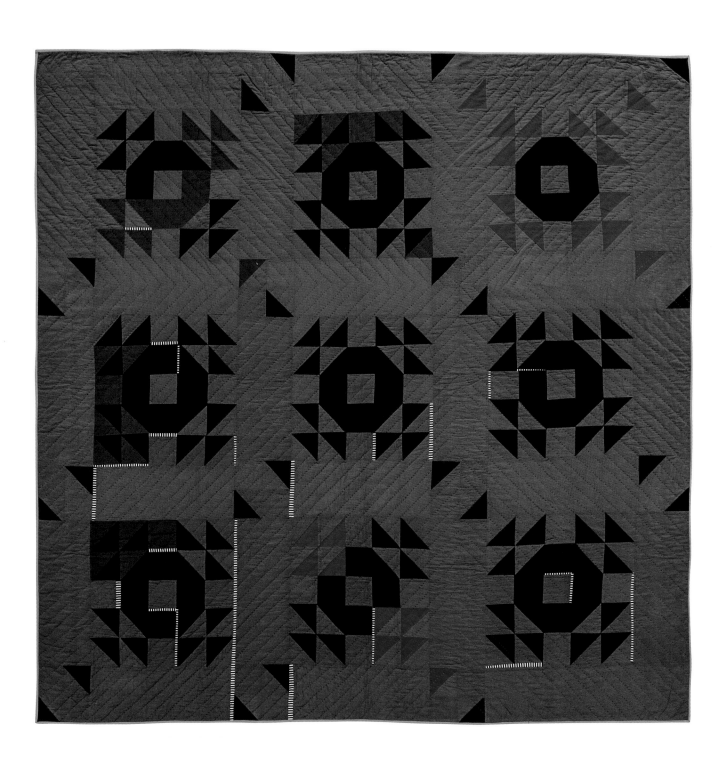

KINTSUGI IV: CROWN OF THORNS
Alexis Deise, 2016, 70″ × 70″

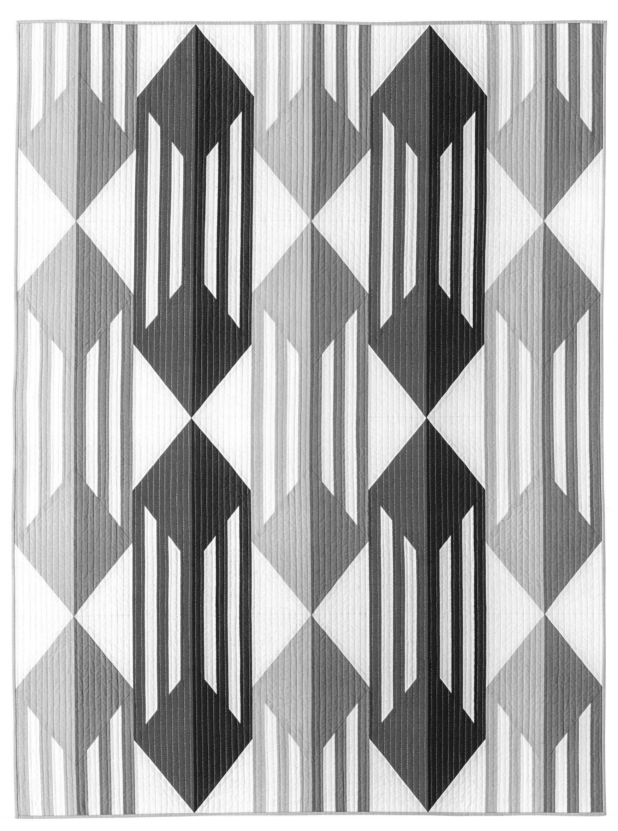

CAGED
Amy Friend, 2016, 50″ × 64″

SELF-PORTRAIT BEHIND THE PIXELS
Made by Angela Bowman, quilted by Laura Pukstas, 2016, 70″ × 70″

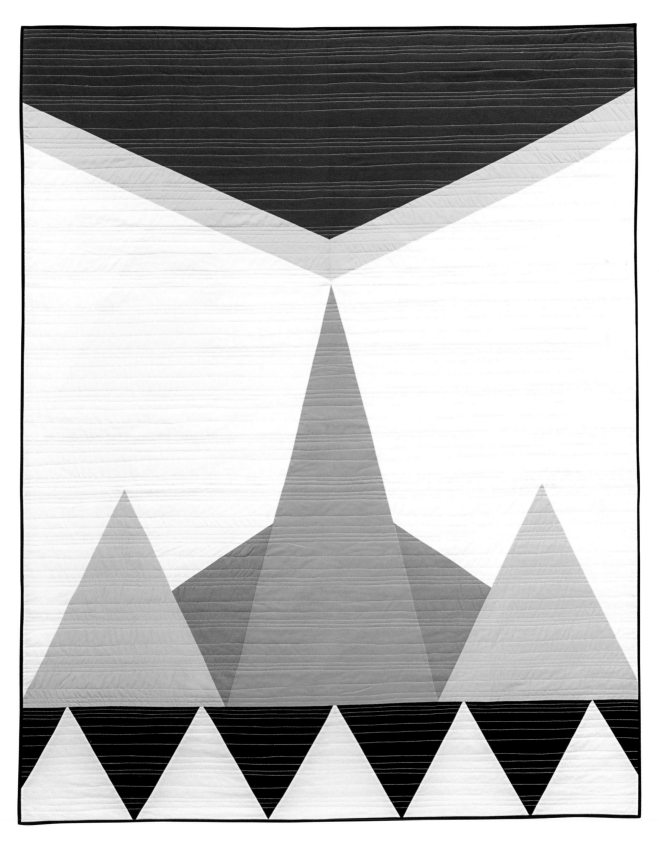

QUILT 005
Arianna Caggiano, 2016, 60″ × 72″

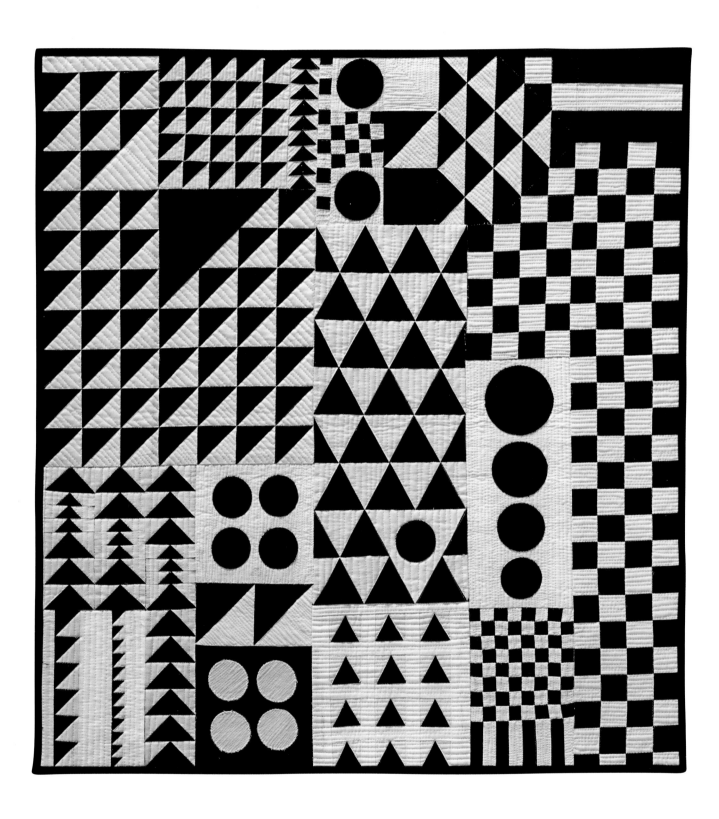

JUMBLE
Betsy Vinegrad, 2016, 24″ × 26″

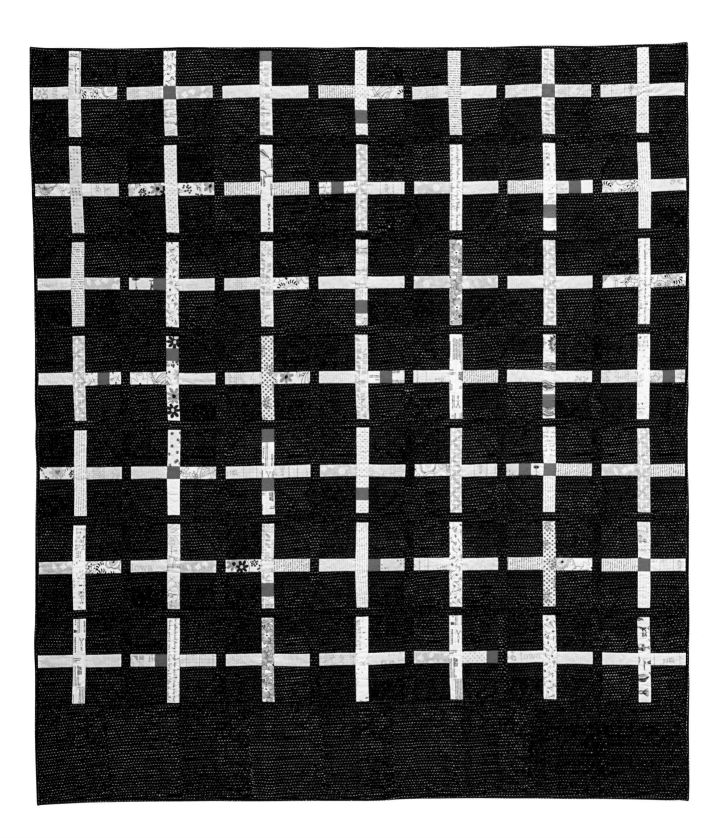

SYNAPSE

Made by Kari Vojtechovsky, quilted by Christine Perrigo, 2016, 54″ × 62″

This quilt was made with inspiration from Stephanie Zacharer Ruyle.

Expansive Negative Space

Since modern quilting is influenced heavily by graphic design, it's no surprise that negative space is a popular modern quilting element. The area between design elements (negative space) is used to draw focus to different areas of a quilt. Modern quilters often use expansive negative space to organize the subject, capture attention and create movement within the quilt, leading the eye to each focal point. Quilts with expansive negative space lend themselves well to alternate gridwork, as well.

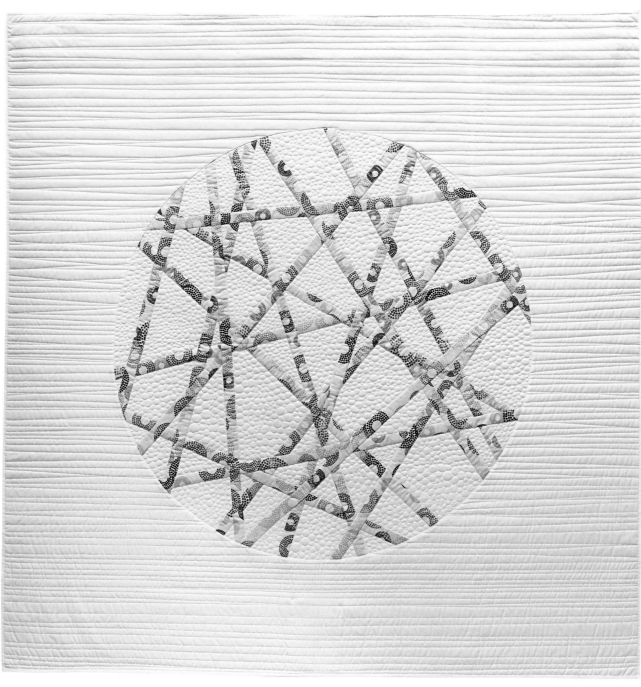

ON THE BALL
Brigitte Heitland, 2016, 60″ × 60″

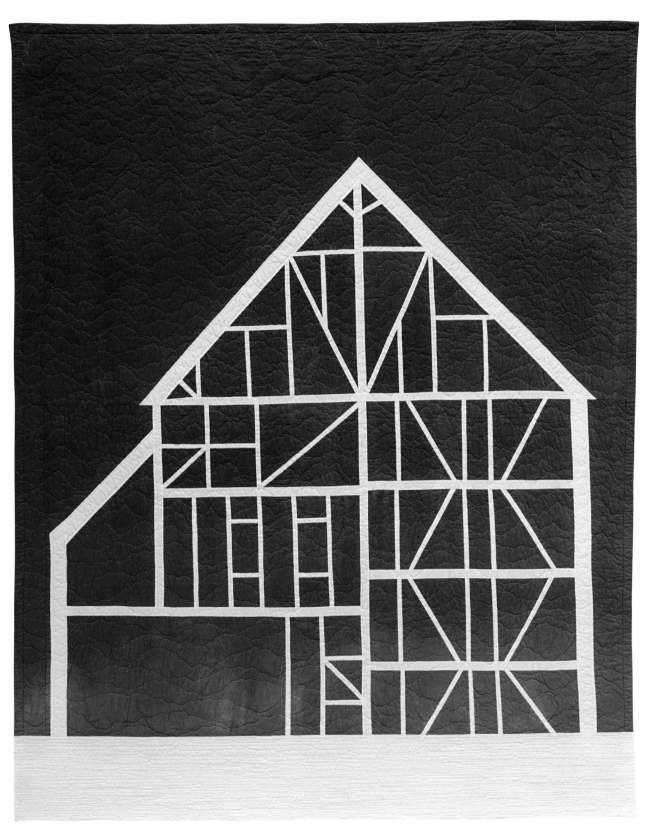

BARN (REMNANT)
Kim Eichler-Messmer, 2013, 72″ × 88″

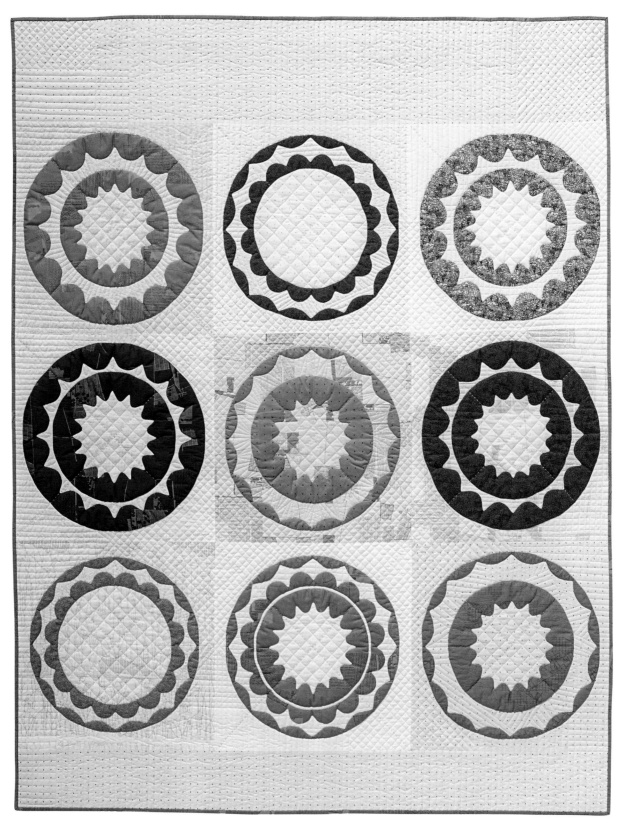

RIN
Carolyn Friedlander, 2016, 59″ × 73″

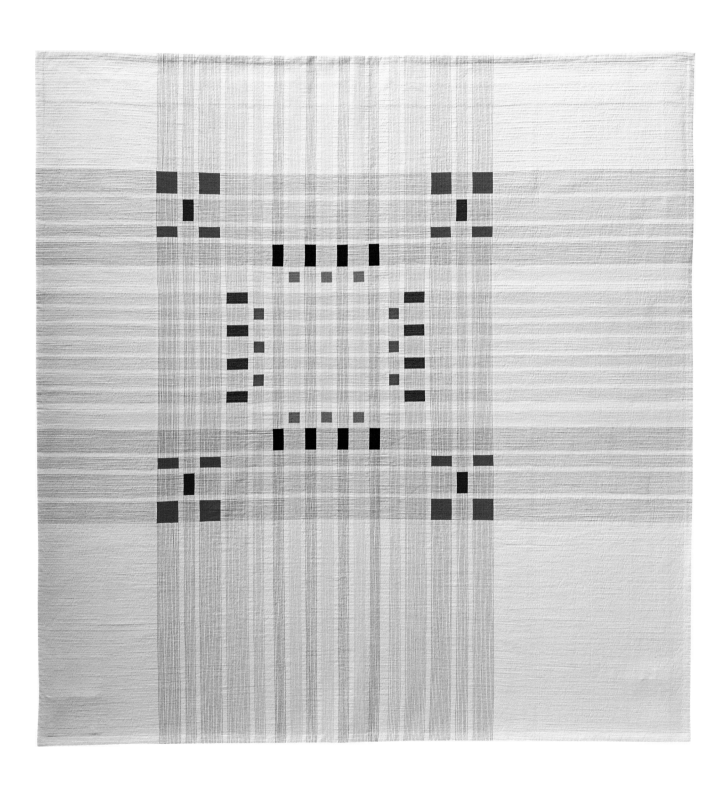

INFUSED PLAID
Cassandra Ireland Beaver, 2016, 61″ × 61″

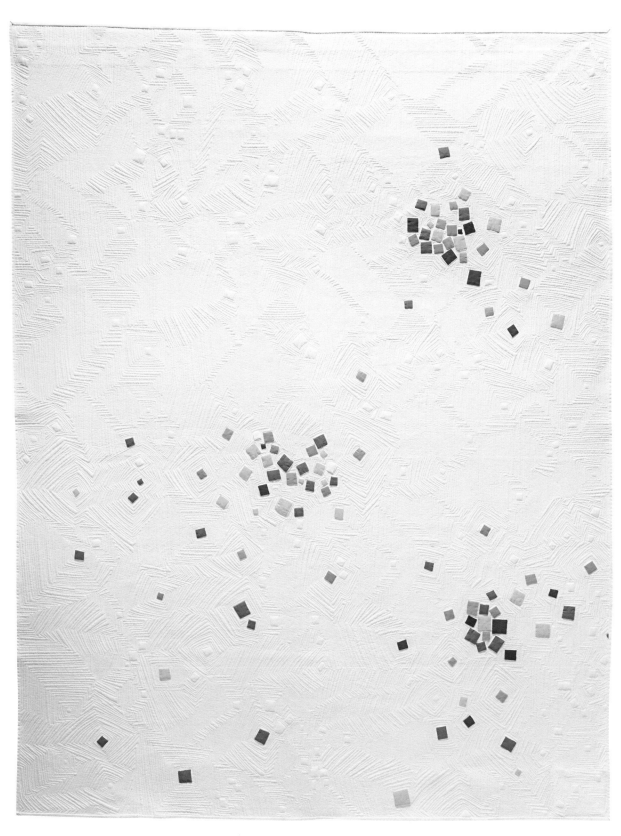

SQUARE COUNT GAME
Debra L. Jalbert, 2016, 62″ × 80″

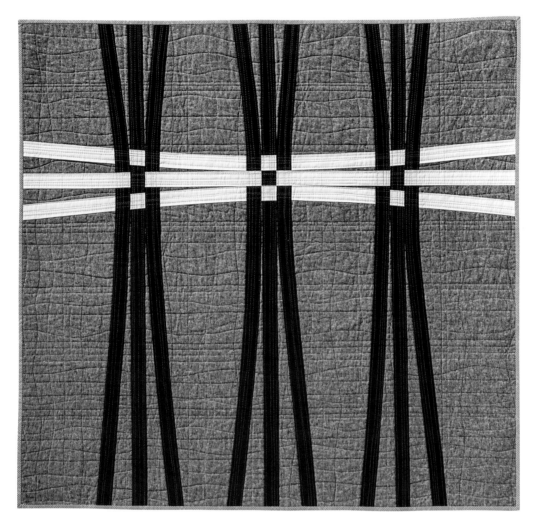

WARP AND WEFT
Cheryl Brickey
2016, 41″ × 40″

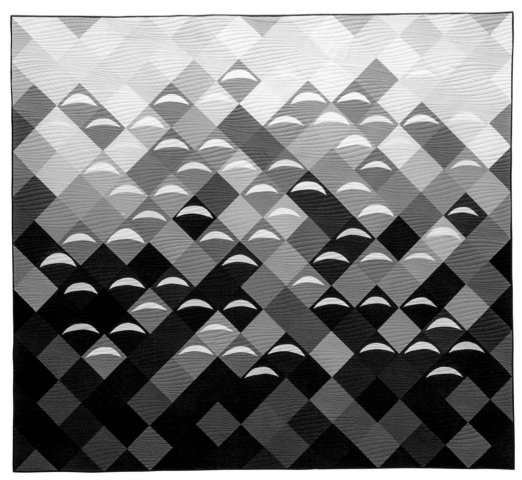

ROOKERY
Made by Daisy P. Aschehoug,
quilted by Charlene Harp,
2016, 110″ × 100″

Scale

Another tool in a modern quilter's toolbox is scale. Using scale is a fun and easy way to modernize a traditional block or quilt layout. By increasing or decreasing the size of a classic quilt block or other design, a modern quilter can achieve a dramatic look with elements that range from minuscule to larger than life. Quilters also incorporate scale by using a mix of different block sizes—small, classic, large, and even jumbo.

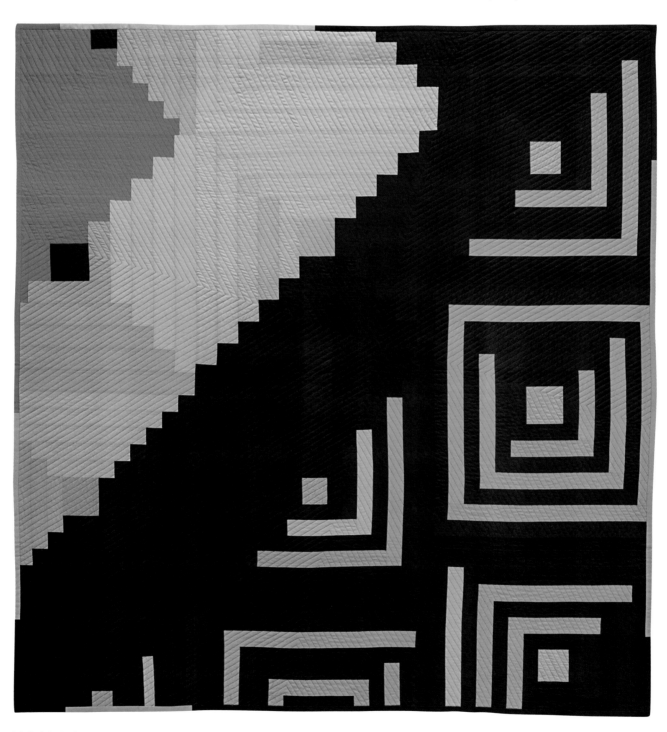

LOG CABIN QUILTER UNKNOWN
Diana Vandeyar, 2016, 60″ × 63″

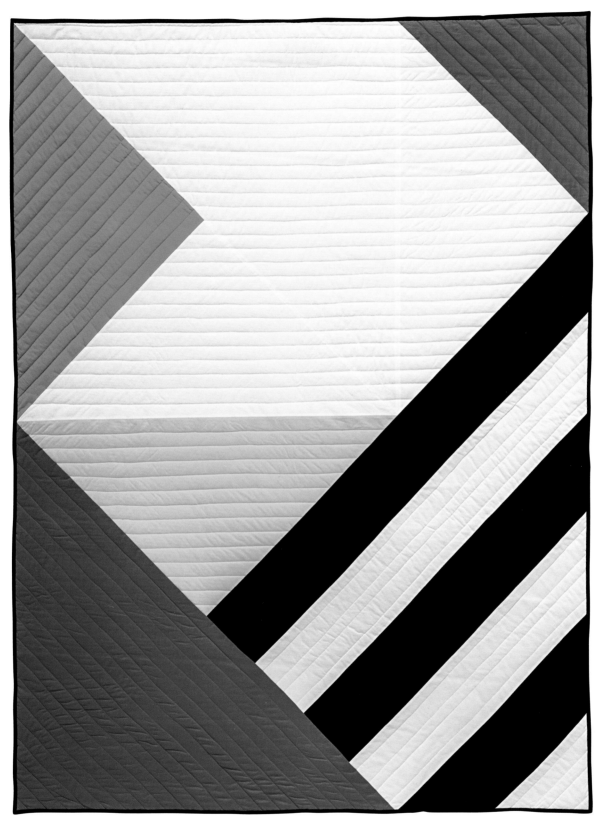

THAT WAY
Corinne Sovey, 2016, 51″ × 68″

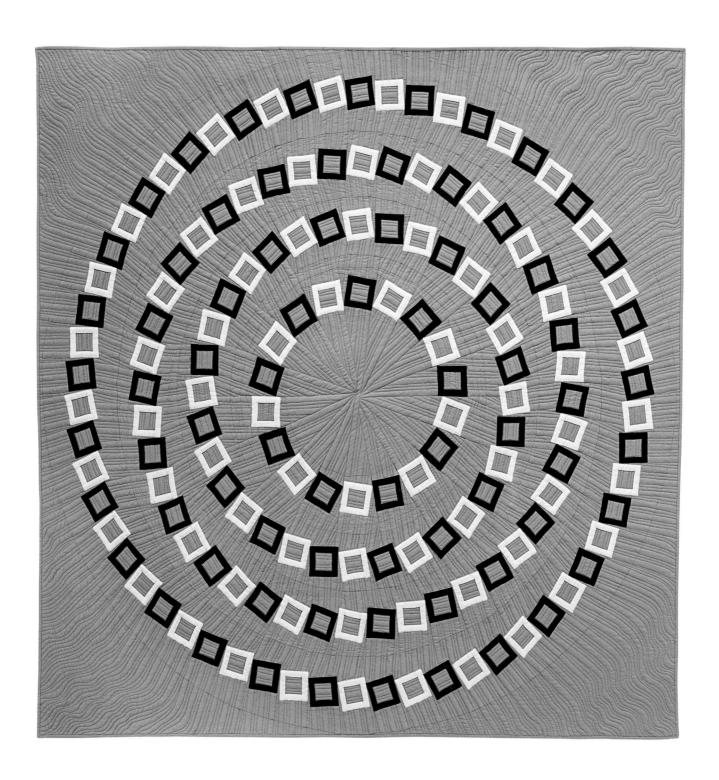

VERTIGO
Elaine Wick Poplin, 2016, 56″ × 56″

This quilt reconstructs the 2002 Pinna illusion with permission from Baingio Pinna, the original designer of the illusion.

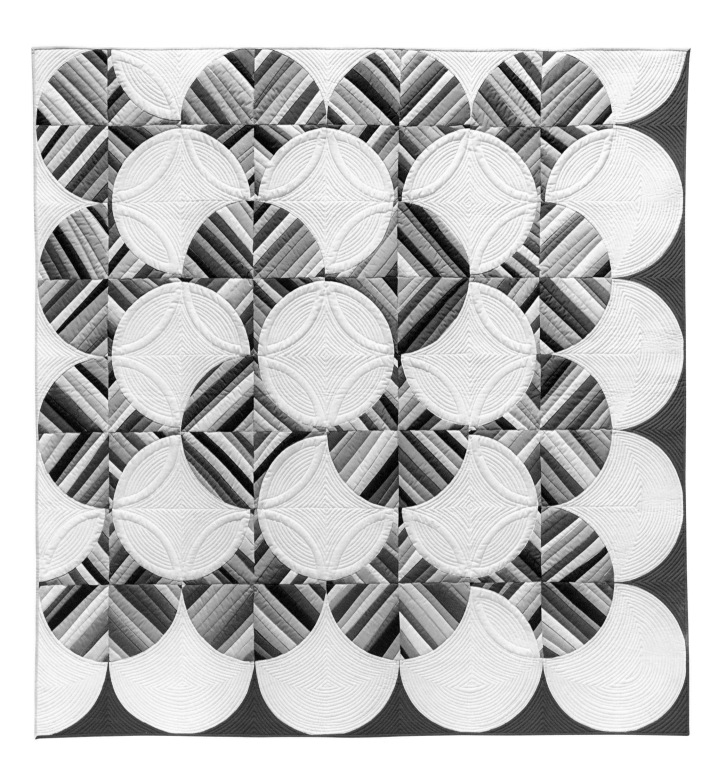

PEARLS ON THE CLAMSHELL
Elaine Wick Poplin, 2016, 56″ × 56″

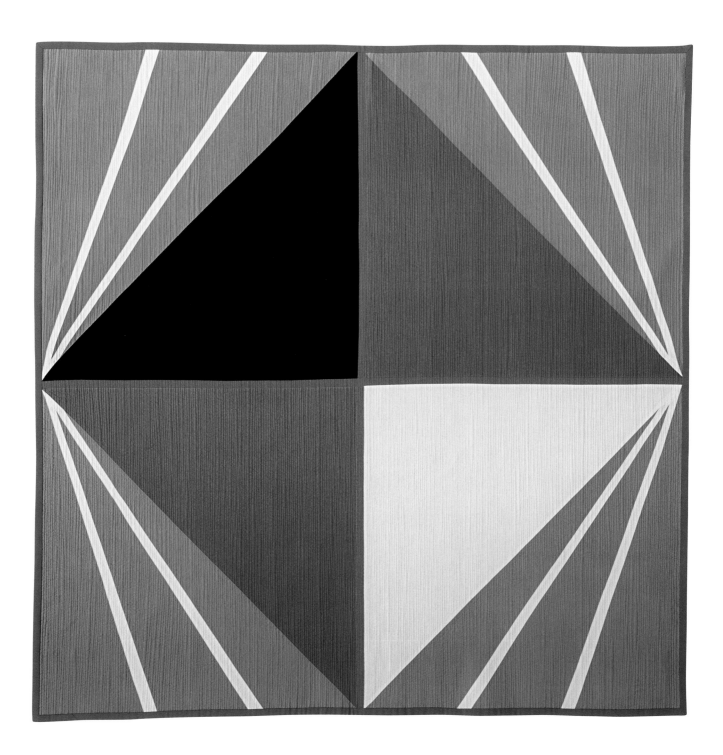

SPIN
Diana Vandeyar, 2016, 49″ × 49″

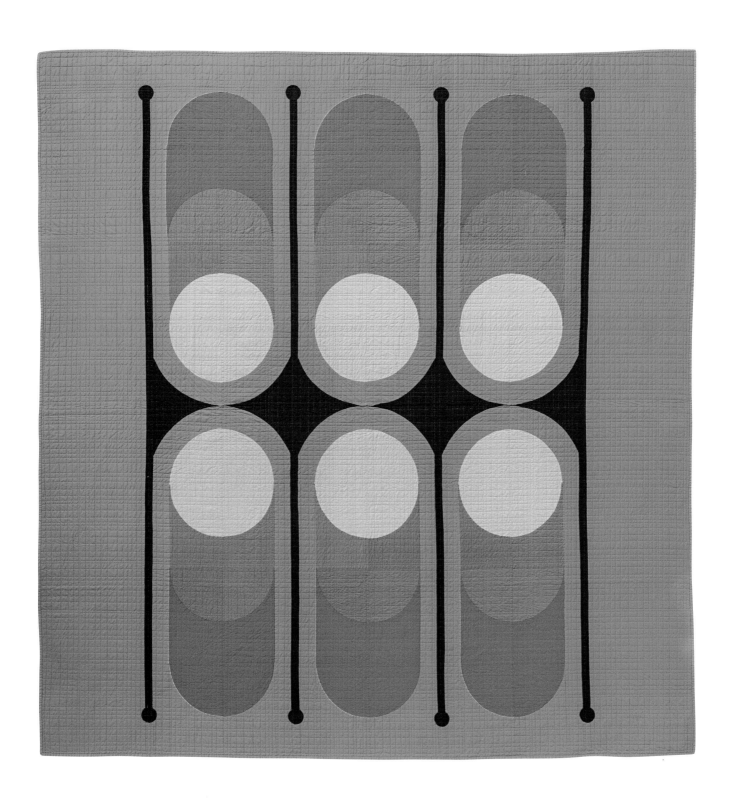

MADE IN GDR 26
Emily Doane, 2015, 90″ × 90″

This quilt was inspired by the motif of a vintage teacup (artist unknown).

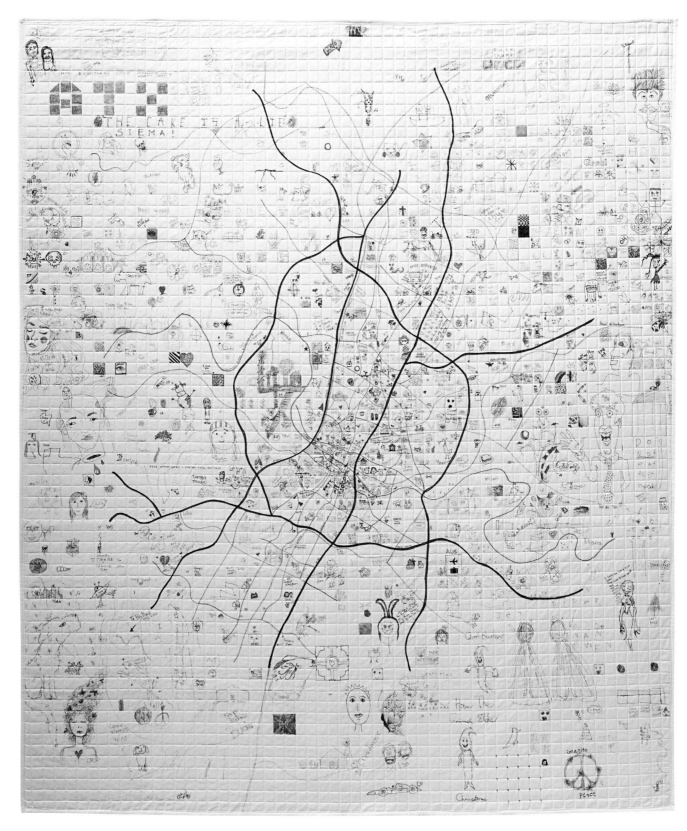

AUSTIN QUILT
Gina Pina, 2016, 59″ × 69″

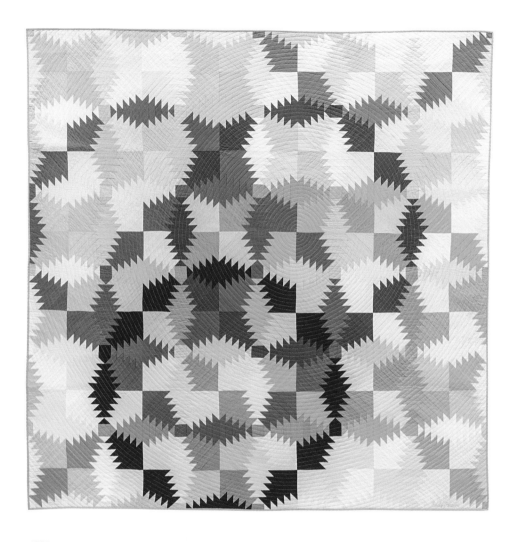

PINEAPPLE RINGS VII
Emily Parson, 2016, 72″ × 72″

SYMMETRY
Hayley Berrill, 2014, 18″ × 18″

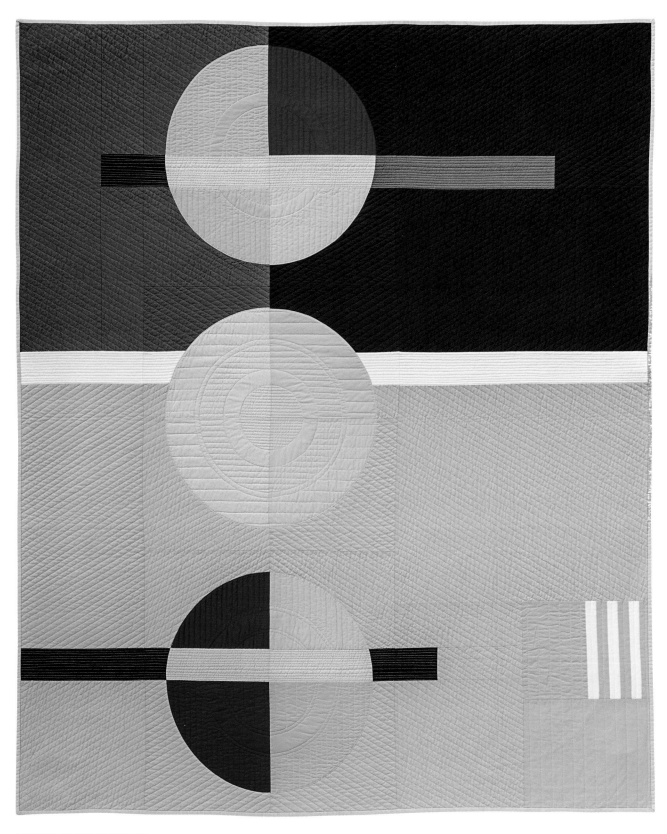

MODERN STEPPING STONES
Heather Black, 2016, 60″ × 72″

This quilt was inspired by the work of Roar + Rabbit for West Elm.

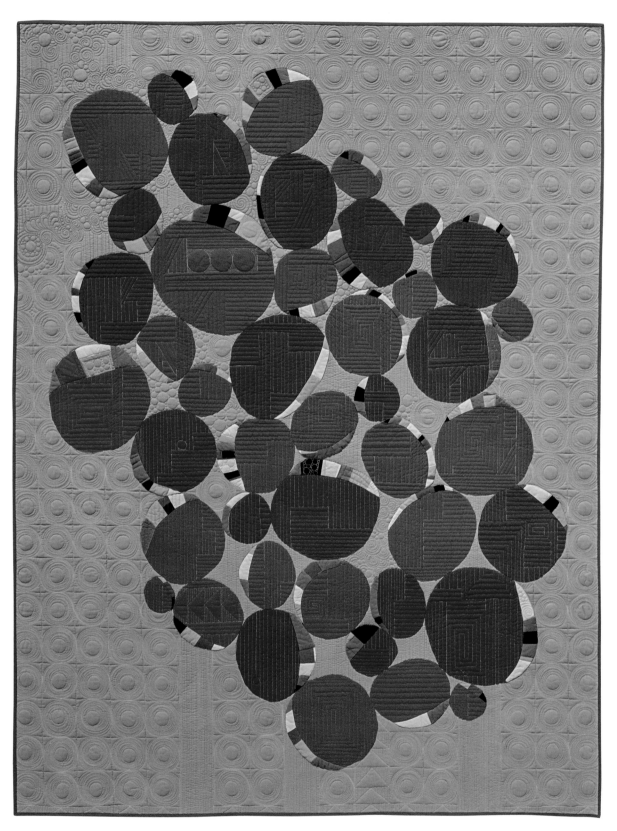

BLOBERELLA
Made by Hillary Goodwin, quilted by Krista Withers, 2016, 52″ × 67″

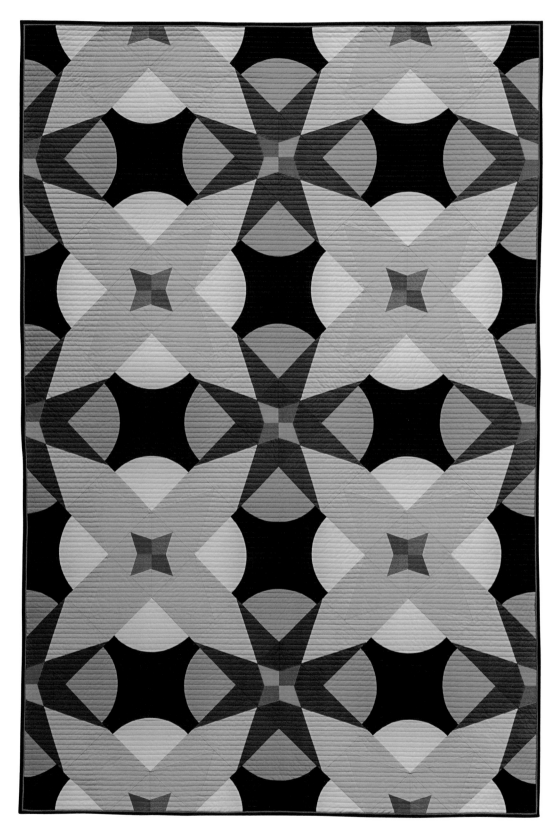

FIREWORKS
Jeannie Jenkins, 2016, 50″ × 76″

LUXE REBELLION
Jen Sorenson, 2016, 35″ × 48″

SELF PORTRAIT IN T
Hillary Goodwin, 2016, 26″ × 26″

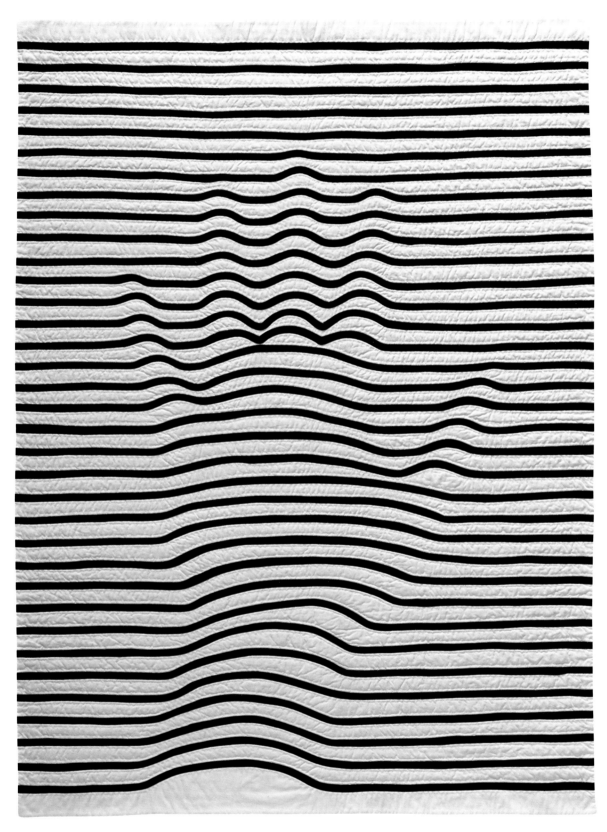

HANDCRAFTED
Jennifer Johnston, 2016, 40″ × 55″

HYPERBOLIC HEXAGON TESSELLATION
Jennifer Kloke, 2016, 109″ × 101″

This quilt was inspired by a mathematics poster by Megan E. Moore.

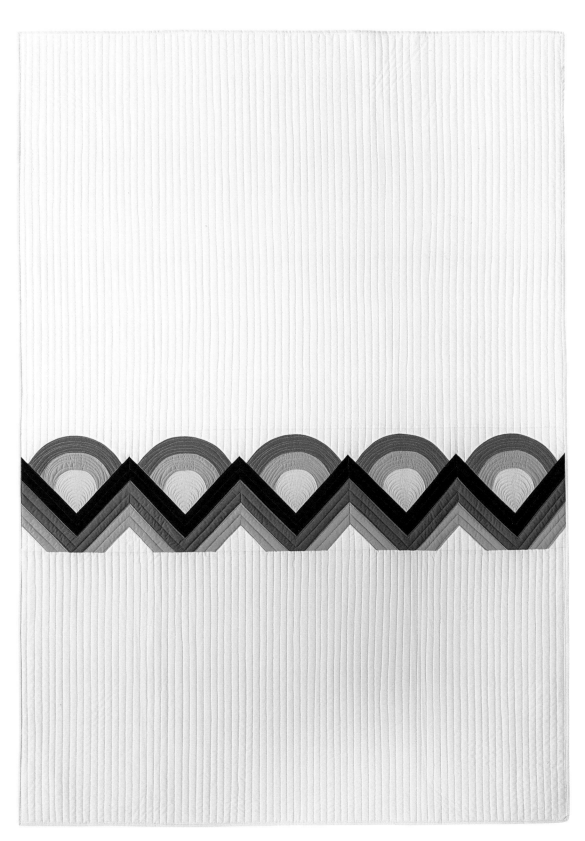

WESTSHIRE
Designed by Julia Williams, pieced and quilted by Kristi Ryan, 2016, 60″ × 80″

Photo courtesy of F+W Media

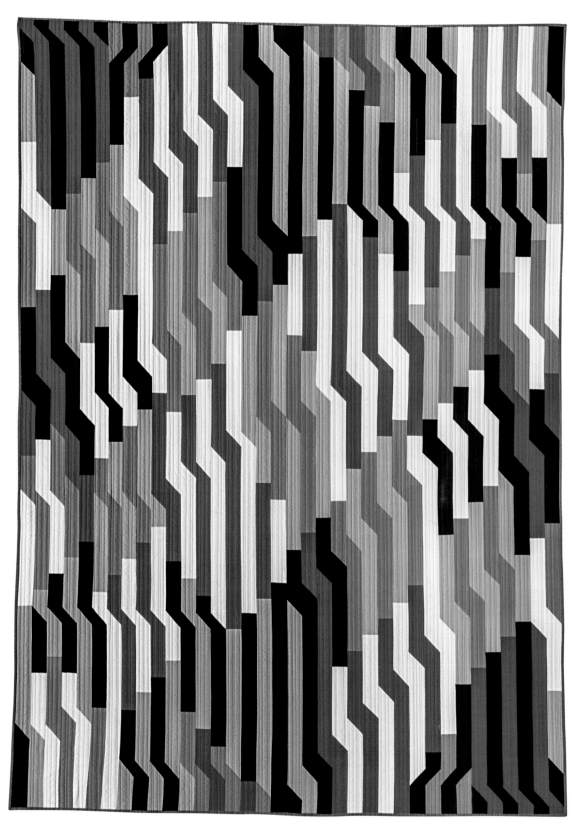

MERGE
Kamie Hone Murdock, 2016, 67″ × 94″

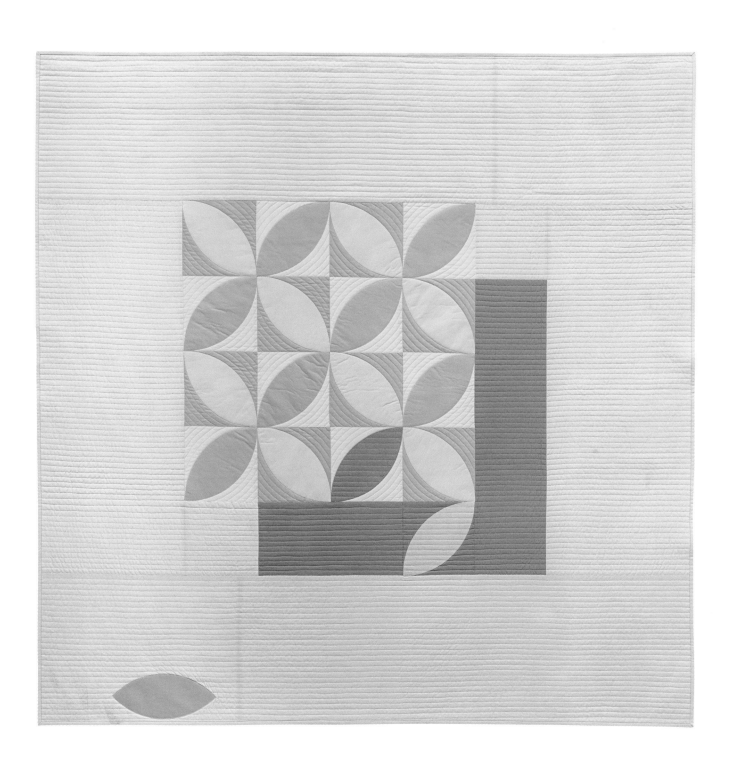

FALLEN PETAL
Karen Harvey Lee, 2016, 62″ × 62″

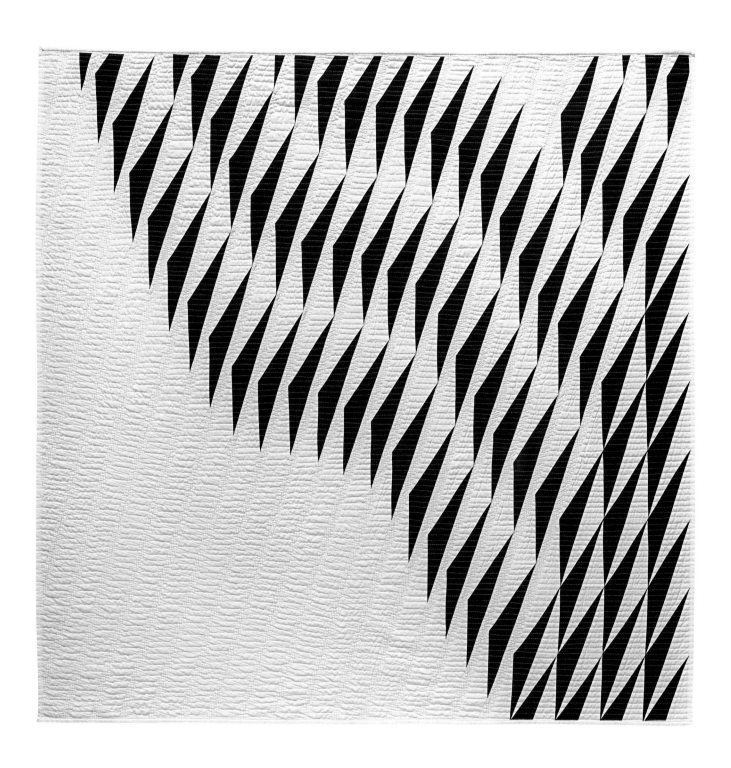

THE GROUND SHE MOVES, FLIES
Kari L. Anderson, 2016, 55″ × 56″

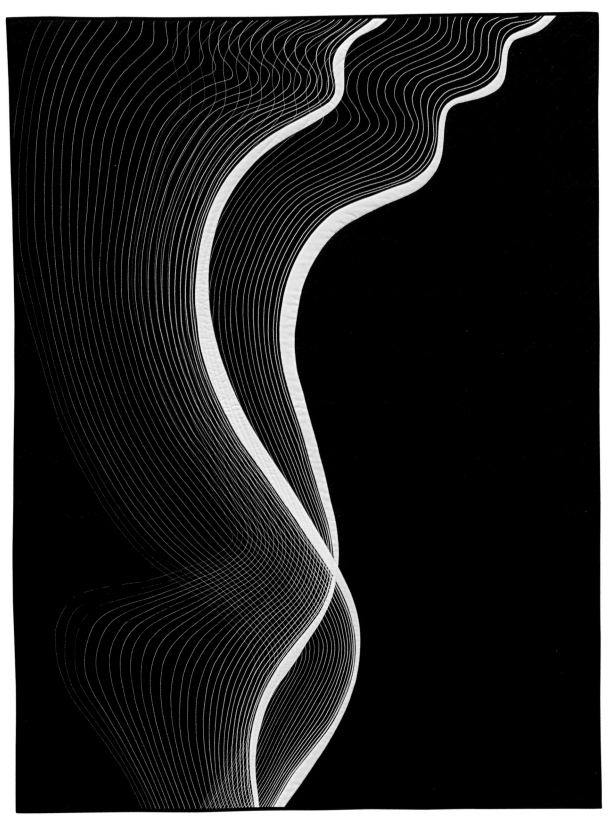

SMOKE
Kat Jones, 2016, 40″ × 54″

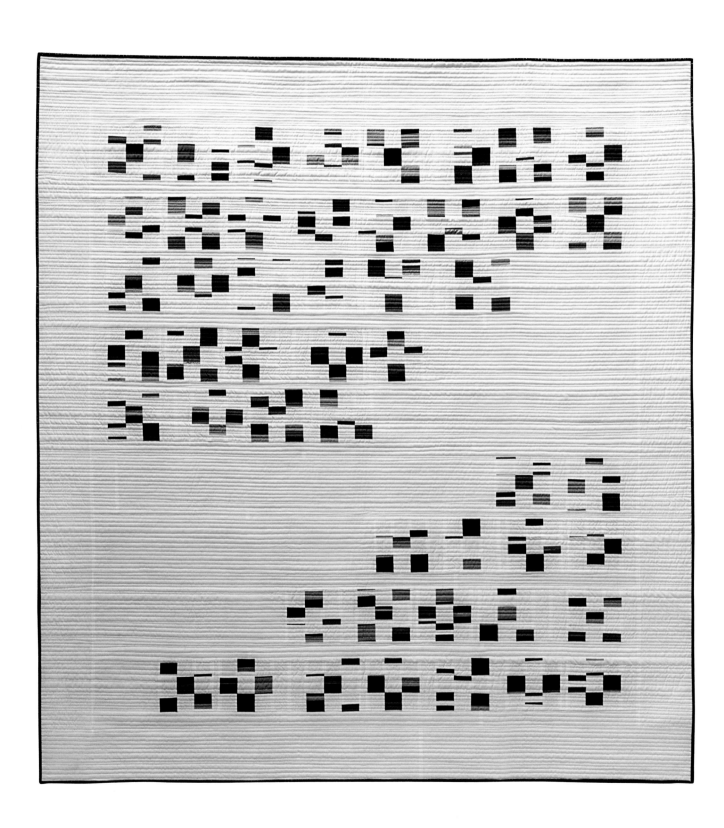

SILVER LINING
Kathryn Upitis, 2016, 75″ × 80″

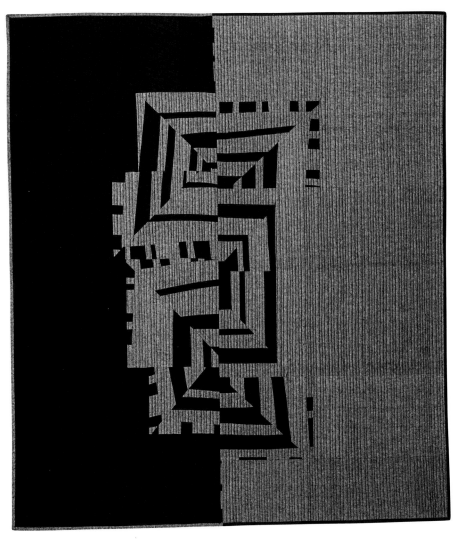

SKEWED SYMMETRY
Katie Pedersen, 2016, 43″ × 49″

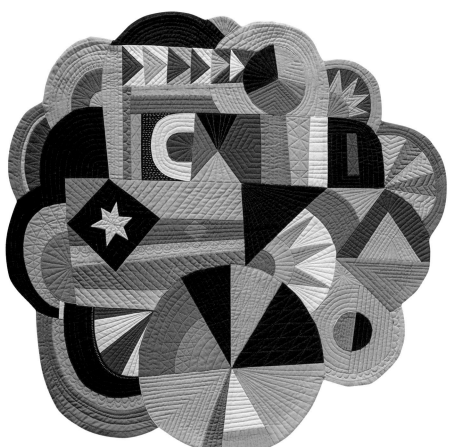

WHATEVER
Katie Larson, 2016, 32″ × 31″

BLING
Kat Jones, 2016, 98″ × 98″

PICKLED PEPPERS
Kristyn Box-McCoy, 2016, 18″ × 18″

MIGRATION QUILT
Made by Kristi Schroeder,
quilted by Lee Jenkins,
2016, 84″ × 92″

Alternate Gridwork

Traditional quilts are commonly laid out in straight columns and rows in a predictable grid structure. Modern quilts can still follow this traditional structure, but oftentimes they incorporate alternate gridwork, or uneven rows and columns. It is a foundational, and the most common, design element in modern quilts.

Sometimes it takes the form of big blocky areas or chunks of piecing; sometimes a whole quilt may be pieced as a large block; sometimes a quilt with alternate gridwork has diagonal seams. Modern quilts often use alternate gridwork to incorporate other modern quilting elements, such as asymmetry, negative space, and scale, as these elements are easier to piece using an alternate grid rather than a block structure.

WAITING FOR SANITY
Kristin Shields, 2016, 49″ × 48″

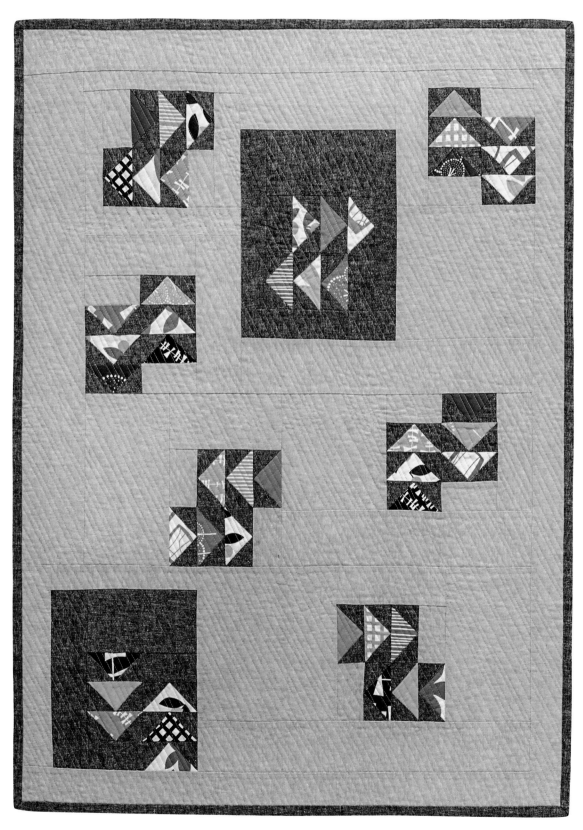

THIS WAY, THAT WAY QUILT
Faith Jones, 2013, 30″ × 40″

This quilt was inspired by traditional folk art quilts and scientific botanical drawings.

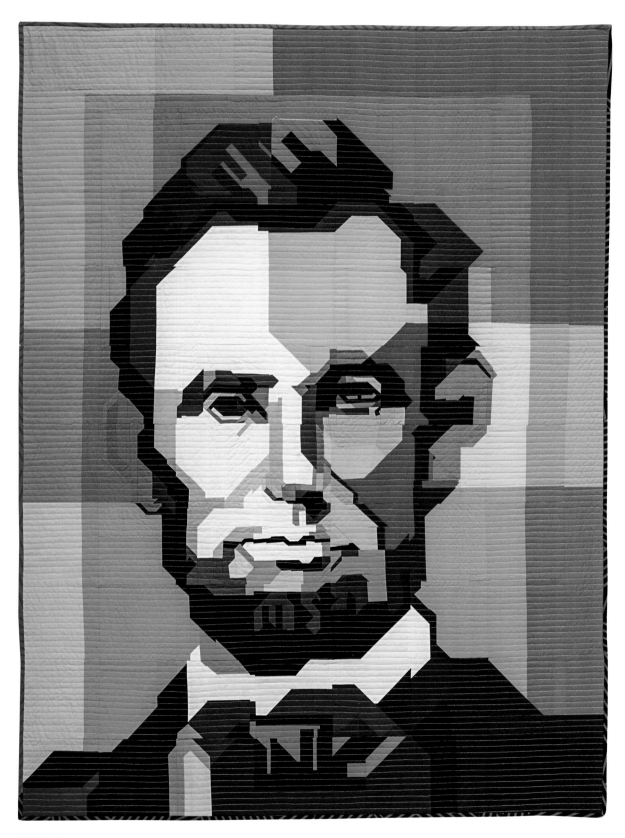

LINCOLN
Kim Soper, 2016, 46″ × 60″

This quilt is an improv-pieced version of a WPAP portrait of Abraham Lincoln by artist Ihsan Ekaputra.

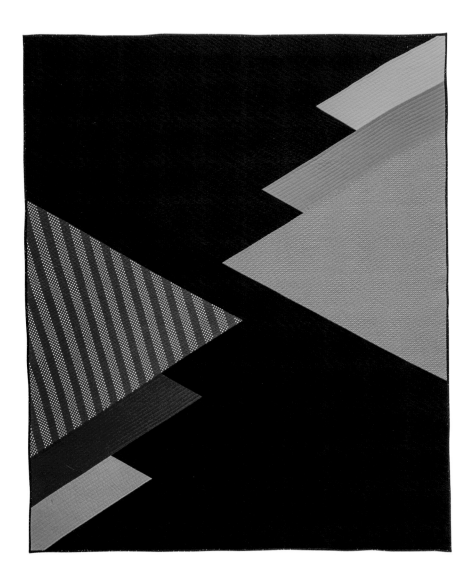

THE RIVER
Laura McDowell Hopper, 2016, 52″ × 62″

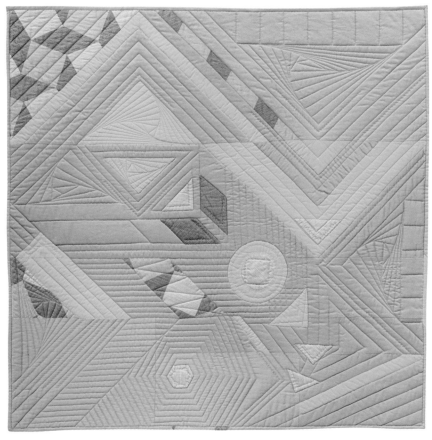

LIME 'N LUXE
Linda Hungerford, 2016, 34″ × 35″

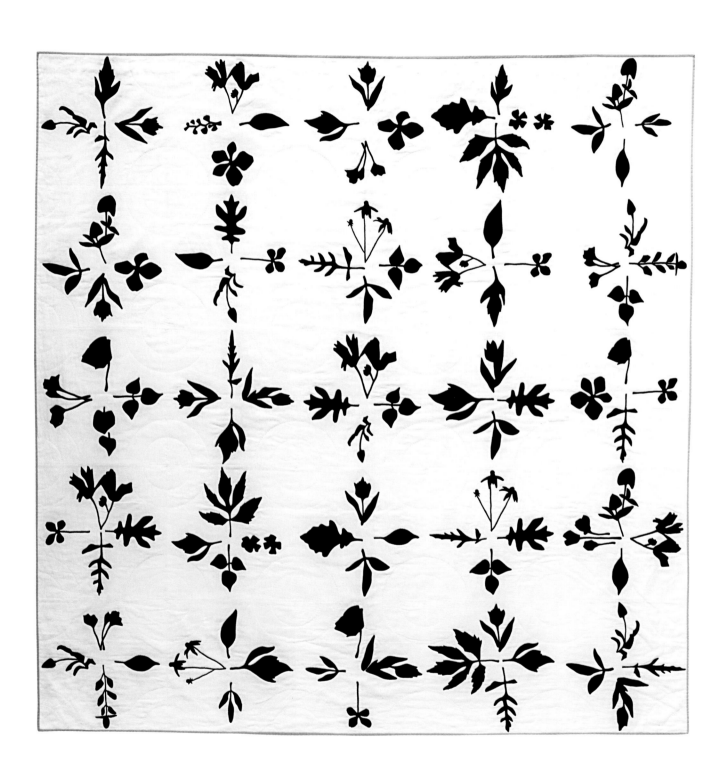

BLACK AND WHITE BOTANICAL QUILT
Made by Lesley Gold, hand quilted by Lesley Gold and Olan Reeves, 2016, 90″ × 90″

This quilt was inspired by traditional folk art quilts and scientific botanical drawings.

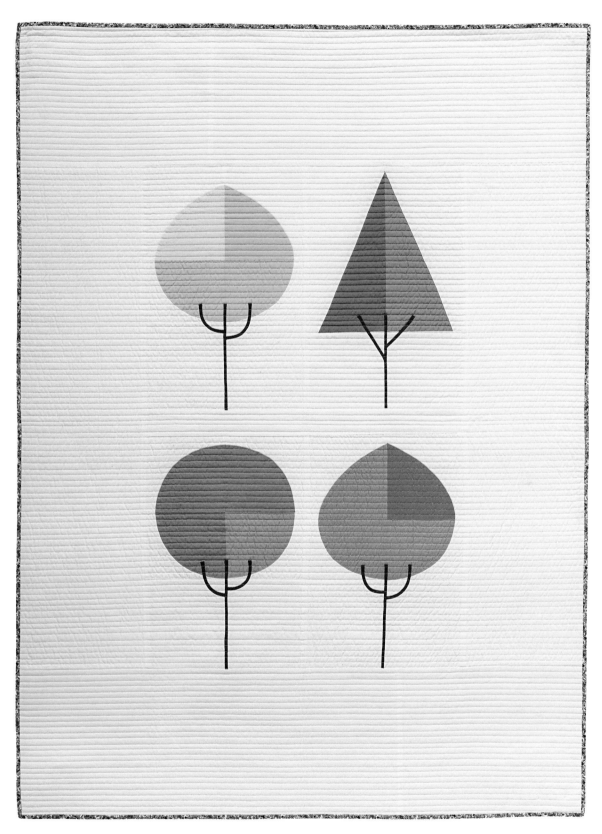

DIE BEEM (TREES)
Made by Lindsey Neill, quilted by Sarah Wilson, 2016, 50″ × 65″

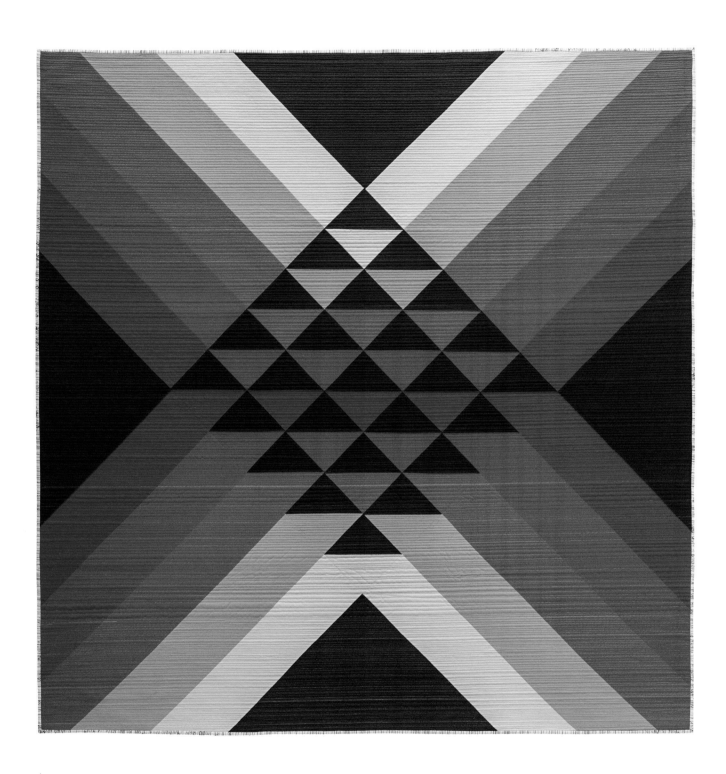

GO NORTH
Maritza Soto, 2016, 69″ × 70″

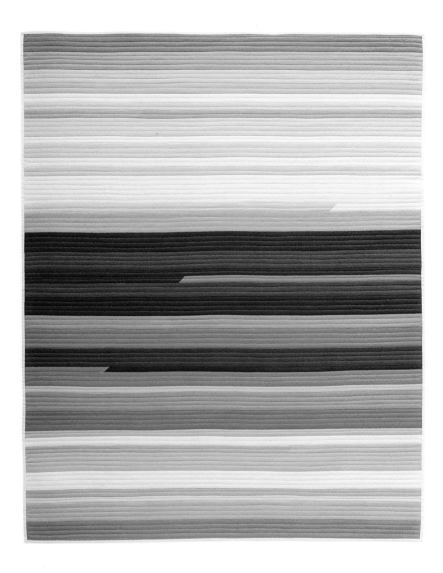

SEA HORIZON, WEST
Lucinda Walker, 2016, 42″ × 52″

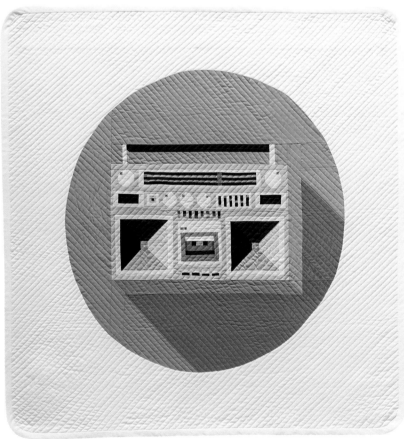

SAY ANYTHING
Lysa Flower, 2016, 43″ × 44″

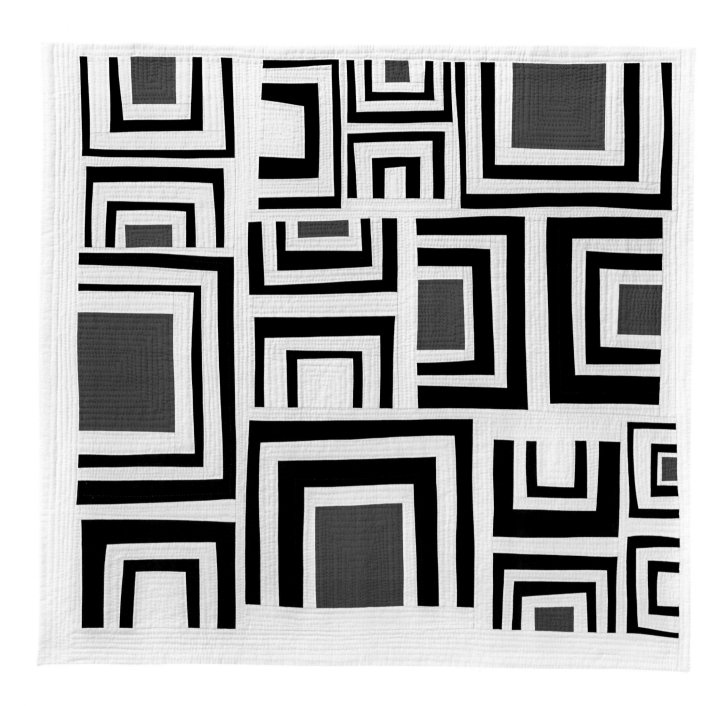

TRESTLE NESTLE
Marla Varner, 2016, 55½″ × 51″

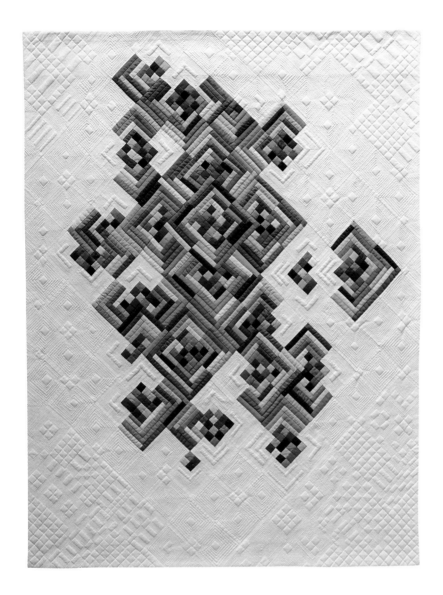

NOT EASY BEING GREEN
Mary Ramsey Keasler, 2016, 40″ × 54″

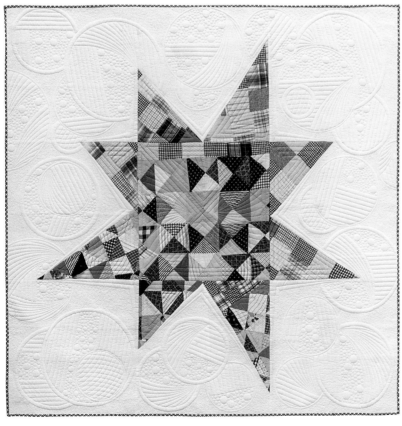

HOMESPUN
Made by Mary Kerr,
quilted by Donna Ferrill James,
2015, 46″ × 46″

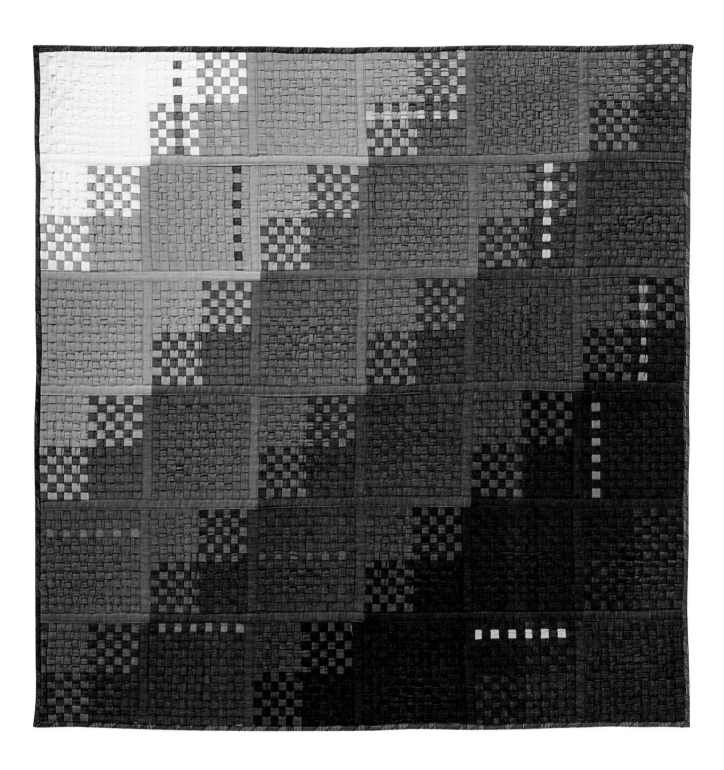

GRADIENT IN DENIM
Mathew Boudreaux, 2016, 52″ × 52″

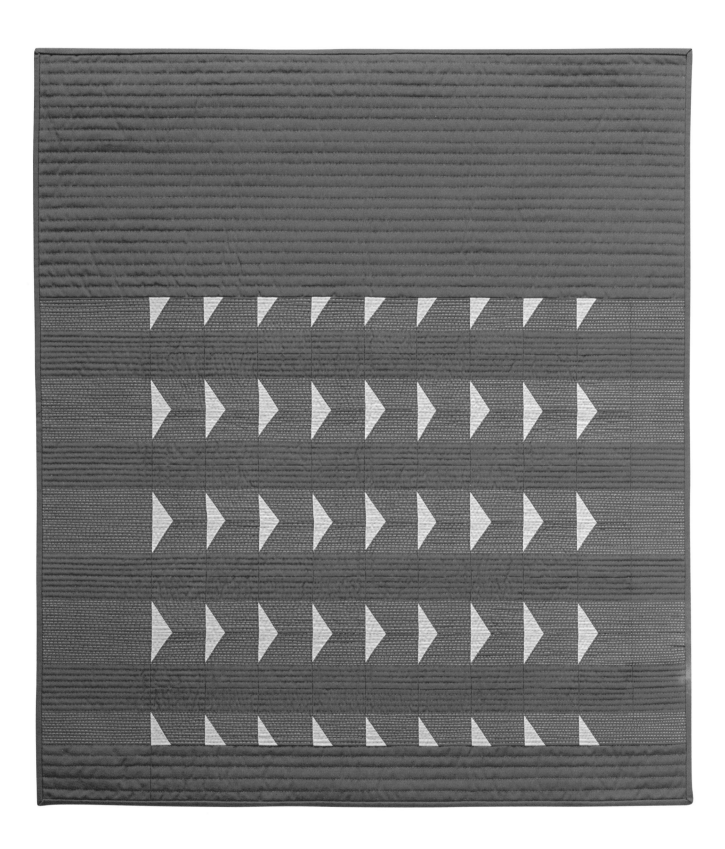

BEN
Melissa Miller Curley, 2016, 30″ × 33″

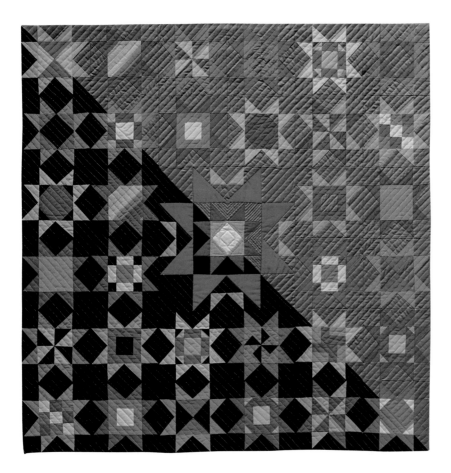

SPLIT DECISION (SPLIT I)
Michelle Reiter, 2016, 36″ × 36″

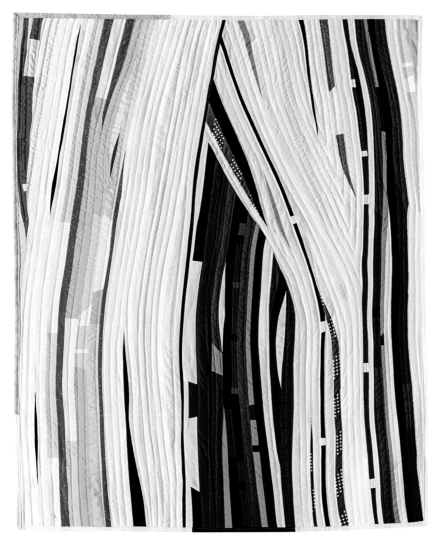

RAILS
Michelle Wilkie, 2017, 33″ × 39″

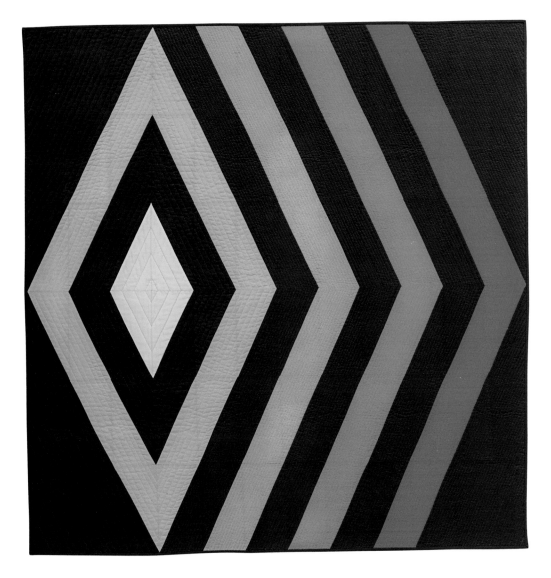

BERTHA
Melissa Miller Curley,
2016, 47″ × 47″

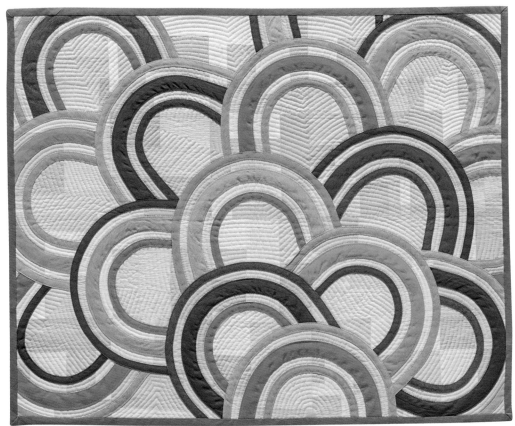

LUCKY ARCHES
Nicole Neblett,
2016, 24″ × 30″

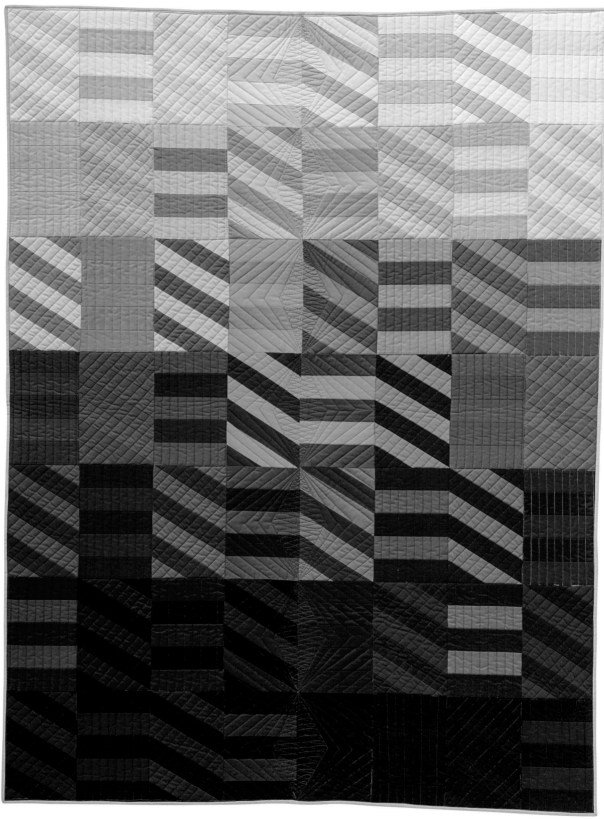

PERCEPTION—OCEAN
Made by Nydia Kehnle, quilted by Kristi Ryan, 2016, 56″ × 70″

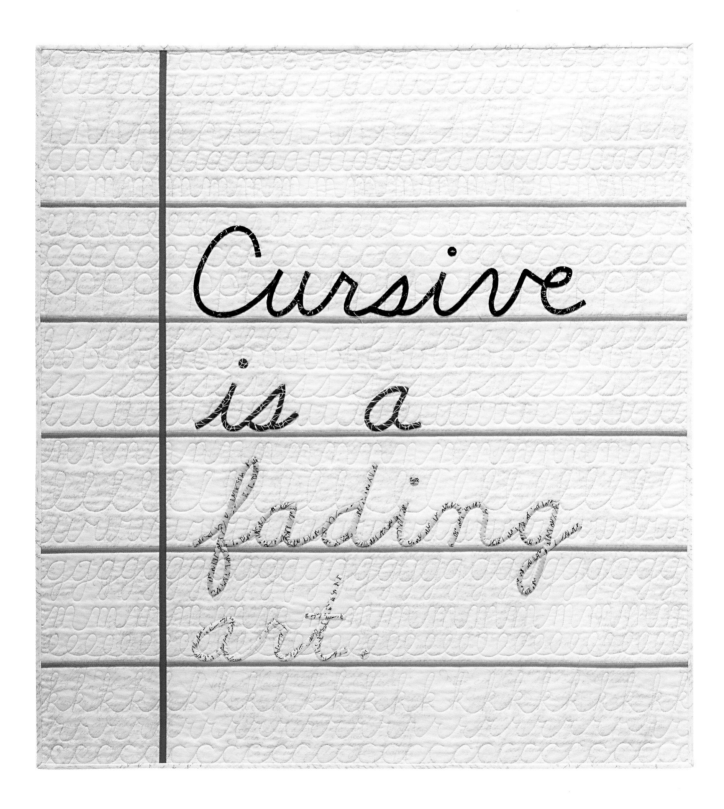

CURSIVE
Paige Alexander, 2016, 34″ × 36″

This quilt is an original design that includes D'Nealian handwriting by developer Donald N. Thurber.
Cursive now resides with Susan P. Bachelder, author of Alphabet Crash.

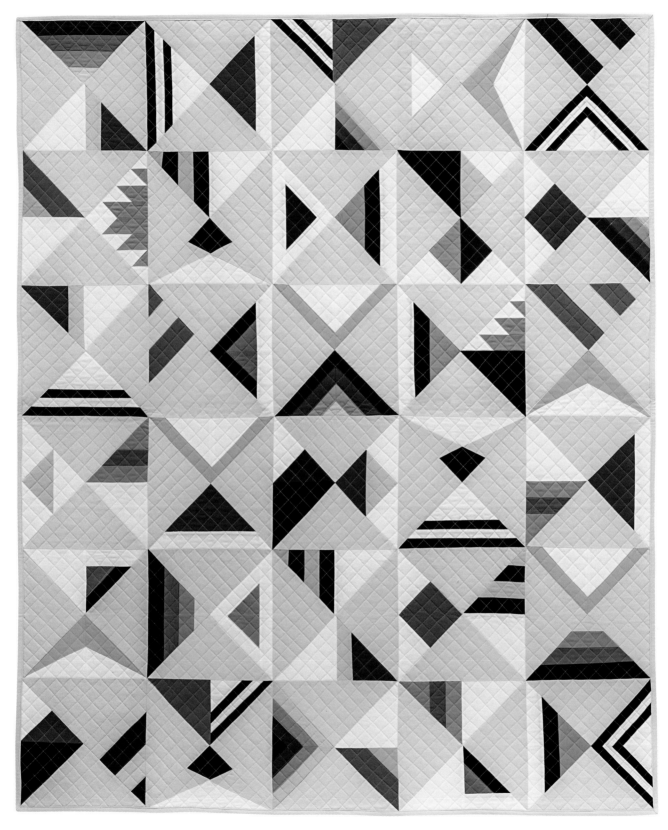

WAKE
Rebecca Bryan, 2015, 57⅛″ × 68½″

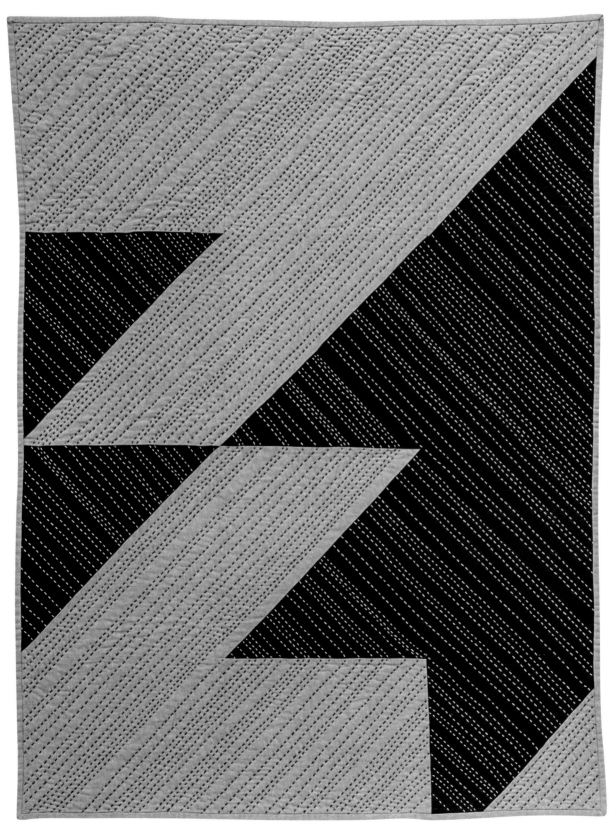

ANVIL REMIX
Riane Menardi, 2016, 34″ × 44″

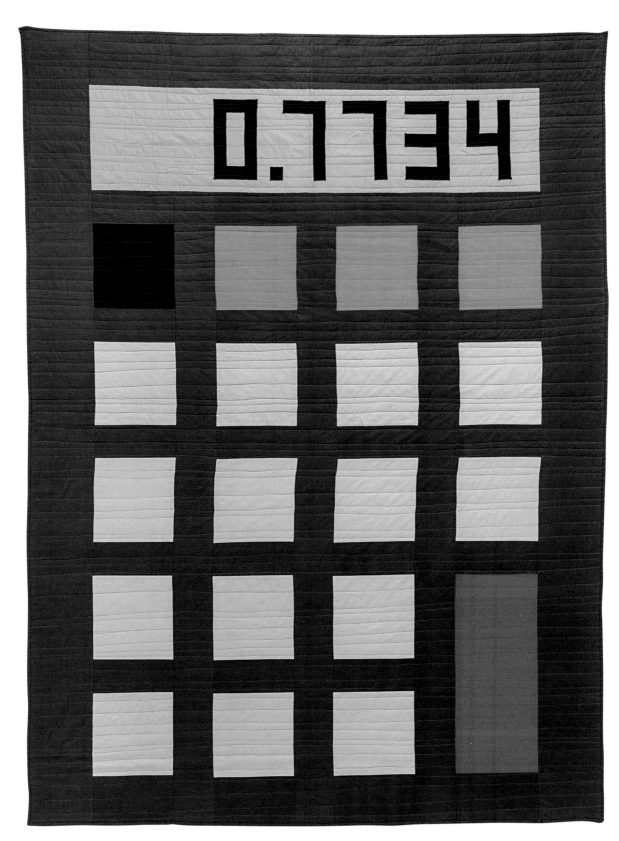

CALCULATOR
Samarra Khaja, 2015, 71″ × 94½″

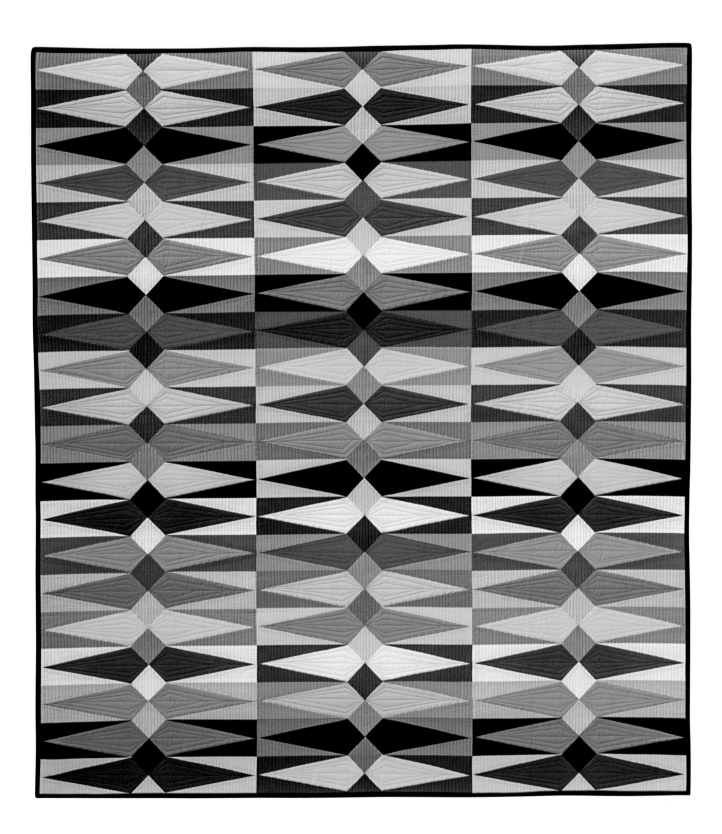

LAWN DIAMONDS
Made by Sarah Schraw, quilted by Krishma Patel, 2016, 54″ × 60″

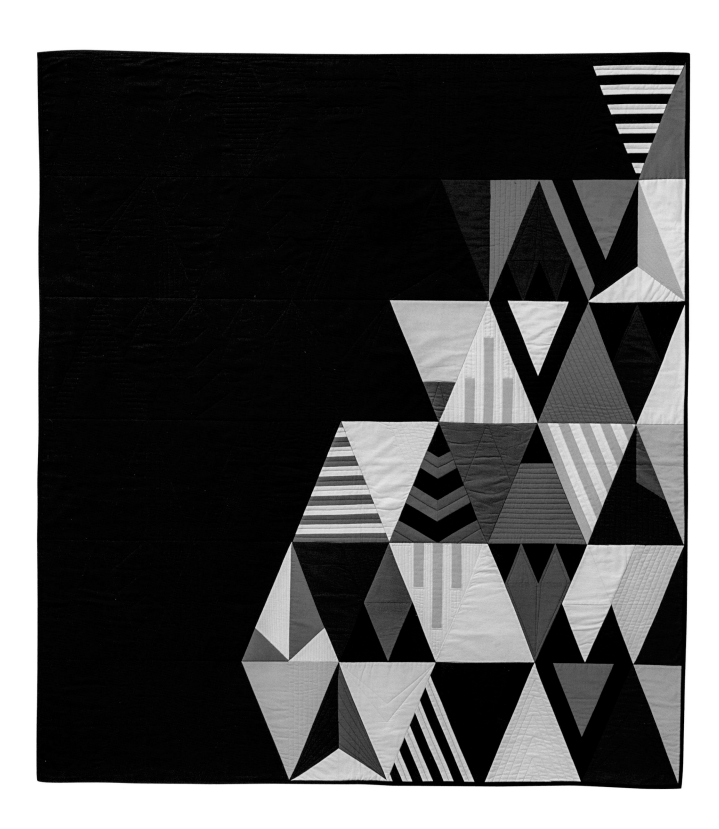

STARDUST
Rebecca Bryan, 2015, 62″ × 73″

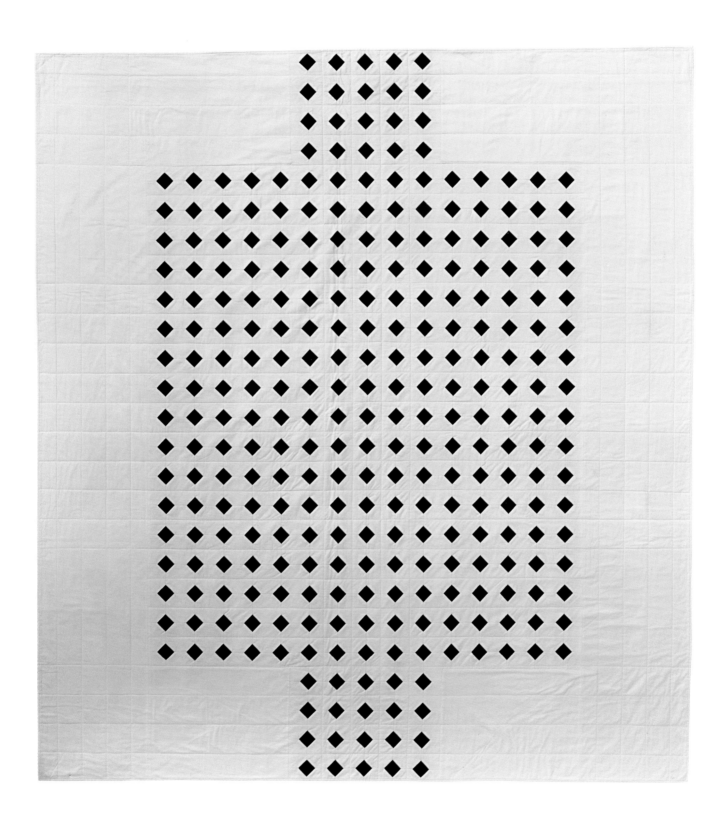

RELOCATION
Season Evans, 2016, 83″ × 96″

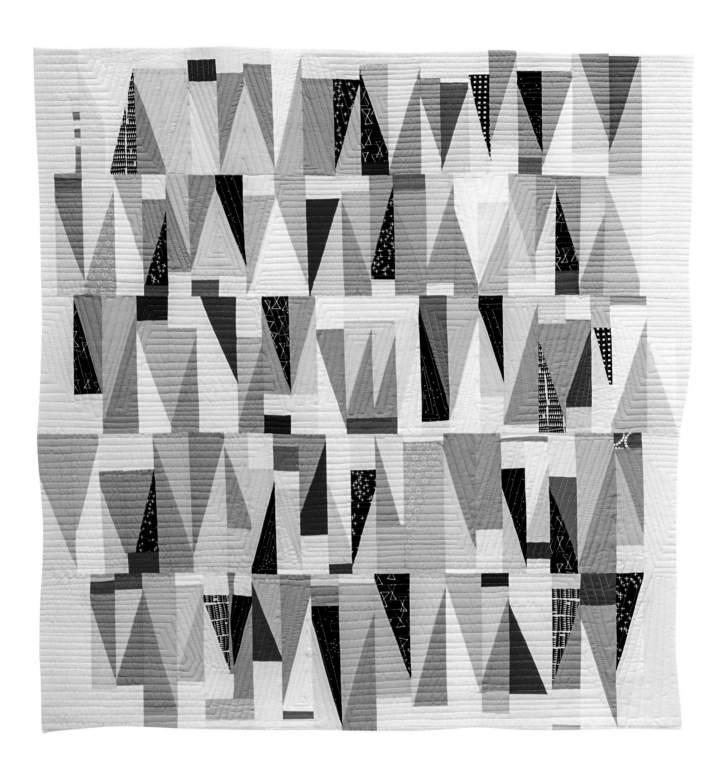

CIRCUS ACT
Silvia M. Sutters, 2016, 41″ × 41″

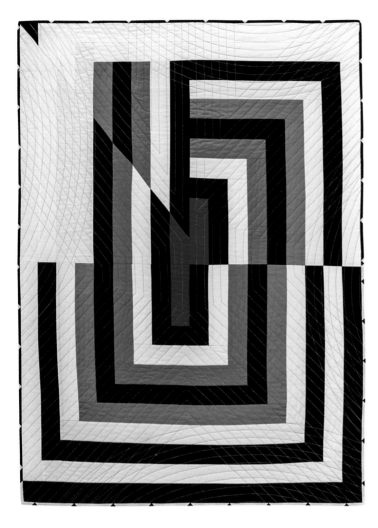

REDN
Susan Borger, 2016, 34½″ × 46¾″

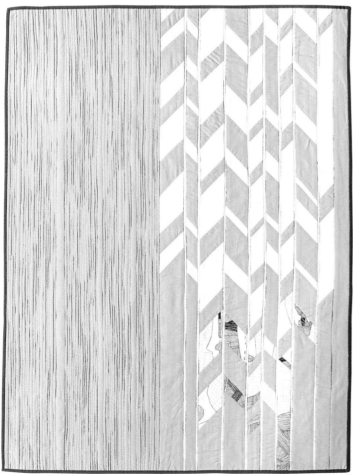

OTHERWISE/AUTREMENT
Suzanne Paquette, 2016, 30″ × 39″

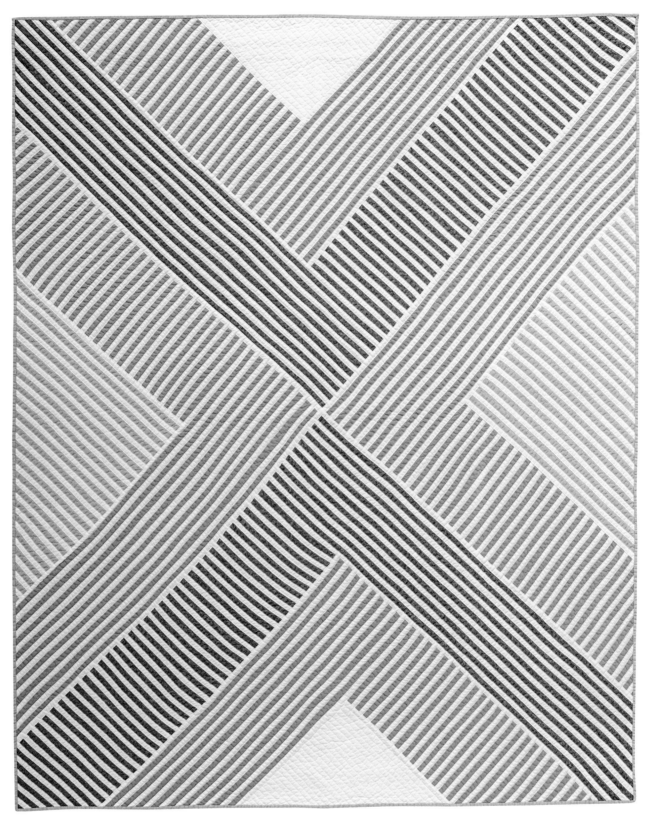

SERENITY
Steph Skardal, 2016, 55″ × 66″

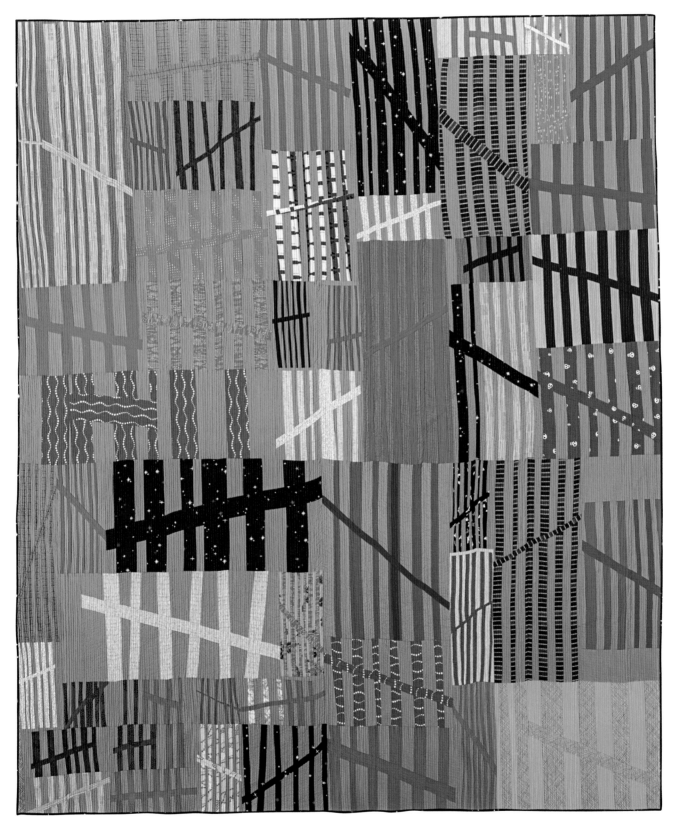

I'M COUNTING ON YOU
Shannon Page, 2016, 75″ × 85″

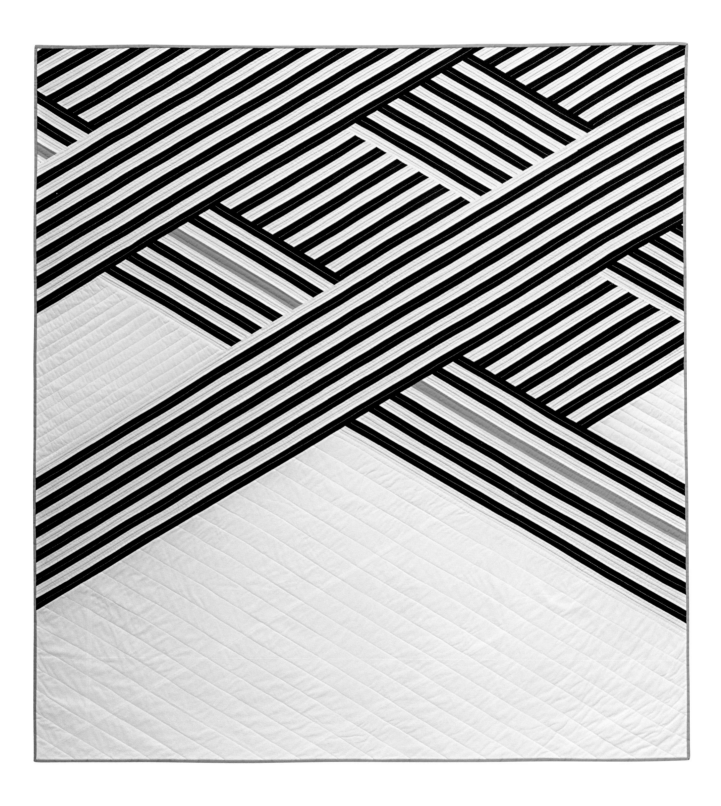

CABANA
Sheri Cifaldi-Morrill, 2015, 67″ × 70″

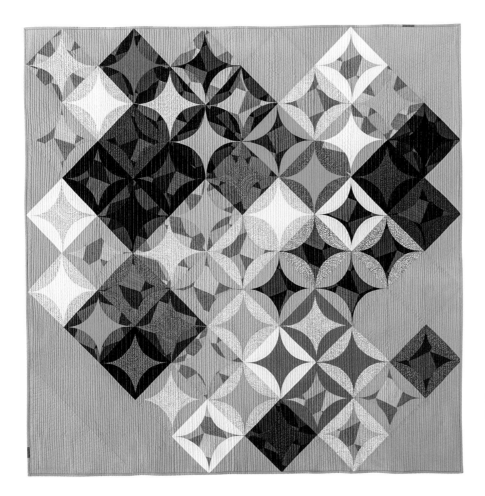

LUXE MODERN
Susan Slusser Clay, 2016, 59″ × 62″

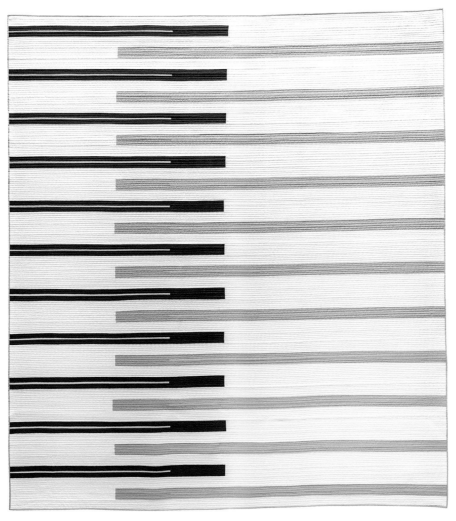

WAX AND WANE
Susan Kyle, 2016, 82″ × 90″

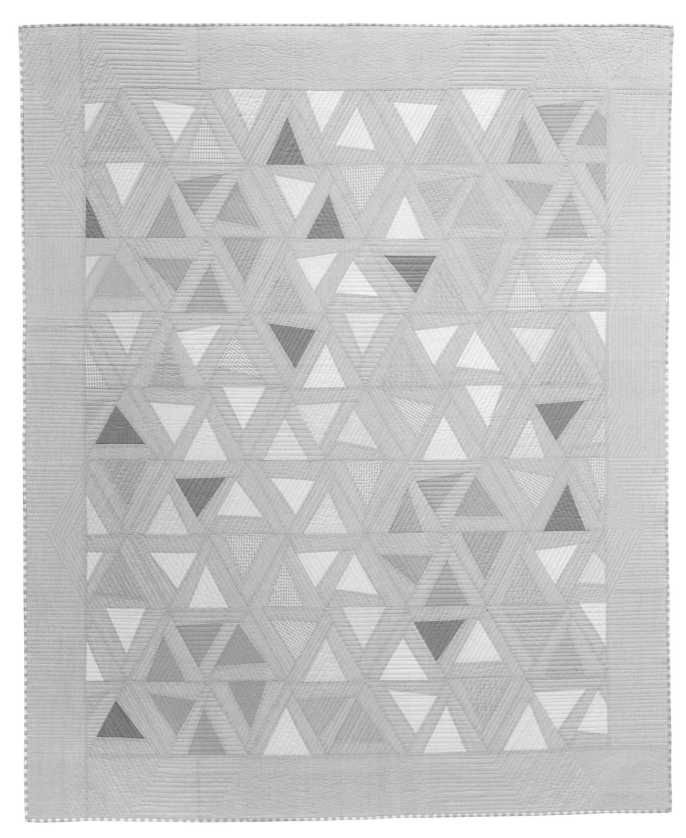

GINGHAM SPRING
Made by Suzy Williams, quilted by Mary Gregory, 2016, 57″ × 67″

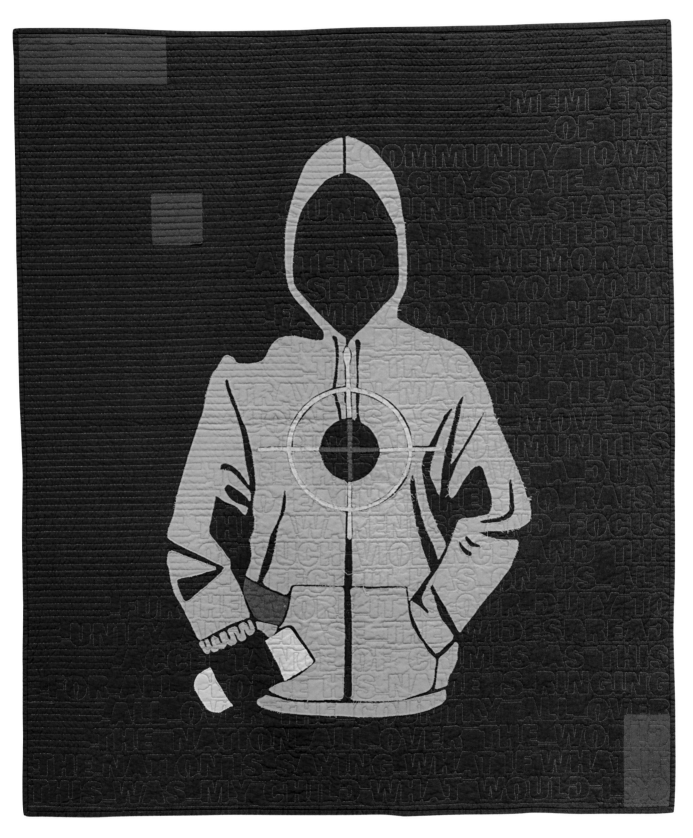

TEA AND SKITTLES
Thomas Knauer, 2016, 40″ × 48″

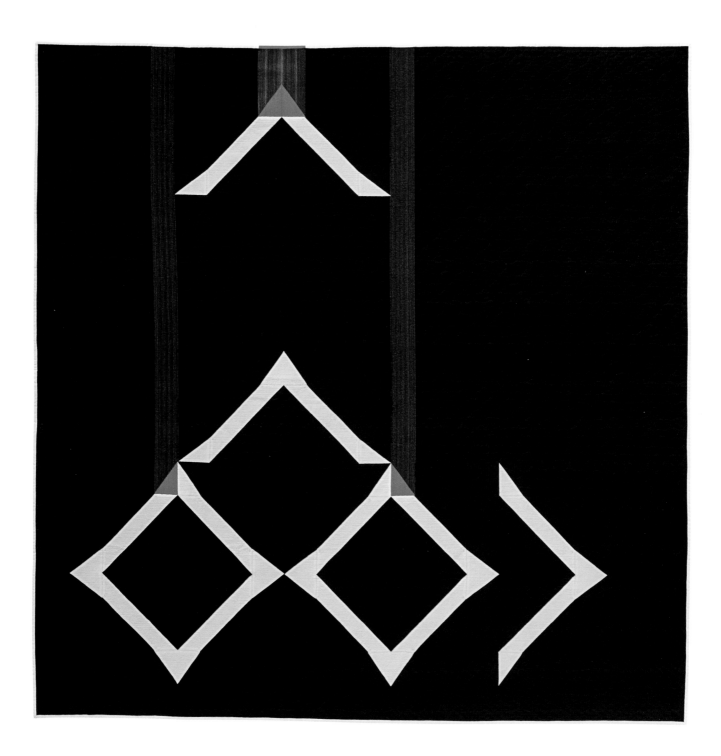

BEACON
Yvonne T. Fuchs, 2016, 68″ × 68″

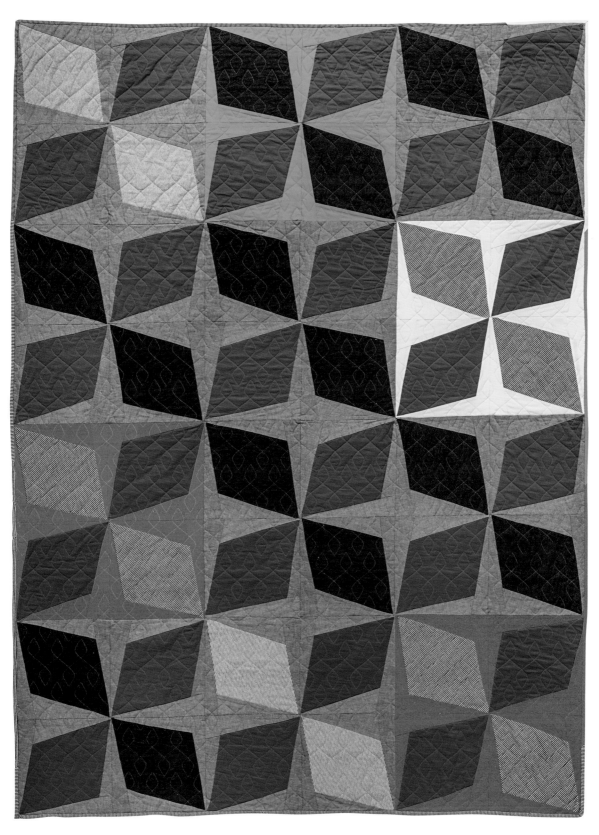

FUNKY MEDINA
Christine Ricks, 2016, 62″ × 82″

INDEX BY QUILTER

INDEX BY DESIGN CATEGORY

SMALL QUILTS

USE OF NEGATIVE SPACE

RIANE MENARDI is the communications manager for The Modern Quilt Guild, as well as a writer, designer, and communications specialist from Des Moines, Iowa. With a background in journalism and marketing, she made the leap to quilting in 2011 and never looked back.

ALISSA HAIGHT CARLTON is a modern quilter, designer, and author and is the co-founder and Executive Director of The Modern Quilt Guild. She has written two quilting books, *Modern Minimal* and *Block Party*. She lives in Los Angeles with her husband and two sons.

A quilter in her early 20s, HEATHER GRANT stopped quilting until 2005, when she was inspired by the modern quilting movement and made her first modern quilt. Heather is the founder of the Austin Modern Quilt Guild and the Director of Marketing and Programming for The Modern Quilt Guild. She lives in Austin, Texas, with her husband, son, and too many pets.

Connect with The Modern Quilt Guild:

WEBSITE: themodernquiltguild.com // FACEBOOK: /themqg // INSTAGRAM: @themqg

Want even more creative content?

Make it, snap it, share it *using* #ctpublishing